ACTION
PHOTOGRAPHY

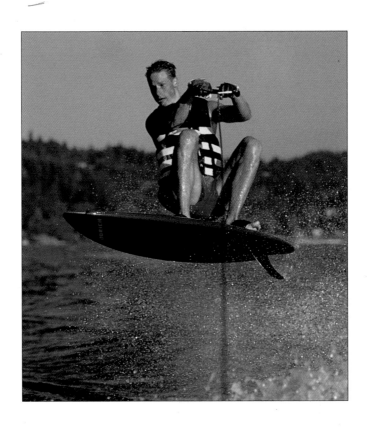

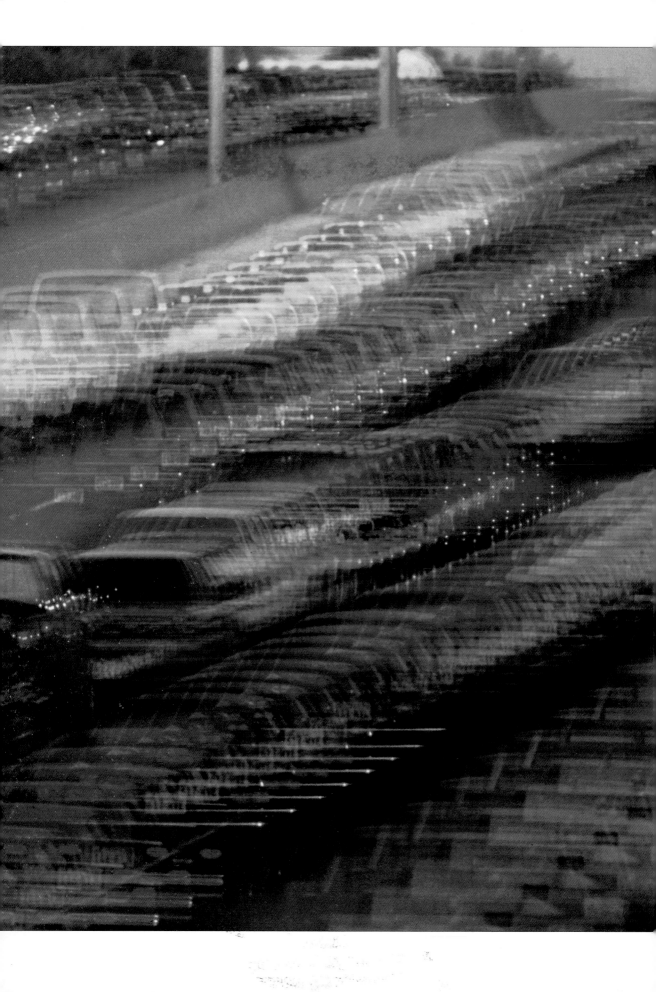

RotoVision

ROTOVISION
PRO-PHOTO SERIES

CTION
OGRAPHY

JATHAN HILTON

PRO PHOTO

A RotoVision Book

Published and distributed by RotoVision SA
Rue Du Bugnon 7
1299 Crans-Pres-Celigny
Switzerland

RotoVision SA, Sales & Production Office
Sheridan House, 112/116A Western Road
HOVE BN3 1DD
Tel: +44-1273-7272-68
Fax: +44-1273-7272-69

Distributed to the trade in the United States:
Watson-Guptill Publications
1515 Broadway
New York, NY 10036

ISBN 2-88046-275-4

This book was designed, edited and produced by
Hilton & Kay
63 Greenham Road
London N10 1LN

Design by Phil Kay
Picture research by Anne-Marie Ehrlich

DTP in Great Britain by
Hilton & Kay
Printed in Singapore by Teck Wah Paper Products Ltd
Production and separation in Singapore by ProVision Pte Ltd
Tel: +65-334-7720
Fax: +65-334-7721

Photographic credits
Front cover: Bob Martin
Page 1: Don Mason/TSM
Pages 2–3: Dale O'Dell/TSM
Back cover: Joe Baker/Refocus

CONTENTS

1 THE ESSENTIAL ELEMENTS

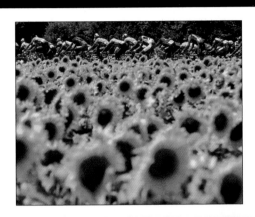

THE DECISIVE MOMENT 2

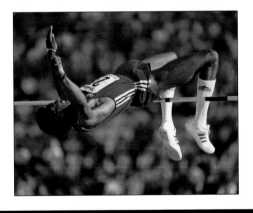

3 ACTION IN NATURE

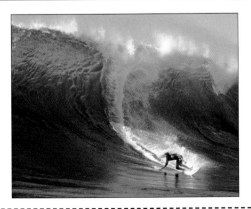

CONTENTS

4 EVENTS

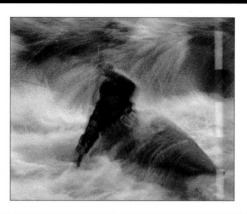

SPECIAL TECHNIQUES 5

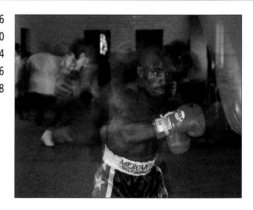

INTRODUCTION

PHOTOGRAPHER:
Nick Kleinberg/TSM

CAMERA:
6 x 4.5cm

LENS:
180mm

FILM SPEED:
ISO 200

EXPOSURE:
¹⁄₃₀ second at f22

LIGHTING:
Daylight only

Perhaps one of the most difficult fields of photography to become involved in as a way of earning your living, but also one of the most satisfying, is action photography. By its very nature, the type of subject matter that will make a winning action picture usually can't be predicted, planned for, or set up in advance. And no matter how good your level of technical skill, or your ability to previsualize and compose a shot, if you are not poised in the right place at the right time you will simply not get the picture.

Sports action

Often you find that professional sports action photographers are either ex-competitors themselves in one or more sporting activity, or else they have a very good amateur knowledge of at least some of the events they are covering.

It is this type of specialized knowledge that gives them the edge they so often need to recognize the developing situation that just may lead to a shot that is syndicated around the world.

Part of your preparation for covering a major event should include some basic research into the personalities of the leading players or participants. The general public's interest in sport of all types is kept alive by only really a small handful of "personalities". It is the flamboyant antics – praiseworthy or otherwise – of these few that always catch the attention and interest of the news and picture editors. When one of

▼ Although the cheetah was only loping along keeping pace with the photographer's vehicle, a slow shutter speed was used to show a degree of subject blur and enhance the sense of excitement. A faster shutter speed would have produced a more prosaic image.

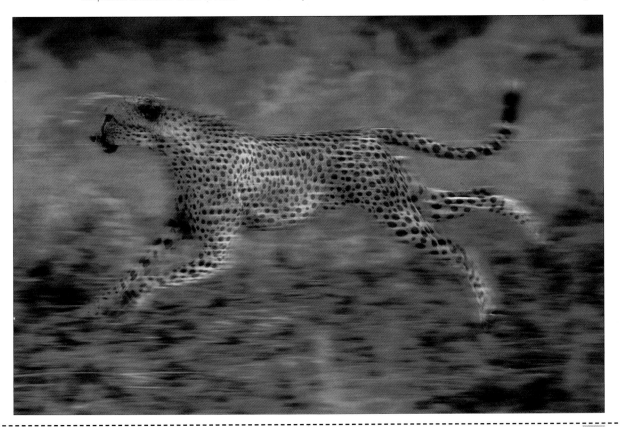

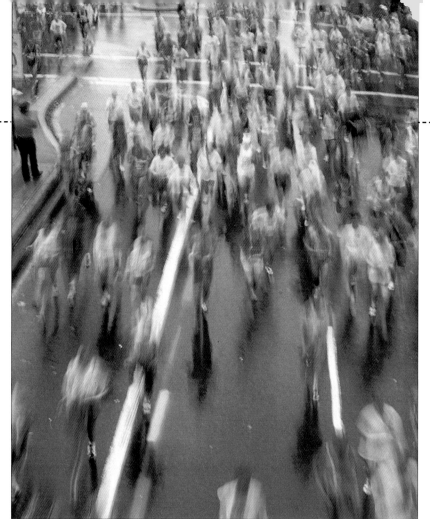

PHOTOGRAPHER:
David Pollack/TSM
CAMERA:
35mm
LENS:
80mm
FILM SPEED:
ISO 64
EXPOSURE:
¼ second at f11
LIGHTING:
Daylight only

◀ *With a good vantage point such as this, overlooking the route of the New York Marathon, it would have been relatively simple to isolate individuals using a long lens. This, however, could not hope to convey the sense of vastness of 25,000 runners surging through the streets.*

these individuals is in your viewfinder's frame, anything could develop.

Press or public

In order to gain access to the special press areas set aside for photographers and journalists you must apply for accreditation to the event organizers some time in advance of the competition. However, only staff or agency photographers, and commissioned or contracted freelancers usually stand any hope of their applications being successful.

The advantages you have with a press pass can be significant at some events, allowing you better access to the players behind the scenes as well as getting you closer to the action during the actual competition.

However, at other events – even some of the major international matches

and tournaments – all a press pass allows you in practical terms is access to a specially segregated area of the spectators' stands. This means that nearly everybody in the audience has an equal chance of capturing that magic moment on film and, if they are lucky, seeing their work paid for and published.

Photographic approach

Certain items of equipment are important for action photography – perhaps fast, long focal length lenses for distant field and track events; motor drives for fast-action sequences; and, for specialized activities such as surfing or yachting, specially adapted waterproof cameras.

But more important than all the equipment is your ability to see the action developing and then to record on film something of the excitement and drama

of what it was like to be there. Hopefully, you will recognize in the photographs in this book just how well the photographers have communicated this through their work.

Basic to all good photography is the pleasing arrangement of subject elements within the frame, and recognizing the contribution all parts of the frame make to the final image – composition. If, for example, you are photographing across the playing area and the background will be the ranked masses of spectators seated opposite, preselect an aperture that limits depth of field and so knocks them so far out of focus that they become just a colourful blur. If, however, spectator reaction to what is happening on the field is important, make sure that depth of field is sufficient to record their facial expressions. Another approach might be

to look for a low camera angle, so that you are shooting up at your subjects, showing them against an uncluttered sky. It sometimes helps to use a focal length that is wide enough to show the subject in a setting that aids the picture's impact. For example, a picture of a hang-glider about to leap of a rock has more drama if the lens lets you see that the rock is on top of a sheer and precipitous cliff face.

Career building

If you are interested in embarking on an action photography career, one line is to start attending the important but less-prestigious events, such as the qualifying rounds of a competition in, say, golf, ski-ing, football, rock-climbing, or whatever.

At these, you will probably have a fair degree of movement, even as an ordinary spectator, and you can start developing your picture skills. If your work is good, local newspapers may be interested in publishing your work, and even some of the glossy magazine may be interested in seeing unsolicited material.

This will inevitably take up your time and there will be travelling, film and pro-cessing costs as well. But it is an investment you must be prepared to make in yourself if you are serious about building a career in this field.

PHOTOGRAPHER:
Douglas Mesney/TSM

CAMERA:
35mm

LENS:
50mm

FILM SPEED:
ISO 100

EXPOSURE:
⅛ second at f11

LIGHTING:
Light from welding torch and accessory flash

▼ *The action inherent in this image of a welder comes from using a shutter speed that allows the sparks to streak and blur across the image. A small accessory flash was used to lighten too heavy shadows.*

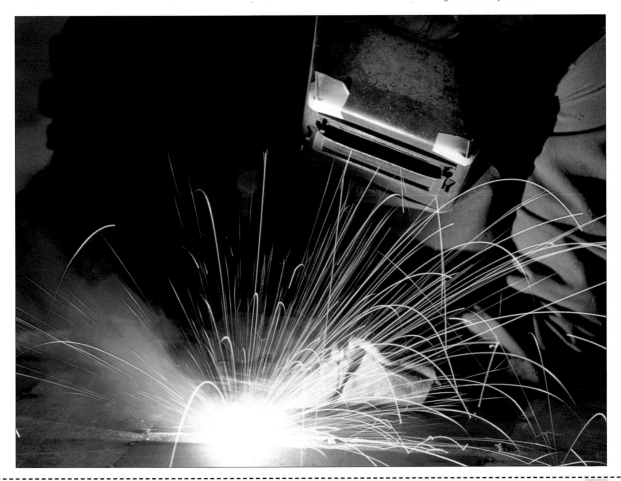

EQUIPMENT AND ACCESSORIES

For action photography you need to strike some sort of balance in terms of the equipment and accessories you take with you when at a sporting or similar event. On the one hand, you don't want to miss out on good shots by not having, say, the right lens or camera support readily available at some critical moment in the proceedings. Or you may suddenly find that your camera runs out of film just as the action looks like developing into a winning shot, and your spare camera, preloaded with film, is safely locked in the back of the car. On the other hand, you can't be so burdened with gear that your mobility is impaired – and you do often have to move quickly to get into position – or that you can't immediately lay hands on just the accessory you need because there is so much unnecessary clutter in your camera case.

POPULAR CAMERA FORMATS

The most popular camera format for action photographers is undoubtedly the 35mm SLR (single lens reflex). After this, the next most popular camera is one of the many variations of medium format cameras presently available. Both have certain advantages and disadvantages, and you will sometimes find that photographers carry both types with them, changing between them if time permits and the occasion demands it.

Medium format cameras

This camera format, of which there are many variations, is based on 120 (for colour or black and white) or 220 (mainly black and white) rollfilm. Colour film has a thicker emulsion than black and white,

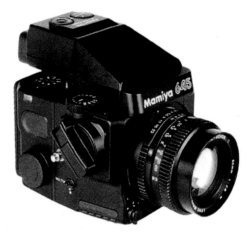

◀ The smallest of the medium format cameras, producing rectangular negatives or slides measuring 6cm by 4.5cm.

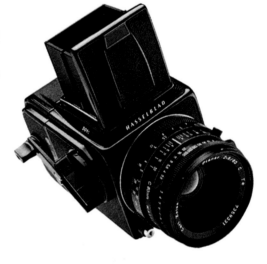

◀ This is probably the best known of all the medium format cameras, producing square-shaped negatives or slides measuring 6cm by 6cm. This format is also commonly known as 2¼in by 2¼in.

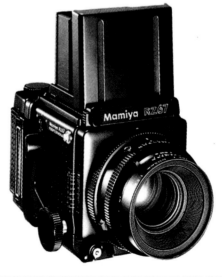

◀ This is the largest of the popular medium format cameras, producing rectangular negatives or slides measuring 6cm by 7cm. (A 6 x 9cm format is also available.)

and so 220 colour film is not generally available because it cannot physically be accommodated in the film chamber of the camera.

The three most popular sizes of medium format cameras are 6 x 4.5cm, 6 x 6cm, and 6 x 7cm models. The number of exposure per roll of film you can typically expect from these three cameras are:

Camera type	120 rollfilm	220 rollfilm
6 x 4.5cm	15	30
6 x 6cm	12	24
6 x 7cm	10	20

The advantage most photographers see in using medium format cameras is that the large negative size – in relation to the 35mm format – produces excellent-

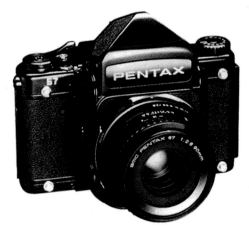

◀ This type of 6 x 7cm medium format camera looks like a scaled-up 35mm camera, and many photographers find the layout of its controls easier to use than the type opposite.

quality prints, especially when big enlargements are called for, and that this fact alone outweighs any other considerations. The major disadvantages with this format are that, again in relation to the 35mm format, the cameras are heavy and slightly awkward to use, they are not highly automated (although this can sometimes be an advantage), they are expensive to buy, and you get fewer exposures per roll of film (making more frequent film changes necessary).

35mm single lens reflex cameras (SLRs)

Over the last few years, the standard of the best-quality lenses produced for the 35mm SLR camera format has improved to the degree that for normal-to-medium-sized enlargements – of, say, 20 x 25cm (8 x 10in) – results are superb.

The 35mm format is the best supported of all the formats, due largely to its popularity with amateur photographers. There are at least six major 35mm manufacturers, each making an extensive range of camera bodies, lenses, dedicated flash units, and specialized as well as more general accessories. Cameras within each range include fully manual and fully automatic models. Lenses and accessories made by independent companies are also available. Compared with medium format cameras, 35mm SLRs are lightweight, easy to use, generally feature a high

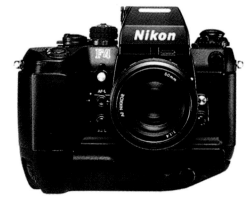

◀ This top-quality, professional 35mm camera, here seen fitted with a motor drive, features a rugged die-cast body; a choice of three different metering systems; interchangeable viewing screens and viewfinders; exposure lock and exposure compensation; and a choice of aperture- or shutter-priority, fully automatic, or fully manual exposure modes.

degree of automation, and are extremely flexible working tools. When bigger-than-normal enlargements are required, however, medium format cameras have the edge in terms of picture quality.

All 35mm SLRs use the same film stock – cassettes of either 24 or 36 shots, in colour or black and white. Again because of this format's popularity, the range of films available is more extensive than for any other.

Useful accessories

When a high through-put of film is likely you can avoid having to change film at the end of each 24- or 36-exposure cassette by attaching a bulk-film back to the camera. This facility is offered only on professional-type system SLRs, and it gives you the option of loading up to 250 frames of continuous film.

Although many modern 35mm SLRs have built-in film advance and continuous shooting at rates of about three frames per second, some older models and professional-quality modern manual SLRs can be fitted with an accessory motor drive. This facility, whether built-in or added, automatically advances the film every time you press the shutter release or continues shooting for as long as you keep the shutter release depressed. Bear in mind, however, that a motor drive uses a lot of film very quickly, and the motor may also be noisy, which may make it unpopular at critical moments if the subject is likely to be disturbed by your camera.

LENSES

When it comes to buying lenses you should not compromise on quality. No matter how good the camera body is, a poor-quality lens will take a poor-quality picture, and this will become all too apparent when enlargements are made. Always buy the very best you can afford.

One factor that adds to the cost of a lens is the widest maximum aperture it offers. Every time you change the aperture to the next smaller number – from f5.6 to f4, for example – you double the amount of light passing through the lens, which means you can shoot in progressively lower light levels without having to resort to flash. At very wide apertures, however, the lens needs a high degree of optical precision to produce distortion-free images. Thus, lenses offering a widest maximum aperture of f1.2 or f1.4 cost considerably more than lenses with a widest maximum aperture of f2 or f2.8.

▲ A 28–70mm zoom lens made for the 35mm camera format.

35mm lenses

At a "typical" action event you may need to cover yourself by having lenses ranging from wide-angle – for broad views showing the setting of the action or when working very close to the action itself– through to moderate-to-long telephoto lenses – to allow you to bring up more distant detail or to crop out extraneous detail when working closer to the event. For the 35mm format, the most useful lenses are a 28 or 35mm wide-angle, a 50mm standard lens, and telephoto lenses of about 135mm to 300mm.

As an alternative, consider using a combination of different zoom lenses. For example, you could have a 28–70mm zoom and another covering the range 80–250mm. This way you have in two lenses most of the focal lengths you are likely to use, plus all the intermediate settings you could need to "fine-tune" subject framing and composition.

Medium format lenses

There are fewer focal lengths made for the medium format compared with 35mm, and lenses are larger, heavier, and more expensive. The same categories of medium format lens requirements apply – in other words, wide-angle, standard, and telephoto. There is also a limited range of medium format zoom lenses from which to choose.

Flash lighting

The most convenient artificial light source for an action photographer working outdoors or inside wherever natural light levels may be low, or shadows too dense in relation to highlights, is undoubtedly flash. Different flash units produce a wide range of light outputs, so make sure you have with you the one that is most suitable for the type of area you need to illuminate.

Indoors, tilt-and-swivel flash heads give you the option of bouncing light off any convenient wall or ceiling, so that your subject is illuminated by reflected, rather than by direct, light. This produces a less-harsh, more flattering effect, although some of the power of the flash will be dissipated as a result. To overcome this fall-off in power, use a wider aperture or move closer to the action.

Outdoors, however, you will only rarely have a wall nearby that you can use as a flash light reflector. But if you then don't want to use direct flash, you can attach an angled plastic or stiff cardboard reflector board above the flash head. Remember that when shooting in colour, you must use only a white or neutral-coloured surface as a reflector in order to avoid colour casts.

The spread of light leaving the flash head is not the same for all flash units. Most are suitable for the angle of view of moderate wide-angle, normal, and moderate telephoto lenses. However, if you are using a lens with a more extreme focal length you may find the light coverage inadequate and flash fall-off occurs around the periphery of the image. Some flash units can be adjusted to suit the

◀ *This style of flash fits into the camera's "hot shoe" on top of the pentaprism, where electrical contacts trigger it to fire when the shutter is operated. This model emits a special beam of light to help the camera's autofocus system to find and lock on to the subject, even in the dark.*

▼ *This "candlestick" style of flash attaches to the tripod mount on the camera's baseplate. The head tilts and swivels and its off-centre position gives a slightly directional lighting effect.*

angle of view of a range of focal lengths, or adaptors can be fitted to alter the spread of light. If you have no time to adjust the flash head to suit the lens in use, try to frame the subject in such away that you can crop in later during printing to omit any unacceptably underexposed areas of the frame.

Camera supports

There will always be occasions when you have to use a shutter speed that is likely to result in camera shake. With a heavy telephoto lens attached, camera shake can occur at relatively brief shutter speeds, especially if you don't have time to brace yourself properly before shooting. The best solution to this problem is to keep the camera attached to a tripod. Even a lightweight one is better than nothing. If this is not possible, then consider using a less-intrusive monopod. Some action photographers favour a rifle grip – this supports the entire length of the lens and is braced into your shoulder, as if you were firing a rifle.

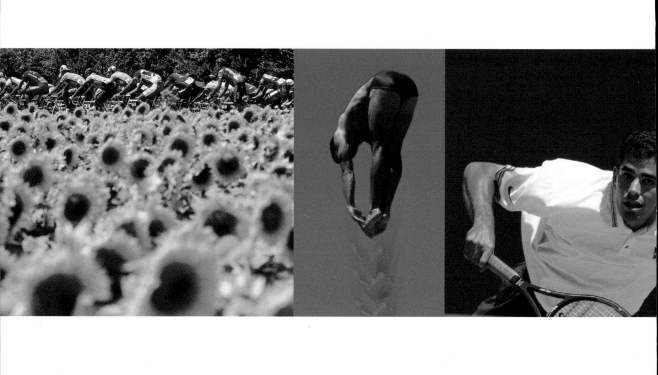

1

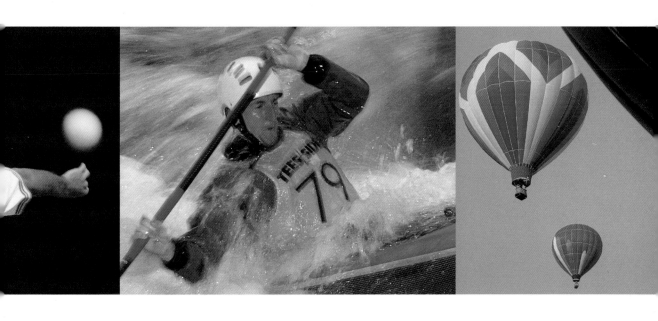

THE ESSENTIAL ELEMENTS

*I*NTERPRETING ACTION

The only rule in photography worth remembering is that there are no rules. The very nature of action photography dictates that you need to be flexible in your approach – if you don't know precisely where or when a photographic opportunity will arise, you can't be fully prepared for whatever will occur. You may, for example, find yourself shooting in low light with a fast-moving subject and you simply do not have the option of using a shutter speed to freeze subject movement. Rather than not take the shot, you could decide to interpret the subject in a totally different way by selecting a very slow shutter speed and allowing subject blur to define the action. In another situation, you may want to inject some action into a totally static subject by using a special effects filter over the camera lens.

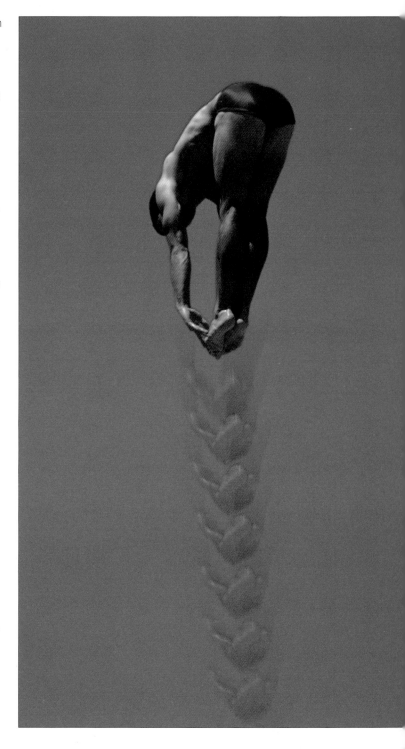

PHOTOGRAPHER:
Anne-Marie Weber/TSM

CAMERA:
35mm

LENS:
135mm

FILM SPEED:
ISO 100

EXPOSURE:
½₅₀ second at f8

LIGHTING:
Daylight only

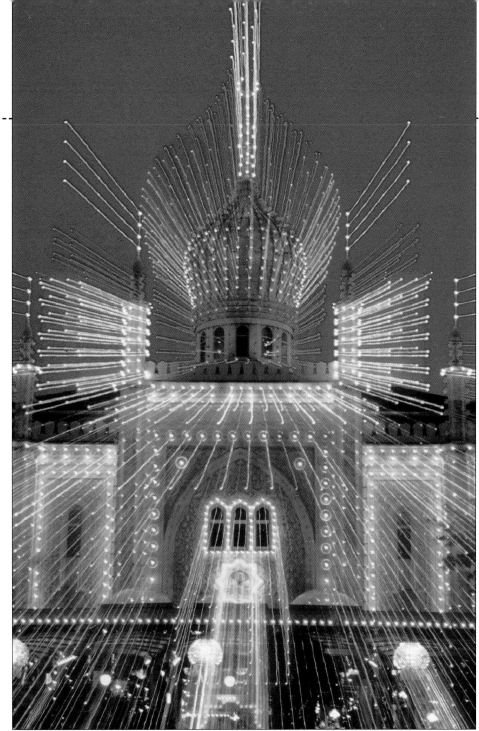

◀ ▶ *If used appropriately, and not too often, special effects filters can have an important role to play in action photography. The shot of the diver, already an exciting image, was made that little bit special by the use of a filter that produced a series of repeating images of the subject, making it look as if he had been propelled into the air on a giant spring. The night shot of a building in Copenhagen, Denmark, has been brought to life by a special effects filter that draws out all point sources of light into streaky lines, making the building appear to throb with activity.*

PHOTOGRAPHER:
Bob Krist/TSM

CAMERA:
35mm

LENS:
90mm

FILM SPEED:
ISO 200

EXPOSURE:
⅛ second at f4

LIGHTING:
Non-photographic tungsten lighting

Hints and tips

● Wait until all traces of daylight have left the sky or a very long, manually timed exposure will produce a dull, daylight type of effect.

● Use a tripod or some other form of stable camera platform when working slow shutter speeds.

● Try to exclude static point sources of lights, such as nearby street lighting, from the frame. With an exposure of many seconds, these lights will start to glow and spread into neighbouring areas (a process known as halation) and weaken contrast overall.

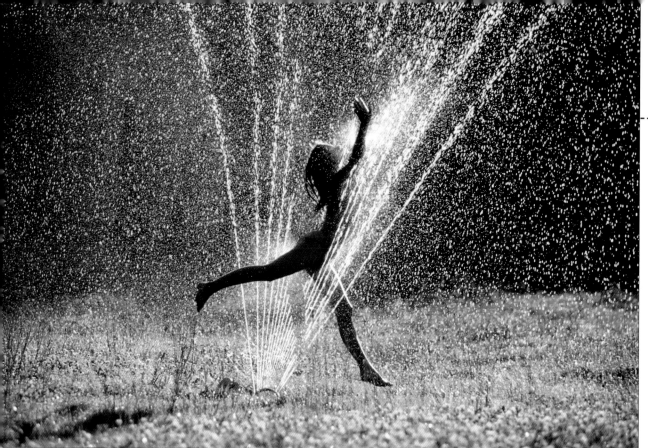

▲ In this obviously posed shot there was the right level of lighting to allow the photographer to choose from any of the camera's shutter speed and aperture combinations to interpret the subject in a range of ways. A slow shutter speed, for example, would have shown the figure and water spray as swirling lines, ill-defined shapes, and patches of colour. The fast shutter speed used here, however, is perfect for communicating the quality and intensity of the backlighting and the cool crispness of the water jets.

PHOTOGRAPHER:
Pete Saloutos/TSM

CAMERA:
35mm

LENS:
200mm

FILM SPEED:
ISO 40

EXPOSURE:
½₅₀ second at f5.6

LIGHTING:
Daylight only

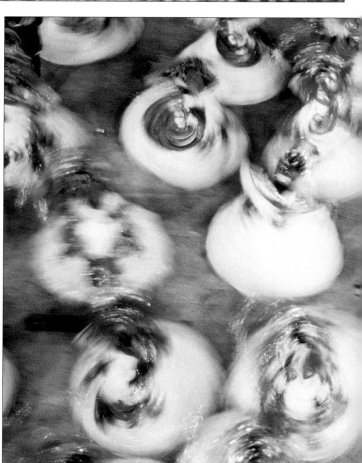

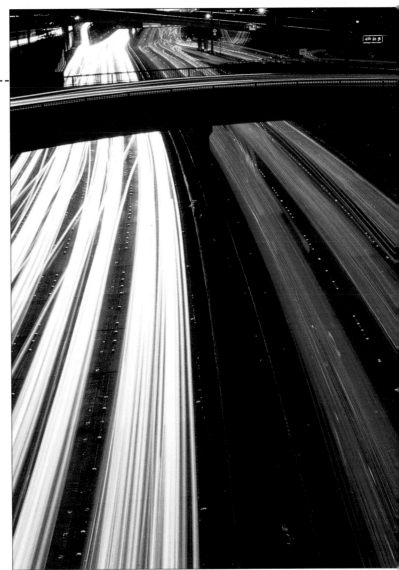

▼ Toward sunset, when this picture at Rio's famous carnival was taken, light levels rapidly decline. This left the photographer with a camera full of ISO 100 film that was not fast enough to allow a shutter setting that would freeze the energetically swirling dancers. Rather than produce a picture that was neither completely frozen nor completely blurred, the photographer decided to select the slowest shutter speed that could, with care, be hand-held and record the dancers as kaleidoscopic patterns of colour and light.

PHOTOGRAPHER:
Lena Trindade/TSM

CAMERA:
35mm

LENS:
55mm

FILM SPEED:
ISO 100

EXPOSURE:
⅛ second at f3.5

LIGHTING:
Daylight only

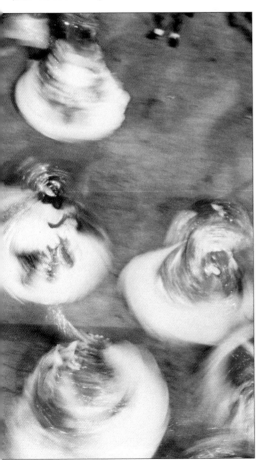

PHOTOGRAPHER:
Benjamin Rondel/TSM

CAMERA:
35mm

LENS:
50mm

FILM SPEED:
ISO 200

EXPOSURE:
20 seconds at f5.6

LIGHTING:
Traffic and street lighting

▲ This interpretation of car traffic is far more evocative of movement and activity than any frozen-action picture taken in daylight could portray. The abstract streaks of white lights, produced by the oncoming cars, and red lights, from those travelling away from the camera, linked with an horizon line very near the top of the frame, come together to make a very dynamic composition. This type of effect is dependent on the speed and density of the traffic flow, but a manually timed exposure of between about 15 and 30 seconds should usually be sufficient.

FRAMING THE SUBJECT

One way to frame your subject is to find a suitable foreground feature through which to shoot. You may need to adjust your camera position if the subject is moving and, if so, you will have to check constantly the combined effect of framing and subject through the viewfinder. Then, when you see exactly the composition you like, trip the shutter before the photo opportunity disappears. If you have time, your next picture can be more studied, since you will then have the confidence that comes from knowing that you have at least one shot safely in the bag.

One of the benefits of using this type of all-encompassing frame is that it effectively obscures the surrounding features in the scene. There may, for example, be a line of parked cars, a lighting pole, power line, or the ubiquitous scaffold supports used for spectators' seating at many outdoor events. Any of these features, or the hundreds of others you are likely to encounter when shooting on location, could detract from the final image. And if the offending feature could not be cropped out during printing for some reason, you might easily lose a valuable reproduction fee.

Moving away from the purely practical application of framing – in other words, using features in the setting to concentrate attention on where it ought to be, on the subject – some types of framing become an important element in a photograph, an inherent part of its strength, impact, and appeal. An example of this type of frame might be children playing in a run-down inner-city area. Framing their activity with features from that environment might give the resulting picture a proper context and even express the photographer's point of view about what is in front of the lens.

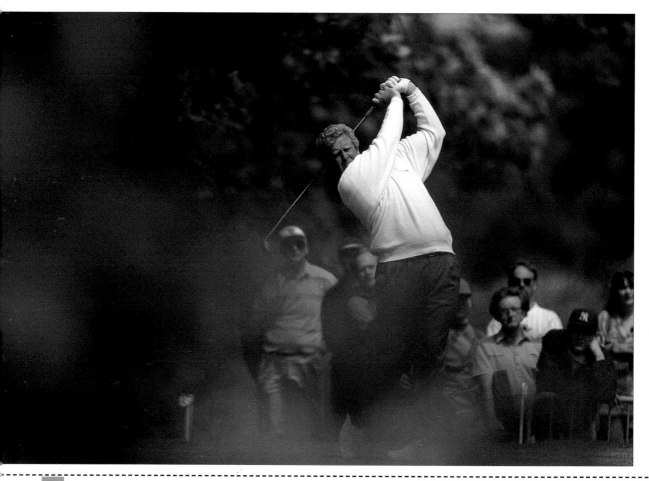

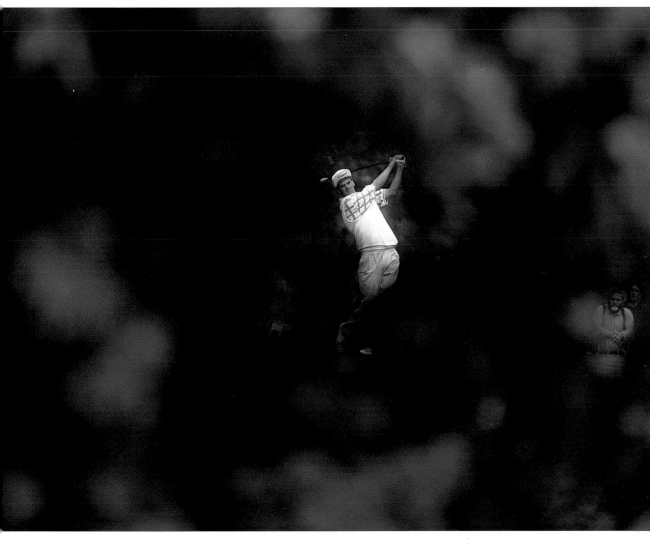

◀ A flowering bush, strategically positioned in the viewfinder to obscure a knot of brightly clothed spectators, makes an attractive frame for this golfer's powerful drive. The closer you position the lens to the foreground framing element the more out of focus and "transparent" it is likely to become.

PHOTOGRAPHER:
Bob Martin

CAMERA:
35mm

LENS:
400mm

FILM SPEED:
ISO 100

EXPOSURE:
¹⁄₁₀₀₀ **second at f3.5**

LIGHTING:
Daylight only

▲ Although similar to the first picture, here the frame has been adjusted so practically the only thing that can be seen through the foreground shrub is the golfer. Look carefully, however, and you can just see a spectator showing through a tiny gap.

PHOTOGRAPHER:
Bob Martin

CAMERA:
35mm

LENS:
135mm

FILM SPEED:
ISO 50

EXPOSURE:
¹⁄₅₀₀ **second at f4**

LIGHTING:
Daylight only

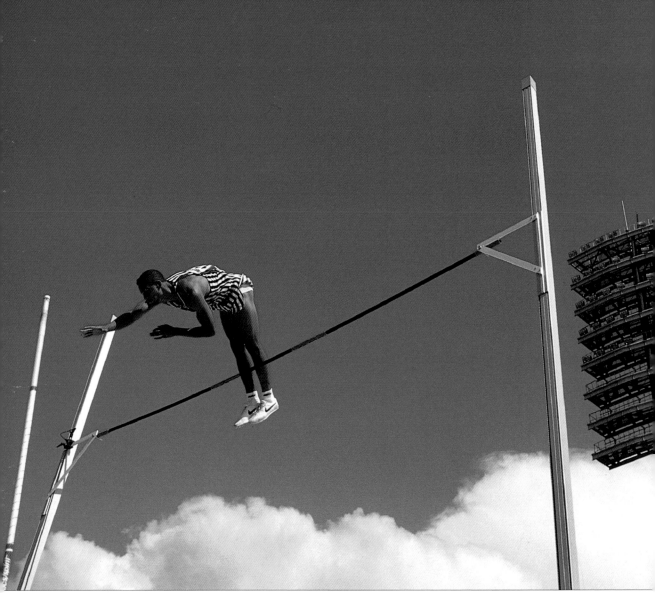

▲ *The strength of this photo-*
graph of a pole-vaulter frozen
in mid-air at the very top of his
ascent comes partly from the
way he is framed between the
two uprights supporting the
bar. The shape of the lighting
tower, too, helps to prevent
your eye leaving the frame.

PHOTOGRAPHER:
Bob Martin

CAMERA:
35mm

LENS:
70–200mm (set at 175mm)

FILM SPEED:
ISO 100

EXPOSURE:
⅟₅₀₀ second at f5.6

LIGHTING:
Daylight only

Problems with autofocus

Many modern SLRs bodies and lenses are
intended to be used in autofocus mode.
As good as these systems are, they all
have their weak points. Types that rely
on the subject being placed in a target
area of the viewfinder (usually the cen-
tre) can be fooled by an off-centre
composition; those that rely on infrared
or ultrasonics can be unreliable when
shooting through glass or other "solid"
obstructions; and those that use contrast
comparison can fail when overall subject
contrast is low.

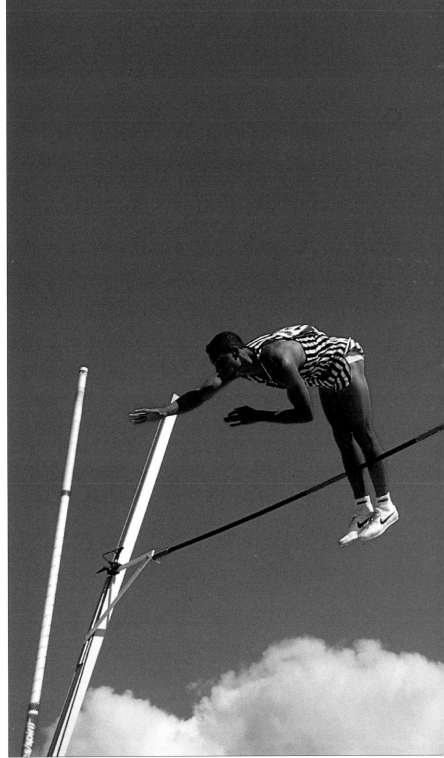

▶ In this version, the picture has been cropped tightly on the pole-vaulter. The impact of the framing is now missing, but the picture benefits from the strengthened contrast between the neutral colouring of the athlete's clothing and the solid blue of the sky.

DYNAMIC COMPOSITION

Action can often be implied by the way in which you compose an image, even if it is not inherent in the subject itself.

A centrally placed subject, for example, often conveys least movement and action to the viewer of a photograph. Subjects placed off-centre, however, have an immediate potential for movement, and the more extreme their positioning in the frame – in other words, the closer to the extremities of the picture area you place them – the more dynamic the composition can potentially become.

Another way to imply action when photographing an essentially static subject is to use differences in scale to set up tensions within the composition. Linked to this is the use of overlapping forms – find a position to shoot from that shows subjects at different distances from the camera obscuring each other to varying degrees. Differences in scale and overlapping forms are also both ways that depth and distances, or perspective, can be implied in a two-dimensional print or slide.

PHOTOGRAPHER:
Joe Baker/Refocus

CAMERA:
35mm

LENS:
85mm

FILM SPEED:
ISO 50

EXPOSURE:
¹⁄₂₅₀ second at f8

LIGHTING:
Daylight only

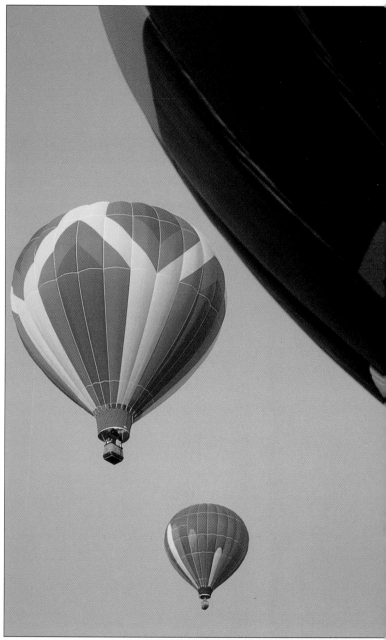

▲ The arrangement of subject elements in this shot, although all are almost static within the frame, is made more dynamic by the dramatic differences in scale of the balloons clearly defining the foreground, middle ground, and background. All of the subject elements are also distinctly off-centre.

▶ Here the photographer has made good use of the corner of the frame to introduce movement into the composition. To see how the composition changes its character, simply cover up the part of the balloon canopy in the bottom corner with the side of your hand. At once, the picture takes on a more static, less vital appearance.

PHOTOGRAPHER:
Joe Baker/Refocus

CAMERA:
35mm

LENS:
50mm

FILM SPEED:
ISO 50

EXPOSURE:
½₅₀ second at f11

LIGHTING:
Daylight only

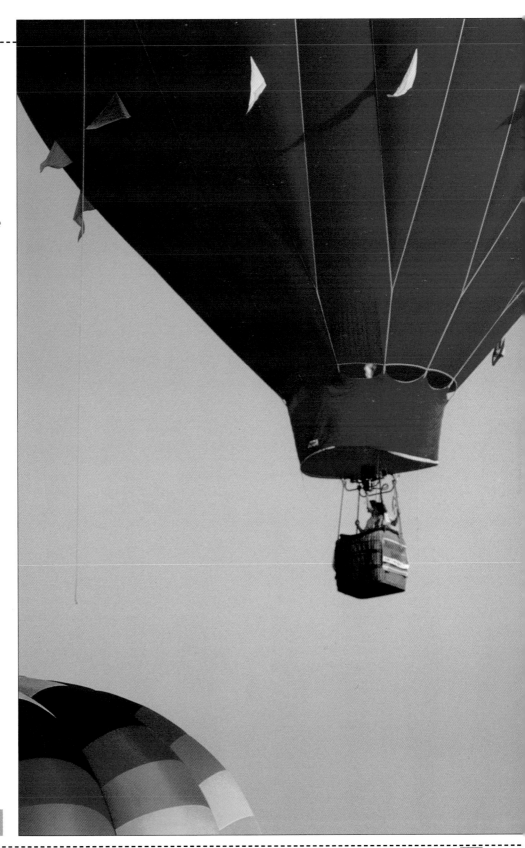

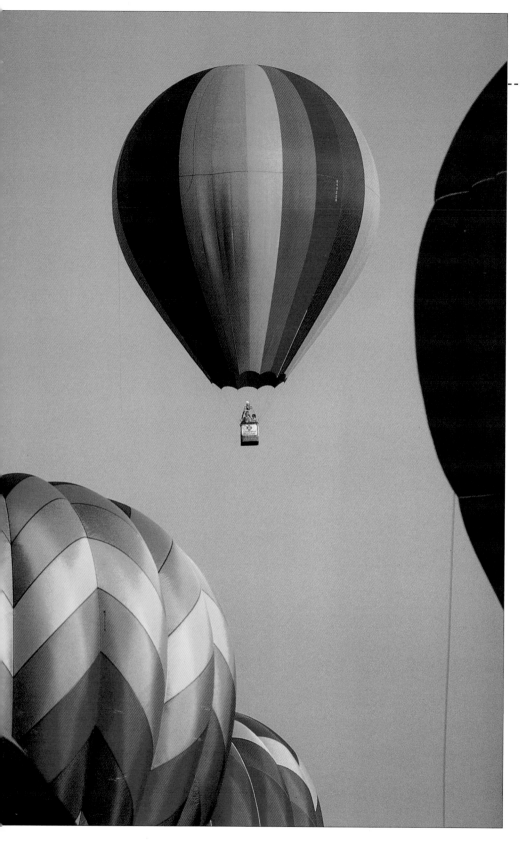

◀▶ In these two examples, it is not differences in scale or overlapping forms that have been used to add to the dynamism of the composition, rather it is the way in which the background balloon each time has been framed by the canopies of the nearer balloons. In both photographs the canopies make a bold, visually very weighty, type of frame that seems to crowd in on the more distant subject making it look as if it is being squeezed upward, like a cork out of a bottle.

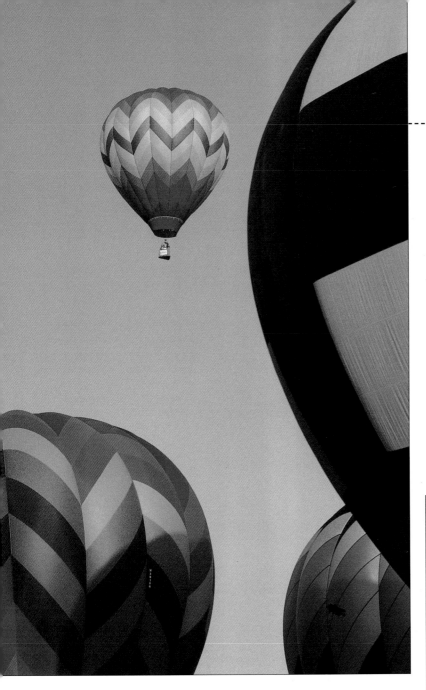

PHOTOGRAPHER:
Joe Baker/Refocus

CAMERA:
35mm

LENS:
50mm

FILM SPEED:
ISO 50

EXPOSURE:
¹⁄₁₂₅ second at f8

LIGHTING:
Daylight only

▼ *In this composition, the photographer has taken a shot showing all of the balloons as approximately the same size, and they are also well spaced out within the picture area. Of the examples in this series, this version displays the least subject movement of all.*

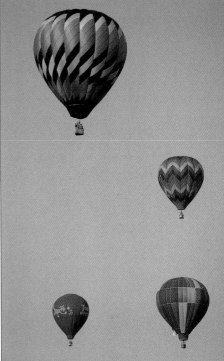

PHOTOGRAPHER:
Joe Baker/Refocus

CAMERA:
35mm

LENS:
35mm

FILM SPEED:
ISO 50

EXPOSURE:
¹⁄₂₅₀ second at f8

LIGHTING:
Daylight only

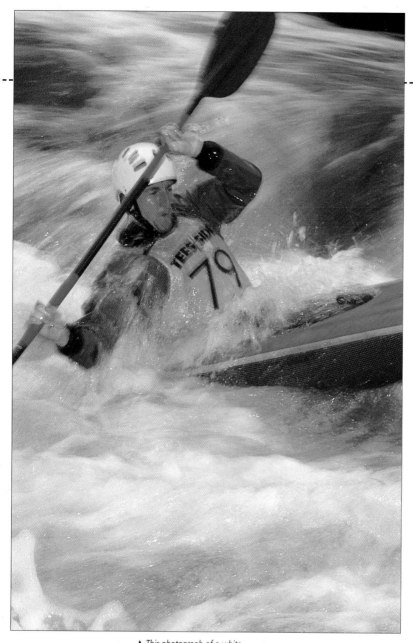

▲ *This photograph of a white water canoeist illustrates the difficulty in using vertical-format framing with a fast-action subject. Although the photograph still contains all of the components of an exciting image, both paddles have been clipped by the picture edges, as has the front of the canoe.*

PHOTOGRAPHER:
Gary Foxton/Refocus

CAMERA:
35mm

LENS:
70mm

FILM SPEED:
ISO 200

EXPOSURE:
⅟₆₀ second at f4

LIGHTING:
Daylight and flash

Picture formats

You have to think about composition – the way you place subject elements within the frame to convey information, mood, or atmosphere – in the context of the picture format being used. For example, 35mm and medium format cameras (except 6 x 6cm models) can be used either horizontally (often called land-scape format) or, by turning the camera on its side, vertically (or portrait format). When subject action is moving quickly across the field of view, your instinct is to use the camera horizontally to minimize the chance of clipping off, say, the arm of a sprinter, the tip of a swinging base-ball bat, or one of the ends of a racing car. This type of horizontal picture fram-ing has the effect of relating different elements of the composition in such a way that the eye of the viewer flows across the picture. Vertical framing can be just as dynamic when used with the right subject. This type of composition can be used to relate subjects at differ-ent distances from the camera, so that the eye is drawn into the picture. Square-format images can be neutral in their effect on subject movement and are then the least dynamic of all. If time permits, compose your image so that it can be cropped for a vertical or horizon-tal effect at the printing stage.

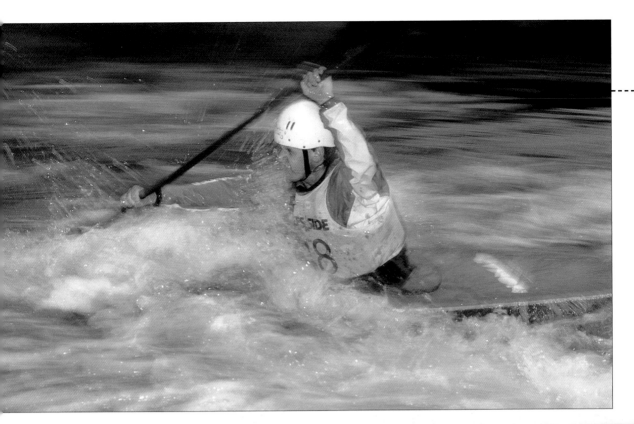

▲ ▶ In the full-frame version of this image (above) you can see that the subject has been centrally positioned in the frame. For the other version (right), the first picture was cropped to place the subject off-centre, with his back close to the side of the frame edge. By allowing extra space in front of the subject in this way the composition strongly implies movement and action across the frame.

PHOTOGRAPHER:
Gary Foxton/Refocus

CAMERA:
35mm

LENS:
70mm

FILM SPEED:
ISO 200

EXPOSURE:
¹⁄₆₀ second at f4

LIGHTING:
Daylight and flash

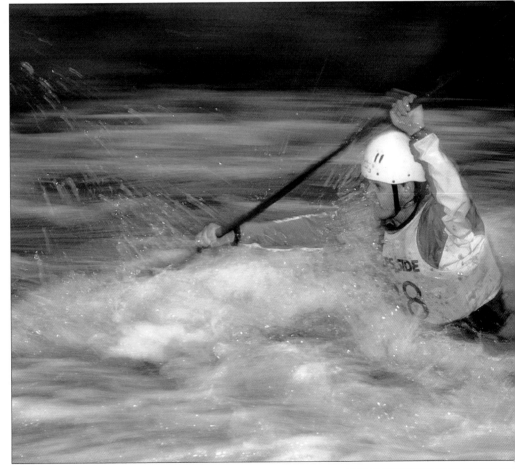

FOREGROUND INTEREST

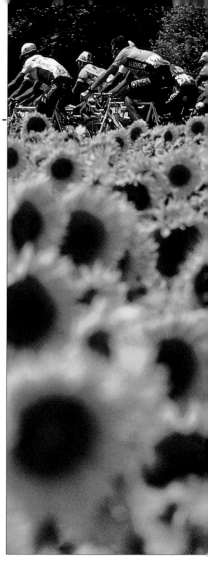

Although it is obvious that the principal function of an action photograph is to show, as clearly as possible, the action taking place in front of the camera, unless you crop in tight on the subject, to the exclusion of all else, you still need to take into account the other pictorial elements that make up the image.

As well as the background, which can have a make-or-break effect on composition, the foreground, too, is vitally important. A wide expanse of flat, uninteresting colour or tone directly in front of the subject may kill any impact your action subject may have had, while a foreground that is full of visual information may compete too heavily for attention and, again, weaken the overall composition. The trick is to find the right balance between these two extremes.

▶ *Although the subjects of this shot are the cyclists, riding in the Tour de France, by emphasizing the foreground field of sunflowers the commercial market for the picture becomes far wider – from sports magazines and Sunday supplements to tourist boards and health food producers.*

PHOTOGRAPHER:
Bob Martin

CAMERA:
35mm

LENS:
300mm

FILM SPEED:
ISO 50

EXPOSURE:
1/1000 second at f4

LIGHTING:
Daylight only

Hints and tips

● A long lens is useful when you want to exclude a foreground that is not making any worthwhile contribution or is competing for attention.

● If appropriate, use the shallow depth of field of a long lens to render the foreground less sharp than a more distant subject.

● The weight of a long lens means you either need to use very fast shutter speeds to avoid camera shake or support the lens and camera on a tripod, monopod, or shoulder brace.

PHOTOGRAPHER:
Bob Martin

CAMERA:
35mm

LENS:
600mm

FILM SPEED:
ISO 100

EXPOSURE:
1/500 second at f5.6

LIGHTING:
Daylight only

▶ *Including the railing in front of the stand in this shot helps to convey the context of the action, giving a strong impression that Pete Sampras, seen here at the Australian Open, is right on top of the camera position. Only a moderately large aperture was used, but on a 600mm telephoto lens the depth of field is extremely shallow and only the subject is critically sharp.*

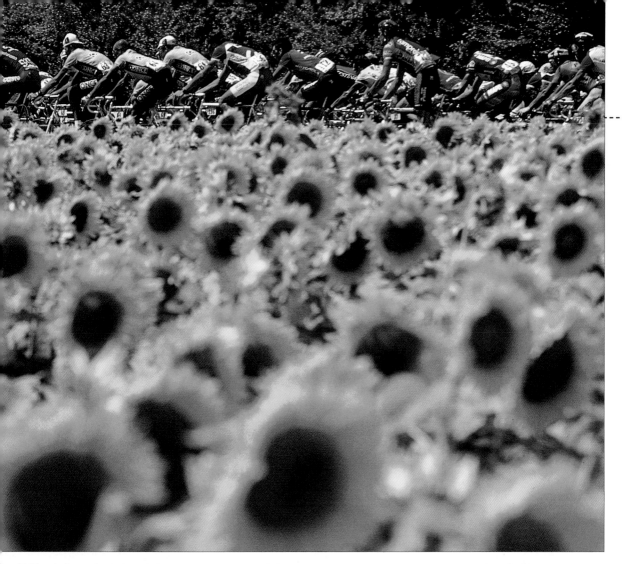
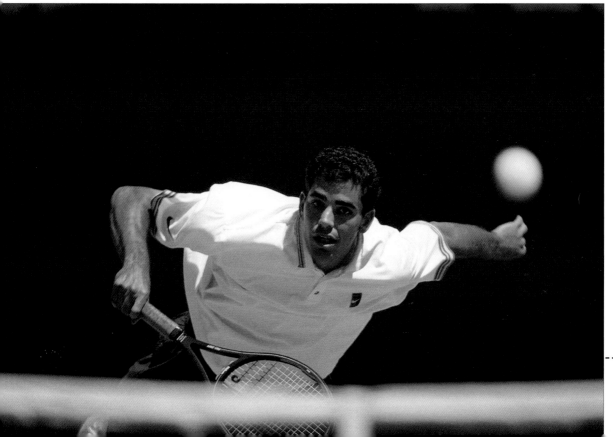

BACKGROUNDS

In the heat of the moment, when the action is developing right there in front of you, and you are under pressure to ensure that you get the right shot, it is all too easy to fail to take much notice of the background and the importance it can have on a picture's overall content and impact. Backgrounds that give you additional information about an event or the subject, or add to the general visual interest of the shot, can make the difference between your picture being selected for publication or it languishing in a cardboard box among all the other out-takes.

In order to avoid any confusion existing in the viewer's mind as to what the principal subject of a shot actually is, it is usually best to show the background as some degree less sharp than the main subject. You don't have to reduce the background to an abstract blur, however, in order to make your point – just slightly less sharp is often enough. Alternatively, you can shoot with the appropriate focal length lens or from a particular angle so that there is a marked difference in scale between the subject and the background elements.

There will be occasions when you want to show the subject isolated from his or her surroundings so that there is nothing in the frame to distract the viewer's eye from the action. If the environment is cluttered, try to gain some height before shooting so that the background to the figure is basically the ground, court, or playing field.

PHOTOGRAPHER:
Bob Martin

CAMERA:
35mm

LENS:
600mm

FILM SPEED:
ISO 50

EXPOSURE:
1/1000 second at f5.6

LIGHTING:
Daylight only

▶ *Pete Sampras, skidding on the clay court at the French Open, just manages to connect with the ball. The overhead framing of the shot effectively removes from the image a whole range of potential distractions – officials, spectators, ball boys, and advertising signs. The result is a shot full of eye-catching appeal and a composition strengthened by the simplified subject matter.*

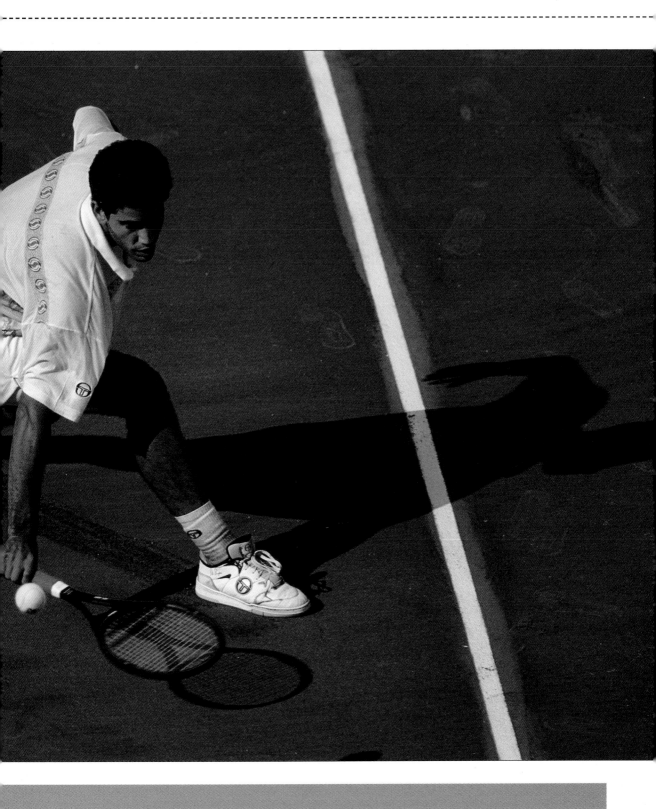

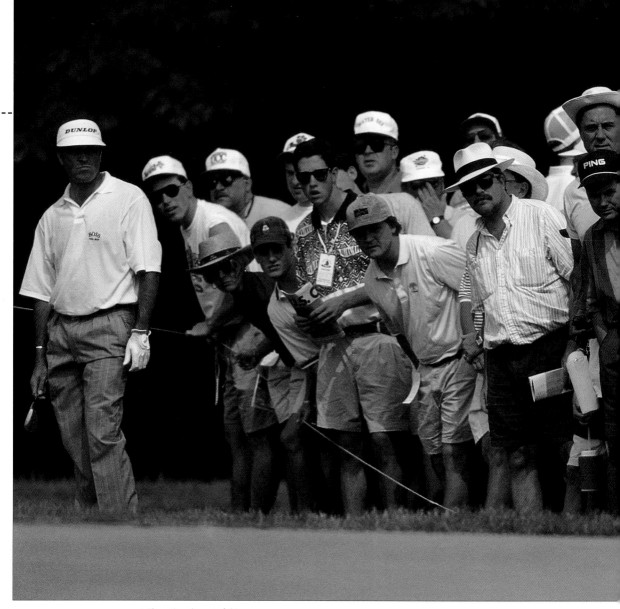

▲ *The action element of this shot, of Seve Ballesteros at the US Open, comes not from the golfer himself but from the tension evident in the faces and bodies of the spectators, straining as if a single body to see the result of his put.*

PHOTOGRAPHER:
Bob Martin

CAMERA:
35mm

LENS:
400mm

FILM SPEED:
ISO 100 (pushed 1 stop in processing)

EXPOSURE:
1/500 second at f2.8

LIGHTING:
Daylight only

Hints and tips

● A long lens tends to enlarge the background in relation to the foreground and, therefore, changes the pictorial balance of your composition.

● The shallow depth of field associated with long lenses makes it relatively easy to draw a distinction between the principal subject and other elements at different distances from the camera.

● A wide-angle lens tends to enlarge the foreground elements and makes the background look more distant and smaller as a result.

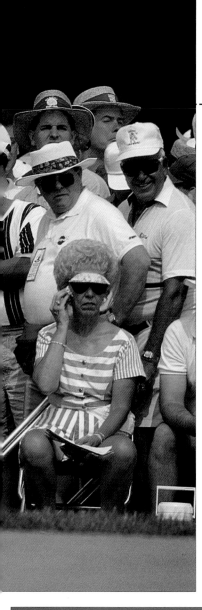

PHOTOGRAPHER:
Bob Martin

CAMERA:
**35mm
(with sound-proof blimp)**

LENS:
500mm

FILM SPEED:
**ISO 50 (pushed 1 stop in
processing)**

EXPOSURE:
½₂₀₀₀ second at f2.8

LIGHTING:
Daylight only

▼ *The background figures to
Greg Norman's swing, at the
US Open, have been rendered
sufficiently out of focus so as
not to compete for attention.
Usefully, however, they form a
colourful backdrop to the
golfer and they also help to
define the start of the fairway.
Any camera noise at this stage
of a match will not win you
any popularity awards.*

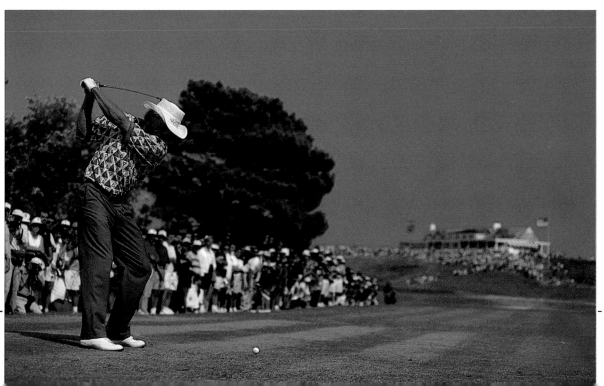

COLOUR CONTENT

The colour content can make or break an action picture. Sporting magazines reproduce almost exclusively in colour, and colour printing is becoming increasingly common on the sports pages of newspapers, too.

The main colour problems you are likely to encounter usually come from brightly dressed spectators immediately adjacent to your subject or from flowering bushes or flower displays you sometimes find at both indoor and outdoor events. Background colours that are particularly distracting can be toned down considerably by selecting a wide aperture on a long lens. The resulting limited depth of field should render them out of focus and a lot less intense and intrusive. Colours that you want to emphasize can often be strengthened when using slide film by slight underexposure – about half a stop is usually enough for this.

Keep on the look out for the type of camera positions that will show your subject against a coloured background you particularly favour. Luck, of course, must play a part, since it is impossible to predict precisely where the action is likely to develop.

▼ Strong, fully saturated colours dominate this photograph of a young boy breaking surface to suck in a breath of air. His skin, streaming with water, has taken on a dark glass-like quality, while the green frames of his swimming goggles are nothing less than startling. All of this is set against the intense blue of the swimming pool's water.

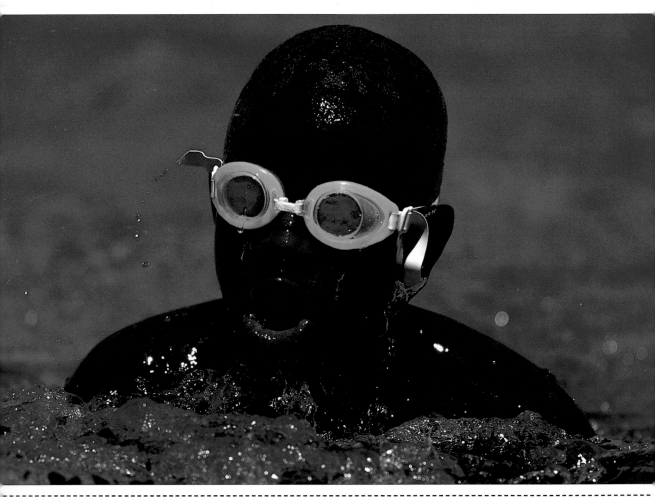

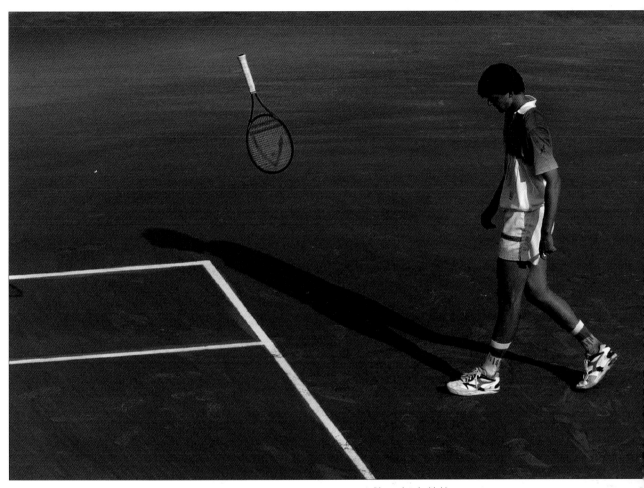

▲ *Disappointed with his performance, the camera has recorded the instant when Goran Ivanisevic throws down his racket. The picture, however, would not be memorable if it were not for the colour contrast between the red of the clay and the white of the player's clothes and the lines defining the playing area. Note, too, how the band of yellow on the racket's grip immediately attracts your eye and holds your attention.*

PHOTOGRAPHER:
Bob Martin

CAMERA:
35mm

LENS:
600mm

FILM SPEED:
ISO 100

EXPOSURE:
⅟₁₀₀₀ second at f2.8

LIGHTING:
Daylight only

PHOTOGRAPHER:
Bob Martin

CAMERA:
35mm

LENS:
600mm

FILM SPEED:
ISO 50

EXPOSURE:
⅟₁₀₀₀ second at f5.6

LIGHTING:
Daylight only

CROPPING THE IMAGE

What you leave out of the image area is often as important as what you include. Purists may argue that every time you expose a frame of film you should already have made all the creative decisions about composition, framing, and other related matters. The truth is, however, that there is no one best way of recording a particular scene, and it is often possible to improve a picture by omitting any extraneous clutter and reproducing only a part of the frame.

Ideally, it is always best to reproduce the whole of the film area simply due to the fact that print quality will be that much better because you have not had to enlarge the original too far. But often when photographing a sporting or some other action event you do not have the luxury of time to ensure that your camera position is perfect, framing is spot-on, or even that you have the most appropriate lens on the camera. You see the scene developing, your instinct tells you that a potential shot is building, and you make the decision when to shoot almost by reflex. Pausing, even for a few seconds, to adjust framing, camera position, or change lenses could mean that you miss the shot altogether.

▼ This bunker at Oakmount, USA, is said to be the largest in the world. This full-frame image shows the extent of the bunker only too well – an inexperienced golfer could spend the best part of the day in it vainly trying to reach the putting green.

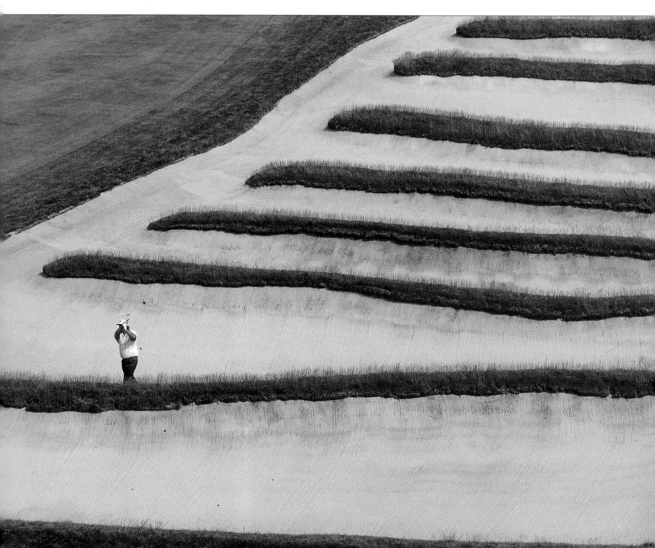

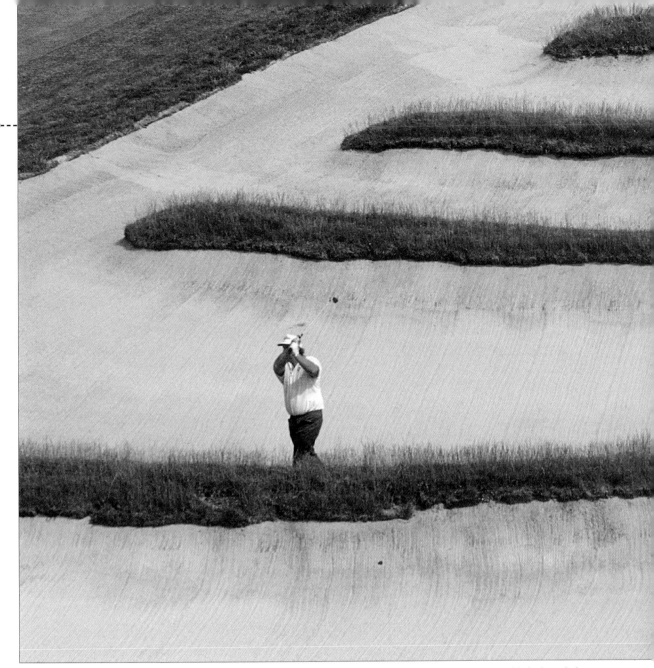

PHOTOGRAPHER:
Bob Martin

CAMERA:
35mm

LENS:
**80–200mm zoom
(set at 200mm)**

FILM SPEED:
ISO 100

EXPOSURE:
¹⁄₁₀₀₀ second at f4

LIGHTING:
Daylight only

▲ *Moving in much closer on the figure at the printing stage, and removing a lot of the visual information that tells you of the task confronting the golfer, this version makes a far better action shot than the full-framed version. It is not that it is a better shot for having been cropped, it is now just more suited to its purpose.*

2

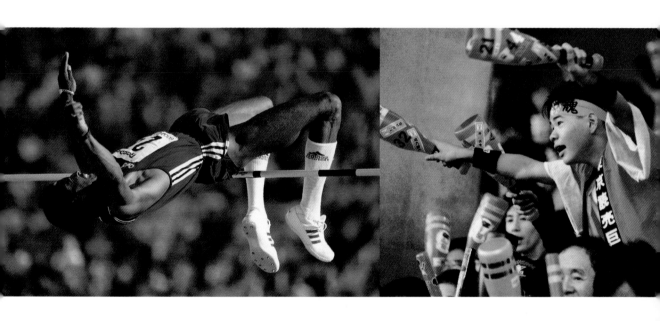

THE DECISIVE MOMENT

WATCHING THE WATCHERS

As exciting as the on-court action may be, don't ignore the photographic potential that could be developing in other parts of the arena. By swinging your camera around and focusing on the spectators you may, if you know who to look for, snap the type of picture sports publications and newspapers routinely print.

Family and friends of the players at events such as Wimbledon, where the picture below was taken, are given special passes and assigned to specific stands around the main courts. If you do your homework, you will readily recognize who in the crowd has a special interest in the players at any particular match. Of course, general crowd shots can also be effective, as in the example on the right, with the faces and body language of those watching mirroring the excitement and action of the event.

The focal length lens to use to bring up a face, or a group of faces, in the crowd depends on where you are shooting from and the amount of light that is available. Using a zoom lens gives you the framing flexibility you often need without having to change camera position. Using your fastest lens, however – that with the widest maximum aperture – may be necessary if light levels are low.

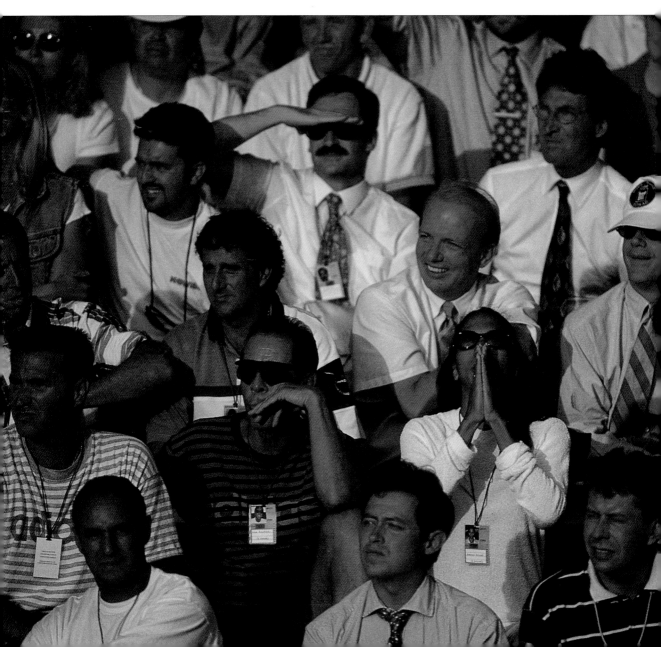

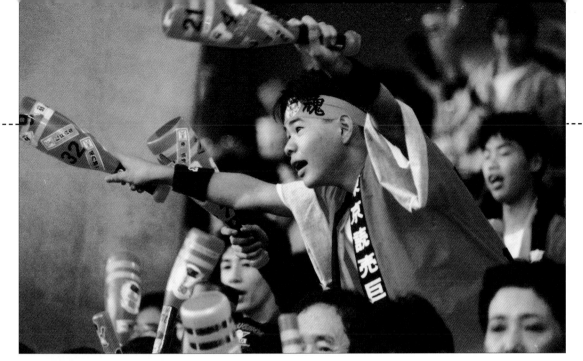

▲ The excitement and tension in the crowd watching the Tokyo World Series baseball has been captured in this shot, taken with a moderate tele-photo zoom lens. What the picture cannot relay, however, is the deafening wall of sound produced by the 90,000 enthusiastic fans present in the stadium for the final.

PHOTOGRAPHER:
Bob Martin

CAMERA:
35mm

LENS:
70–200mm (set at 200mm)

FILM SPEED:
ISO 800 (negative film)

EXPOSURE:
½₅₀ second at f2.8

LIGHTING:
Daylight only

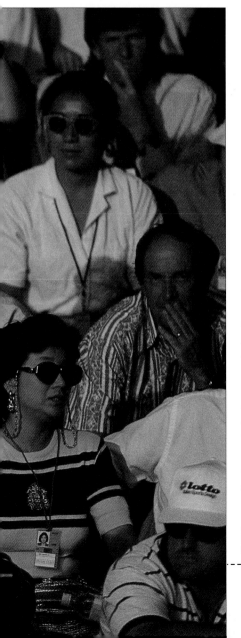

◀ Taken late afternoon on a warm summer's day at Wimbledon, this picture is a classic of its type. The photographer had to make a decision – whether to concentrate on the tennis match, where Boris Becker was playing, or to turn his lens on to the spectators' stand instead. As it is, he has captured the very moment when Becker's girlfriend brings her hands together in prayer just as a crucial point is about to be played.

PHOTOGRAPHER:
Bob Martin

CAMERA:
35mm

LENS:
600mm

FILM SPEED:
ISO 100

EXPOSURE:
½₅₀ second at f4

LIGHTING:
Daylight only

RIGHT PLACE, RIGHT TIME

When an action-type subject presents itself you usually have only the briefest of instants to react with your camera – hesitate too long to adjust your framing, for example, or the exposure controls and you may miss your chance altogether. If, however, you can predict the action with some degree of certainty and set up beforehand so that you are in the right place at the right time, you may be able to buy yourself an extra second or two of precious thinking time.

Experienced sport and action photographers, those who tend to cover the major competitions around the world, become accustomed to seeing the same leading athletes perform. Over a period of time, they start to build up an almost instinctive understanding of how these athletes' are likely to react when in competition. If, for example, you know that a particular runner likes to keep away from the pack and often reacts physically when boxed in by other competitors, you may concentrate your attention on that athlete alone – hoping for a situation to develop – and thereby take a chance on missing out if a more unpredictable piece of action should occur in a different part of the field.

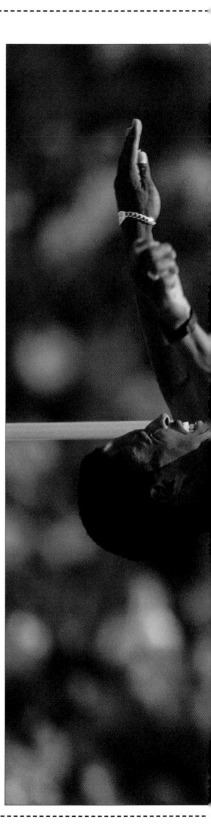

PHOTOGRAPHER:
Bob Martin

CAMERA:
35mm

LENS:
400mm

FILM SPEED:
ISO 100

EXPOSURE:
¹⁄₁₀₀₀ second at f3.5

LIGHTING:
Daylight only

▶ *Before this picture of Cuban high jumper Javier Sotomayer was taken, the photographer had seen him jump four or five times at lesser heights in the previous hour. He noted that Sotomayer invariably launched himself at the same area of the bar and so was set up with the correct exposure locked into the camera before the athlete had even left the ground. The extra second or two gained in this way allowed him to concentrate that little bit harder on the framing of the shot, which, here, is particularly critical – any slight mistake would have resulted in the subject's fingers, toes, knees, or head being cropped out of the picture area.*

PHOTOGRAPHER:
Bob Martin

CAMERA:
35mm

LENS:
400mm

FILM SPEED:
ISO 400

EXPOSURE:
½₅₀ second at f2.8

LIGHTING:
Daylight only

▼ *You will greatly improve your chances of a winning picture if you are, at least potentially, set up in the right camera position before the competition commences. Wait too long to arrive and you will have to contend with spectators and other photographers all trying to secure the best positions for themselves. For this shot of Russian and Turkish wrestlers competing in the 1994 Goodwill Games, the photographer arrived early enough to secure a place in the front row of the spectators' area, and so ensured an unobscured view of the action. But to strengthen the picture's impact further, the photographer brought the camera down so low that the lens was just above the level of the floor.*

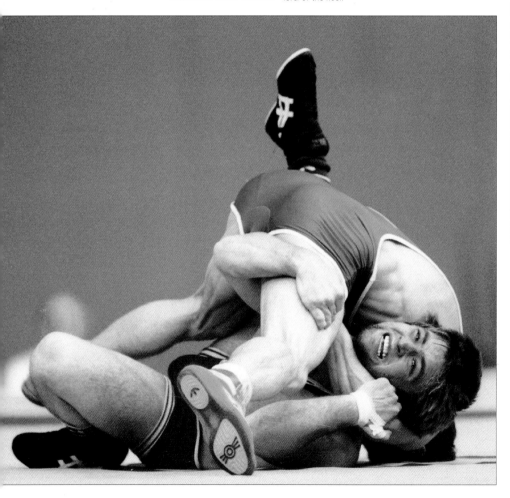

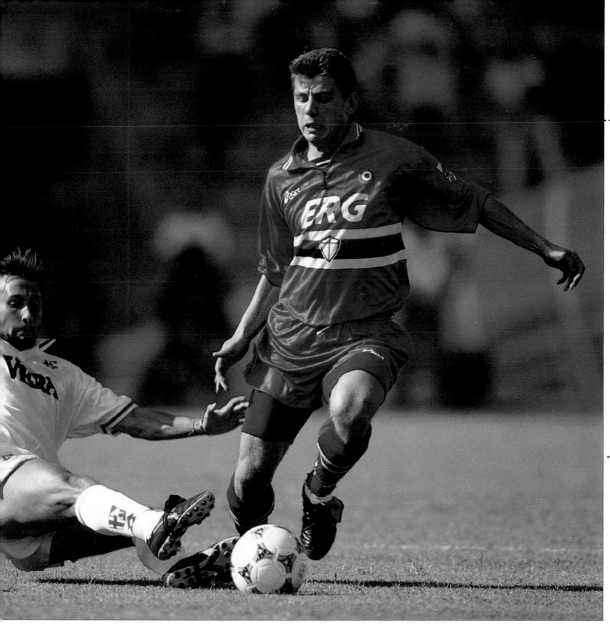

PHOTOGRAPHER:
Bob Martin

CAMERA:
35mm

LENS:
400mm

FILM SPEED:
ISO 100

EXPOSURE:
$\frac{1}{1000}$ second at f2.8

LIGHTING:
Daylight only

▲ By understanding the sport you are photographing, as well as the roles of the different participants, you are more likely to be in the right place at the right time. Here, the photographer used his telephoto lens to follow the white-kitted defender as he ran back to intercept the opposition player. The resulting photograph, exposure adjusted to allow for the backlighting, shows perfectly the concentration and skill levels required by professional soccer players as both focus their entire attention on the position of the ball.

APPROPRIATE SHUTTER SPEED

Shutter speeds do far more than simply help to determine correct exposure. Although it is true that every time you make the aperture one stop smaller or larger you need to double or halve the length of time the shutter remains open in order to achieve the same level of exposure, shutter speeds also determine the way action subjects are recorded.

Selecting a very brief shutter speed, say 1/2000 second, will freeze all but the fastest action subjects such as racing cars or the spokes in the wheels of a speed cyclist. The resulting picture will show the subject sharply rendered and in clinical detail. This can make a dramatic picture, but it is also very different from the way we see fast-moving action subjects in reality.

The alternative approach is to use a slower shutter speed and allow the subject's image to blur (which more closely corresponds to normal vision). This happens because the subject is moving while the shutter is open and the film is being exposed. You can control the degree of subject blur through your use of different shutter speeds and a technique known as panning (see opposite).

Because of the demands of correct exposure, you cannot always select the shutter speed you might most want to use. For example, you may decide that a shutter speed of 1/4000 second is appropriate for a particular subject. However, if you then need to select an aperture of f2.8 to compensate and your lens has a maximum aperture of only f4 or f5.6, you will have to choose 1/2000 or 1/1000 second instead.

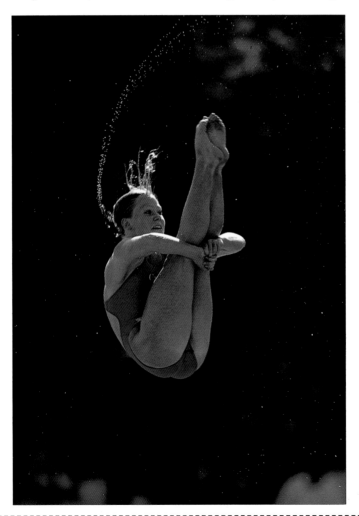

PHOTOGRAPHER:
Bob Martin

CAMERA:
35mm

LENS:
600mm

FILM SPEED:
ISO 100

EXPOSURE:
1/1000 second at f4

LIGHTING:
Daylight only

◄ *Frozen by a shutter speed of 1/1000 second as this diver enters the tucked position, every detail of her style and grace can be studied at leisure. Note, too, the perfectly formed string of water globules flicked out from her hair.*

Panning

One way to control the degree of subject blur to give the impression of speed and action is to pan the camera while taking the photograph. To do this, select a shutter speed that would not normally be fast enough to stop your subject dead, and then move the camera steadily and evenly to keep the subject in the viewfinder throughout the exposure. In this way, the subject will appear sharp against a blurred impression of all stationary features in the frame, such as the foreground and background areas in this photograph of cyclists. The slower the shutter speed you select, the more blurred will the surroundings become. However, it also becomes harder to keep the subject completely sharp when using very slow shutter speeds.

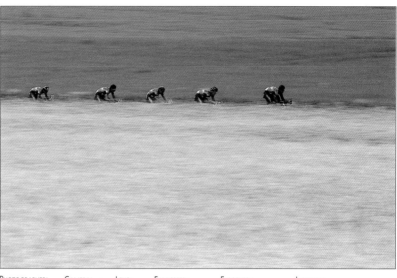

PHOTOGRAPHER:	CAMERA:	LENS:	FILM SPEED:	EXPOSURE:	LIGHTING:
Bob Martin	35mm	600mm	ISO 50	⅟₃₀ second at f11	Daylight only

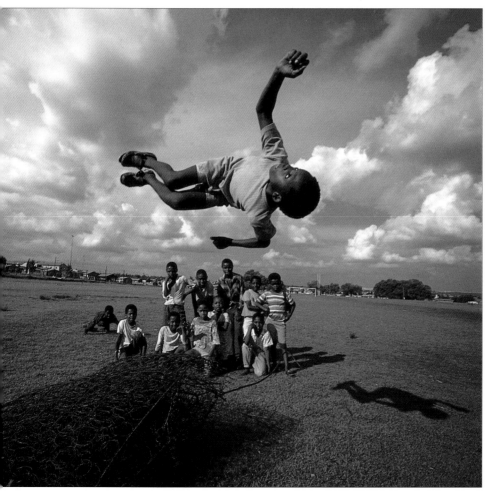

◀ Looking bizarrely unnatural, this boy bouncing on a set of old bed springs has been completely frozen in mid-air. The clarity of the image is so startlingly clear that, initially, it is difficult to understand how he comes to be suspended there with his shadow prone on the grass to one side.

PHOTOGRAPHER:
Bob Martin

CAMERA:
35mm

LENS:
14mm

FILM SPEED:
ISO 100

EXPOSURE:
⅟₂₀₀₀ second at f2.8

LIGHTING:
Daylight only

▶ The degree of blur is such in this picture of cyclists competing in the Tour de France that the subjects have been reduced to ghostly smudges of movement across the frame. To achieve this effect, the camera was mounted on a tripod to avoid any camera movement and a very slow shutter speed was selected. This arrangement has recorded a perfectly sharp background as a contrast to the subjects.

PHOTOGRAPHER:
Bob Martin

CAMERA:
35mm

LENS:
28–70mm (set at 50mm)

FILM SPEED:
ISO 100

EXPOSURE:
⅟₃₀ second at f11

LIGHTING:
Daylight only

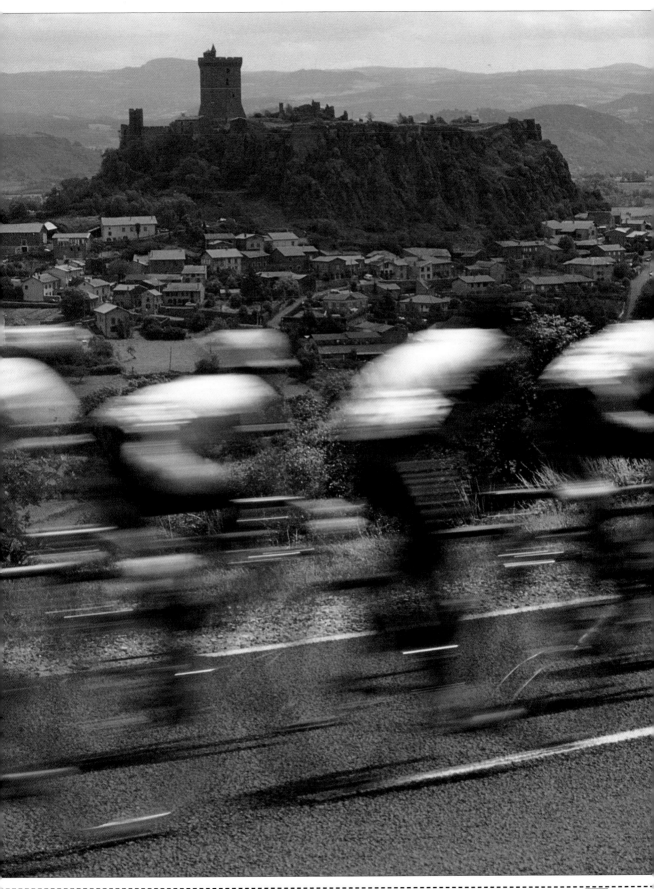

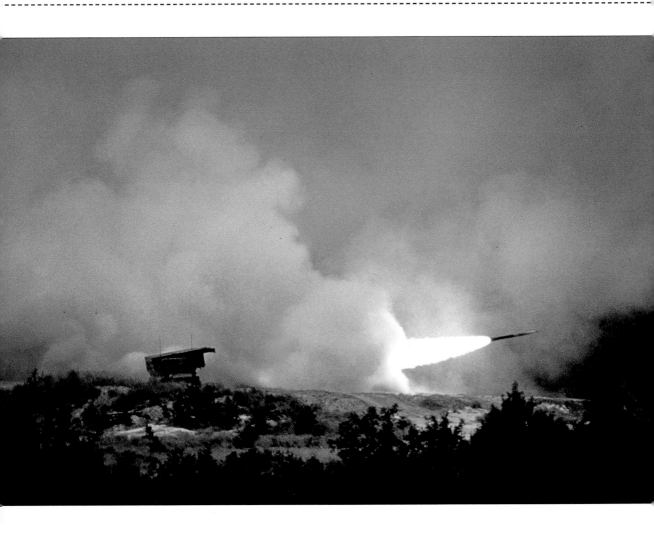

Photographer:
Hans Halberstadt/TSM

Camera:
35mm

Lens:
500mm

Film speed:
ISO 400

Exposure:
½₂₀₀₀ second at f5.6

Lighting:
Daylight only

◀ ▶ *Although the speeds of the space shuttle and the missile were not identical when these two shots were taken, they do help to illustrate an important point about what is the "appropriate" shutter speed to set to freeze action. The factor that most directly affects the way movement is recorded is its direction in relation to the camera. Movement directly toward or away from the camera, for example, can be frozen using a shutter speed slower than that needed to freeze movement at 45° to the camera. Movement at 90° to the camera requires the fastest shutter speed of all if you want to prevent blurring. Bear in mind, however, that the closer the subject is to the camera (or if you are using a telephoto lens to enlarge the subject's size) the faster the shutter speed you need for a sharply recorded image.*

PHOTOGRAPHER:
Mark M Lawrence/TSM

CAMERA:
35mm

LENS:
50mm

FILM SPEED:
ISO 200

EXPOSURE:
⅟₁₀₀₀ second at f4

LIGHTING:
Daylight only

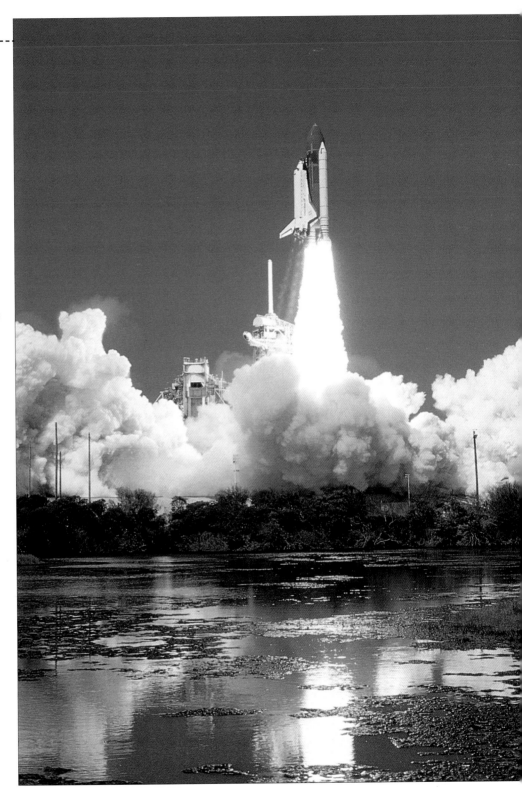

IN THE SWIM

The poolside represents another excellent opportunity for action photography. Moving water is a particularly good medium to work with when you want to experiment with a variety of photographic techniques. Select a fast shutter speed, for example, and you can "freeze" water drops into jewel-like globules; change to a much slower shutter speed, using a tripod if necessary to avoid camera shake, and the character of the water in the resulting picture can be completely transformed.

The constantly shifting surface of a pool full of swimmers can make judging exposure tricky, however, since each wave or ripple can act as a string of reflectors, catching the light – perhaps for just an instant – and throwing intense highlights back toward the camera. If too many of these reach the camera's light meter as you trip the shutter, you may find your subject is a few stops too dark. If you have time, it is best to bracket important exposures and take additional frames giving 1 and 2 stops of extra exposure.

One of the advantages of photographing an event such as swimming is that you can keep up with the action quite easily by walking (or trotting) along the pool edges, picking shots off as the opportunities present themselves. When photographing competitive swimming, however, you usually only have this degree of freedom of movement during the practice sessions – when the race is on for real, photographers are usually confined to the spectators' stands or designated areas set aside for the press.

PHOTOGRAPHER:
Bob Martin

CAMERA:
35mm

LENS:
600mm

FILM SPEED:
ISO 50

EXPOSURE:
¹⁄₅₀₀ second at f4.5

LIGHTING:
Daylight and available indoor lighting

PHOTOGRAPHER:
Bob Martin

CAMERA:
35mm

LENS:
600mm

FILM SPEED:
ISO 50

EXPOSURE:
¹⁄₅₀₀ second at f4.5

LIGHTING:
Daylight and available indoor lighting

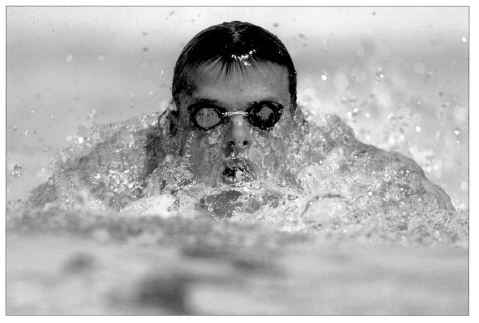

◄ *Simply counting the number of seconds taken by a breast stroke swimmer between breaths will let you anticipate pretty accurately when your subject's face will break the surface of the water. The use of a fast shutter speed for this head-on picture has frozen every trace of movement in the swimmer and in the water as it explodes away from his surfacing body.*

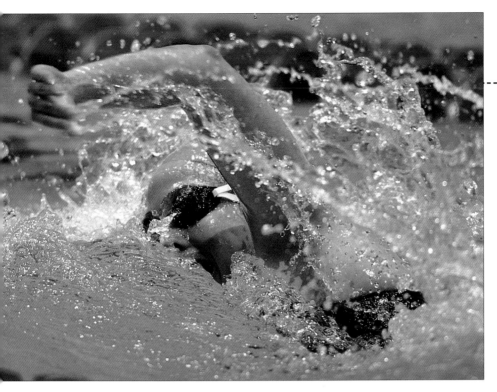

◄ The use of a particular shutter speed to freeze or blur the appearance of movement depends on a number of factors, including the speed the subject is moving and the direction of that movement in relation to the camera. Although taken at the same shutter speed as the picture opposite, there are some indications of blurring in this shot because the subject is, first, swimming faster than the breast stroker and, second, is moving at approximately 90° to the camera.

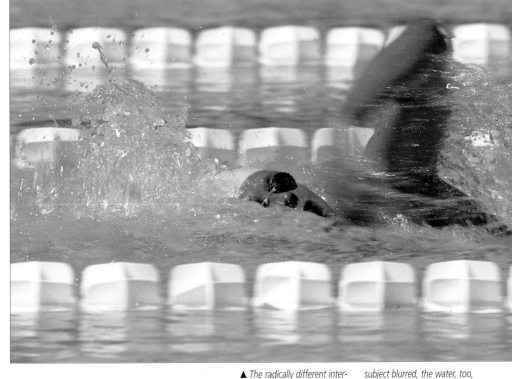

PHOTOGRAPHER:
Bob Martin

CAMERA:
35mm

LENS:
600mm

FILM SPEED:
ISO 50

EXPOSURE:
⅟₃₀ second at f11

LIGHTING:
Daylight and available indoor lighting

▲ The radically different interpretation of movement here was achieved by selecting a much slower shutter speed than in the previous photographs. Not only are the fastest-moving parts of the subject blurred, the water, too, seems to be smeared across the frame. The important part of the picture – the subject's face – was, however, relatively static as the picture was taken and so appears pin sharp.

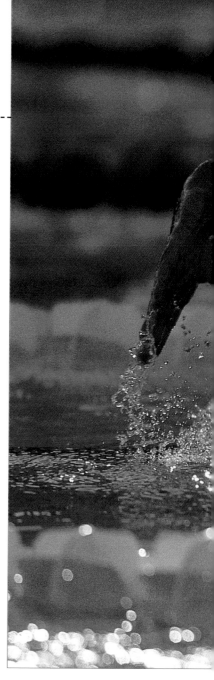

Minimizing reflections from water

Reflections of the poolside surroundings, and particularly of overhead lighting if indoors, coming from the water's surface can be sufficiently distracting to kill the impact of a swimming shot. If it is not possible to change your shooting angle to minimize or eliminate these reflections, or there simply is not enough time for a change of position, consider using a polarizing filter over the camera lens. Depending on the nature of the reflections and the light sources creating them, a polarizing filter may subdue or remove them completely, if correctly orientated. The penalty you pay for this undoubted benefit, however, is a loss of lens speed – the filter prevents an amount of light equivalent to about 2 stops from reaching the film.

▼ ▶ *The use of filters in conjunction with colour film is quite limited, unless you want to try some of the special effects filters that are available – prism, star burst, fog and haze, and so on – which have only a very limited application. As well as removing reflections from surfaces such as water, polarizing filters can also be used to strengthen certain colours and increase the contrast between subjects and their surroundings.*

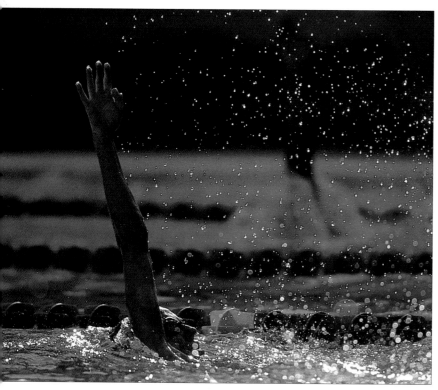

PHOTOGRAPHER:
Bob Martin

CAMERA:
35mm

LENS:
600mm

FILM SPEED:
ISO 100

EXPOSURE:
¹⁄₁₀₀₀ second at f4

LIGHTING:
Daylight only

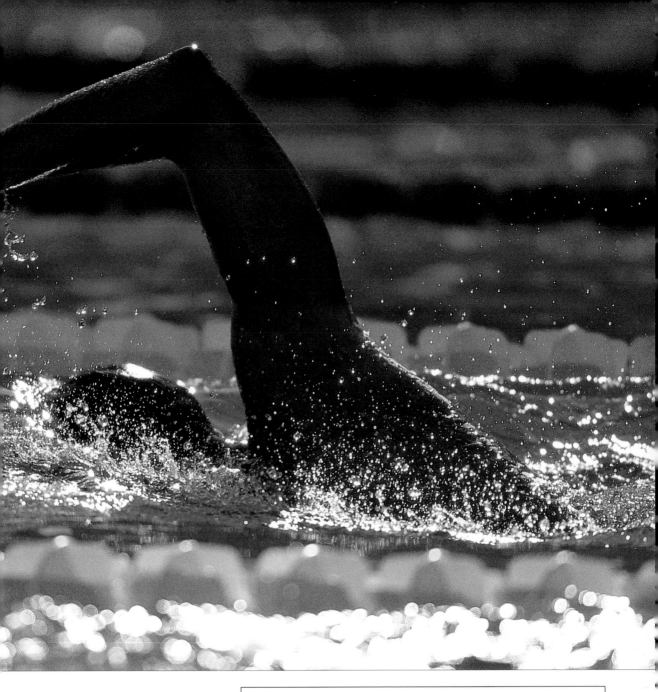

Hints and tips

● When you look through the camera's viewfinder, think of the empty frame as being like a blank piece of paper on which you need to arrange the various subject elements in order to communicate a particular message to the picture's intended audience. This is the first step in composing your image.

● In a studio environment, more often than not you have the time to take a considered approach to each picture. Before triggering the shutter release, look at the area bounded by the four sides of the frame and make certain that everything there is making a positive contribution to the composition.

LOW-LIGHT SHOOTING

Any photographer interested in covering indoor action activities, such as gymnastics, is going to come up against the problem of shooting in low light at some time or another. Problems associated with poor lighting conditions include a dim viewfinder image, which can make focusing very difficult, for example, or mixed and incompatible light sources, which can give rise to colour casts. These difficulties may be further compounded by the need to shoot with a reasonably fast shutter speed in order to produce a crisp, blur-free image of the subject and a prohibition on using supplementary lighting such as flash.

The two steps you can take to minimize these types of problem are to use the "fastest" lens you have – in other words, the one with the largest maximum aperture – and to load your camera with a "fast" film emulsion. The benefit of using a fast lens is obvious – you can shoot with a shutter speed of, say, $\frac{1}{500}$ second to freeze the action when the lighting is dim and still have an aperture wide enough to ensure correct exposure.

Using a fast film, however, to overcome poor lighting brings with it some disadvantages. First, fast emulsions often have a slightly different colour and contrast response than slower emulsions; and, second, fast films often have a more obvious grain response than slower types. The appearance of grain can become a problem if the film image, or especially if only a part of it, needs to be blown up large.

PHOTOGRAPHER:
Bob Martin

CAMERA:
35mm

LENS:
400mm

FILM SPEED:
ISO 800

EXPOSURE:
$\frac{1}{500}$ second at f2.8

LIGHTING:
Daylight only

▶ *Stopped dead with a shutter speed of $\frac{1}{500}$ second, this low-light picture of a gymnast was originally shot on high-speed negative film. It was then copied on to slide material to produce a positive image suitable for projection. The grain of the film can be detected, especially in the mid-tones, but unless the original is going to be enlarged greatly this should not represent too much of a problem.*

Shooting on negative film

Nearly all professional sports and action photographers shoot on transparency, or slide, film. With only processing to consider, slide images can be out of the camera and on a picture editor's desk with less bother than pictures taken on negative film, which have to be printed. Also, it used to be the case that publishers of newspapers, magazines, and books would usually accept only slide images for reproduction, which is not true anymore. However, negative film is more forgiving of exposure errors than slide material, and it is available in faster emulsions. Negative film can also be push-processed to squeeze another stop or two of speed out of it. If required, once negative film has been processed it can be copied to produce positive film images for projection.

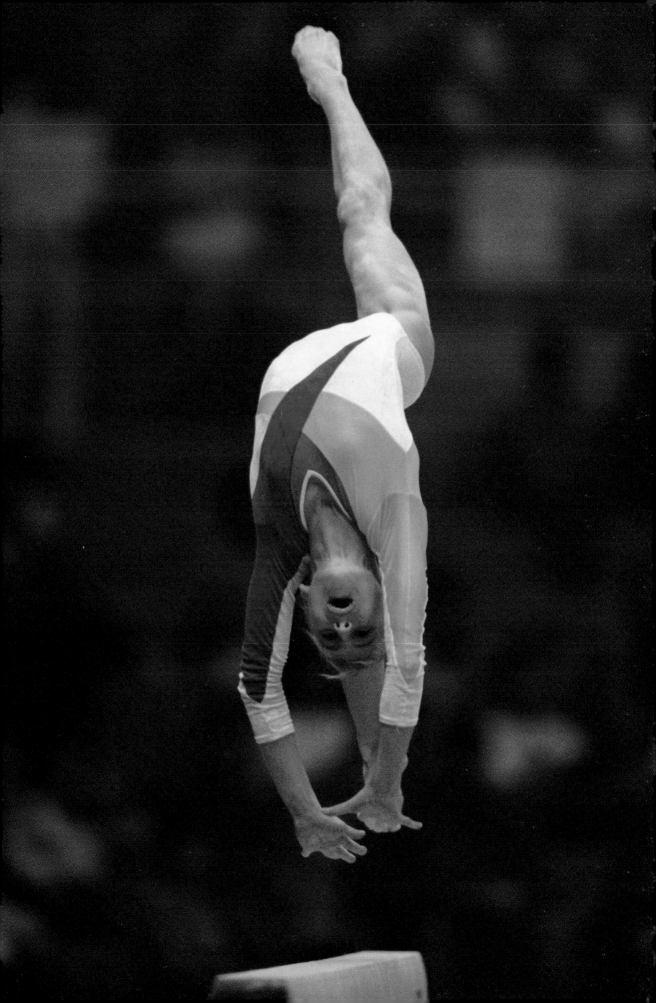

FOLLOWING THROUGH

Covering a major sporting event, such as an international golfing tournament, the last thing you can afford to worry about is the amount of film you are shooting. Hundreds of photographers are themselves in competition to have their work published in the scores of specialist magazines and newspapers that cater for sports fans. Inevitably, many photographers will be disappointed and all their effort will have counted for nothing.

In order to maximize your chances of recording the very moment when the action is at its best, many photographers use either a built-in or add-on accessory motor drive. With the camera set to "C", or continuous, a typical motor drive will shoot four to six frames a second, for as long as you keep the shutter release depressed (or until you run out of film, which won't take long with a 36-exposure cassette). To avoid coming to the end of a roll of film at a crucial moment, most photographers always have at least one spare camera body with them, already loaded with film and ready to shoot.

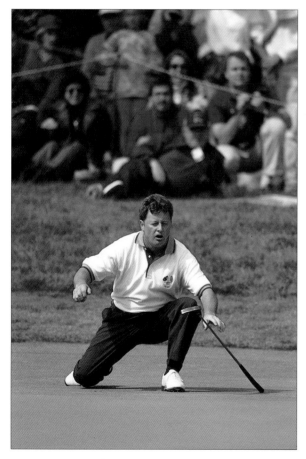 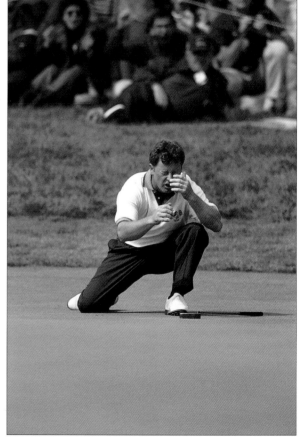

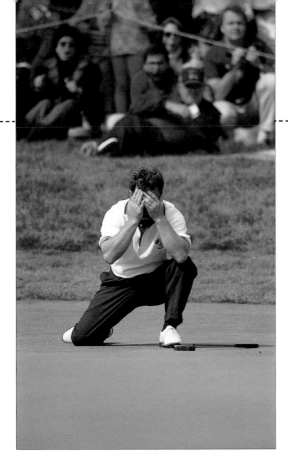

▼ ▶ *Golfing star Ian Woosnan is seen in this motor drive sequence casting his putter aside so that he can hide his face in his hands as, with horror, he realizes that his ball is just going to slip past the hole. Using a motor drive for this type of sequence means that you are entirely free to concentrate on framing, composition, and exposure, since you don't have to take your eye away from the viewfinder to wind the film on between exposures. As well, the rate of fire using a motor drive is far quicker than you could achieve manually.*

PHOTOGRAPHER:
Bob Martin

CAMERA:
35mm

LENS:
400mm

FILM SPEED:
ISO 100

EXPOSURE:
1/1000 second at f4

LIGHTING:
Daylight only

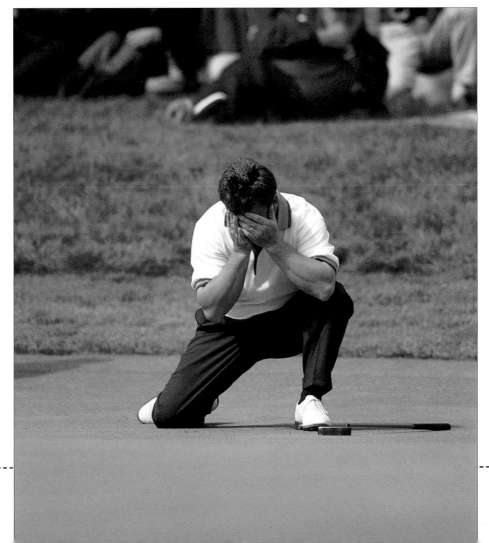

USING SHADOW FOR IMPACT

As a way of adding dramatic impact and increasing visual interest and content, shadows can have an important part to play in your composition. Shadows tend to have least presence when the sun is directly above the subject, which occurs at about noon each day. Any shadows cast at that time will be foreshortened and often have no clearly defined shape. Either earlier in the morning or later in the afternoon the sun is closer to the horizon and the light reaching the subject will be, therefore, more directional. As a result, any shadows cast at these times of day will be longer, have more of a recognizable shape, and have greater pictorial impact.

PHOTOGRAPHER:
Bob Martin

CAMERA:
35mm

LENS:
300mm

FILM SPEED:
ISO 100

EXPOSURE:
1/1000 second at f5.6

LIGHTING:
Daylight only

Hints and tips

● Shooting against the light causes shadows to fall in front of the subject and toward the camera.

● Shooting with the light produces the opposite effect.

● Shadows will have better definition if the sunlight reaching the subject comes from a bright and cloudless sky. Cloud cover diffuses sunlight, making it less directional in quality.

▼ *Low yet intense afternoon sunlight throws a perfect, elongated shadow of this speed cyclist on to the steeply banked race track. Picking colours up from the subject, half the shadow is outlined in yellowy gold and half in blue.*

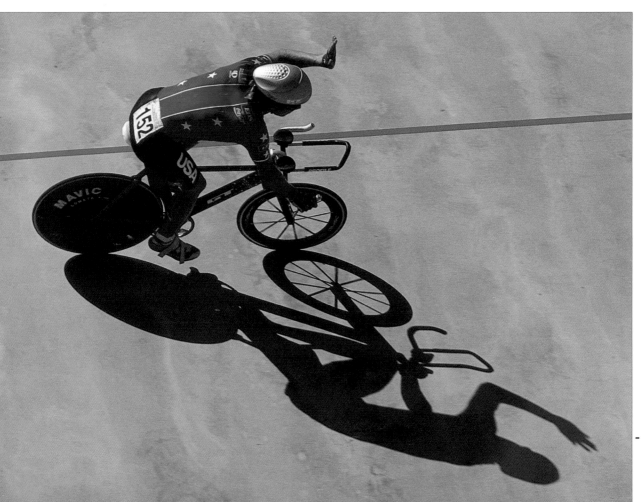

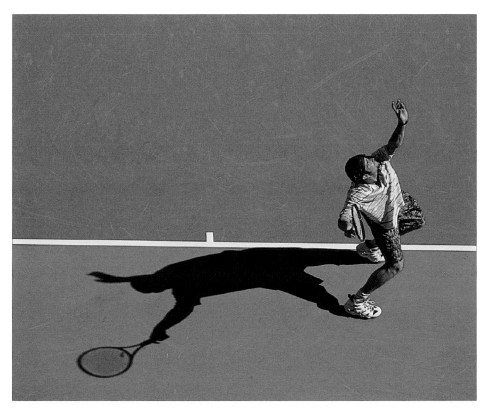

PHOTOGRAPHER:
Bob Martin

CAMERA:
35mm

LENS:
400mm

FILM SPEED:
ISO 50

EXPOSURE:
½₀₀₀ second at f4.5

LIGHTING:
Daylight only

◄ ▼ *Taken from high up in the spectators' stands, these two pictures are of tennis star Andre Agassi playing at the Australian Open. Both pictures show the subject as being foreshortened to varying degrees, and without the clear-edged shadows to help fill the frame the images would have had less dramatic impact and the action component would have been diminished.*

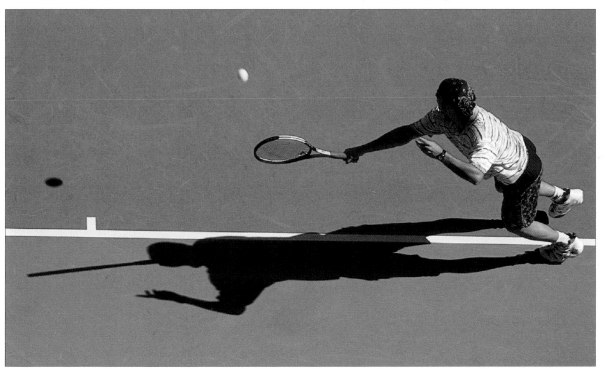

FIREWORKS

The principal difficulty in photographing a subject such as a fireworks display is that you just don't know where the explosions are going to happen. By watching whoever it is lighting the touch papers you know approximately when the fireworks will go off, but where exactly do you point your camera? If the lens is just fractionally out in any direction, the picture will be spoiled.

The absolutely essential piece of equipment for photographing fireworks is a tripod, or some other very stable and adjustable type of camera support. Once the camera is mounted securely with the lens pointing at the area of sky where most explosions are happening, manually set the focus control to infinity and select as slow a shutter speed as your camera allows. Better still, hold the shutter open using its "T" (time) setting, only releasing it when you have recorded an explosion. For this type of work, exposures of many seconds are usual and you may record more than one explosion on the same frame.

You may want to use a telephoto lens in order to bring the fireworks up as large as possible in the frame. However, don't use an extreme focal length – its angle of view is so narrow that you may miss the display altogether or only get part of it.

All the fireworks pictures on these pages, and the ones that follow, were taken by Simon Hennessey, using a 35mm camera and a 90mm lens. Exposure times varied between 5 and 15 seconds with an aperture of about f5.6. Film speed was ISO 200.

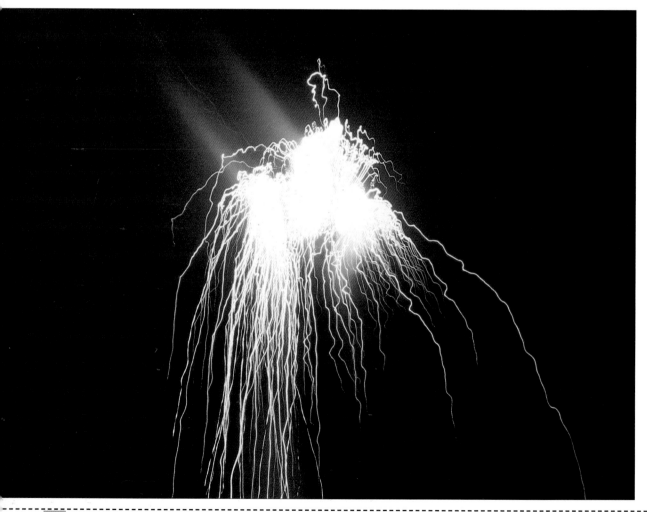

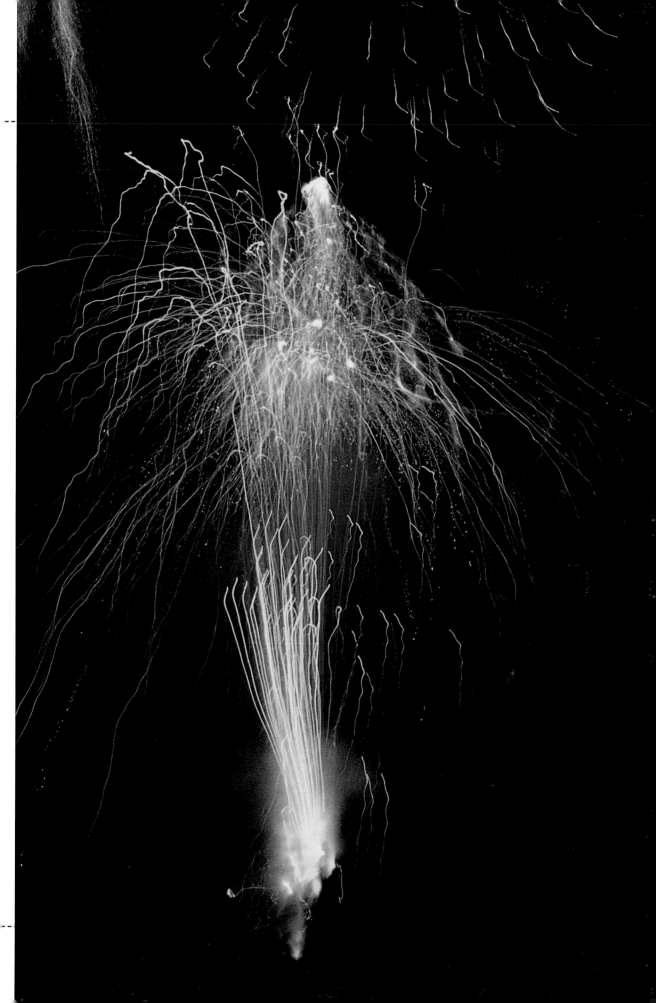

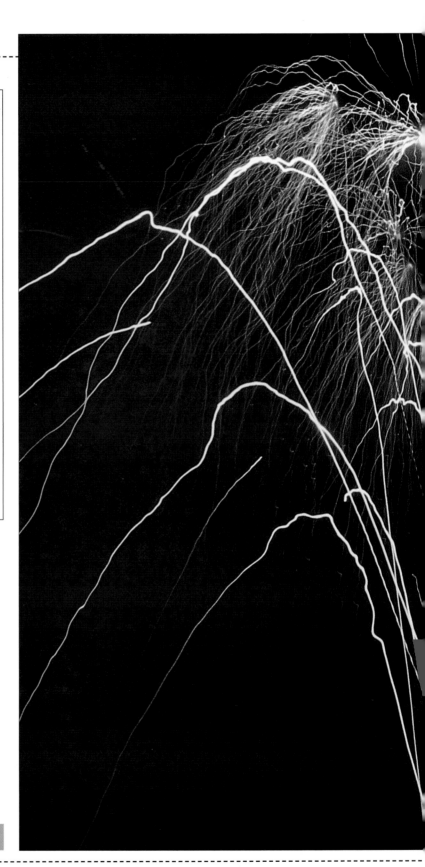

Hints and tips

● Because of the long exposure times required to record a fireworks display, make sure you exclude any continuous-light sources from the frame, including street lighting, house lights, a bonfire, or a bright moon.

● It is best to shoot when the sky is fully dark, well after sunset. If there is any twilight, a long time exposure will probably cause the sky to lighten up considerably and this will lessen the impact of the fireworks.

● When you are using a camera set to "T", it is best to lock the shutter open using a cable release. Keeping the shutter button depressed with your finger for many seconds will almost inevitably produce some camera movement and give blurred pictures.

● If you don't have a tripod available, you can rest the camera on a flat-topped wall, the top of your car, or even wedge it in the crook of a tree branch to keep it steady throughout the exposure.

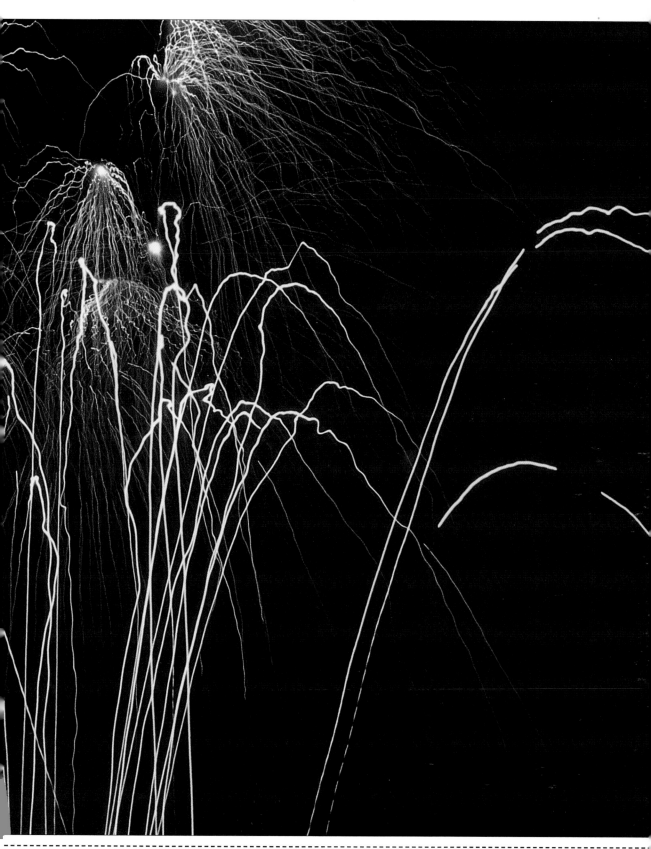

ACTION FRAMING

Motor racing is a difficult action subject to photograph well. For one thing, unless you are an accredited photographer you will probably be confined to the spectators' stands during the race itself, and so your angle of view of the subject, as well as the distance between the camera and action, may not be ideal. Added to this, at a formula or even a production car event, the competitors will be flashing past your camera position at speeds of anything up to 300km (180 miles) per hour – or more if you are adjacent to one of the straights. At these speeds, you have mere fractions of a second to select your subject, frame the shot, check for the best shutter speed and aperture, and trip the shutter. And you cannot be certain until the film is developed

that you have the pictures you were hoping for. This is where the automatics really can make a difference. Their speed of response to, say, fluctuations in light, is immediate and generally reliable, and they can relieve you of the routine, technical decision-making.

If your camera position is not ideal, you still need to maximize the number of good shots you come away with. If you cannot shoot an entire car and make it an exciting image, look for the special details that really say something about this event. Tightly framed shots of smoking rubber tyres, or wheels leaving the ground on a challenging bend, will communicate more of the thrill of a race than zooming back for an indifferent, middle-ground profile of a racing car seemingly frozen into inaction by a super-fast shutter speed.

PHOTOGRAPHER:
Autosport

CAMERA:
35mm

LENS:
70–210mm zoom (set at 210mm)

FILM SPEED:
ISO 100

EXPOSURE:
1/500 second at f4

LIGHTING:
Daylight only

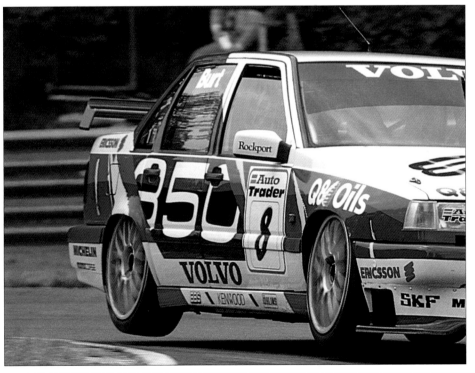

◀ The photographer has made the best of this camera position, adjacent to a series of bends, by framing as tightly as possible on the rear wheel of the Volvo as it hurtled toward the camera. The photographer had prefocused on this spot, since it was a likely place for just this type of shot.

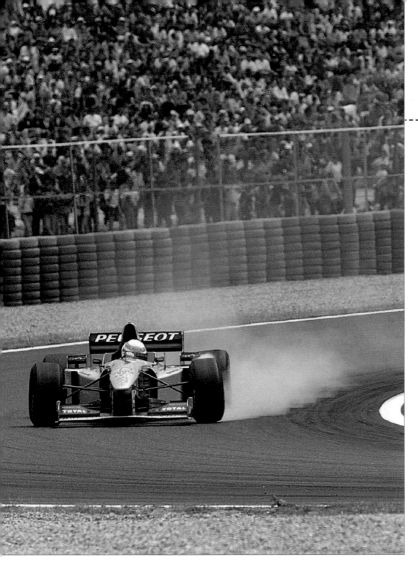

PHOTOGRAPHER:
Autosport

CAMERA:
35mm

LENS:
300mm

FILM SPEED:
ISO 200

EXPOSURE:
¹⁄₅₀₀ second at f5.6

LIGHTING:
Daylight only

◀ *Finding a camera position overlooking a bend has once again proved to be the correct picture-taking decision. Taken with a long lens from near the front of the spectators' stand, the photographer has managed to avoid all of the potential visual distractions encountered at a race track and refined the subject matter to just the simplest and most important elements.*

▶ *The framing here is superb for communicating the speed and thrill of motor racing. By framing this panned shot so that the immediate foreground and the background can both be seen as elongated bands of streaks flashing by, the sharp image of the car itself is thrown into stark relief. If it were not for the obviously spinning wheel hub, the car would appear stationary.*

PHOTOGRAPHER:
Autosport

CAMERA:
35mm

LENS:
135mm

FILM SPEED:
ISO 100

EXPOSURE:
¹⁄₁₂₅ second at f11

LIGHTING:
Daylight only

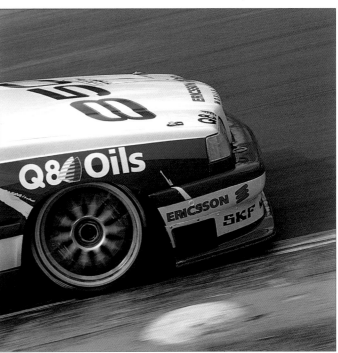

Hints and tips

● Action is more likely to happen on the bends of a race circuit or where the circuit favours overtaking. These are often the best camera positions.

● Well before the cars are in view, practise the ideal framing you would like to see. Check that the background is not distracting, for example, and that the spectators' heads, banners or flags are not likely to get in the way.

● Autoexposure is of great benefit when photographing fast-moving action, since the system will monitor the subject, adjusting exposure until the very instant you press the shutter. Autofocus, however, is of less-certain benefit. Even the fastest autofocus reaction times are not likely to be able to cope with a racing car flashing past. As with framing, it is best to plan ahead and manually prefocus on the spot where you hope the action will take place.

● Use the smallest practicable lens aperture (taking into account the shutter speed you need). Smaller apertures have a greater depth of field than larger ones, and this can help to compensate for any minor focusing errors.

PHOTOGRAPHER:
Autosport

CAMERA:
35mm

LENS:
400mm

FILM SPEED:
ISO 100

EXPOSURE:
⅟₅₀₀ second at f8

LIGHTING:
Daylight only

▶ *Part of the colour and atmosphere of the race circuit are the advertising hoardings lining the track, sited where they can be easily picked up in the background by stills and video photographers. Here, the photographer has framed his shot so that one of these advertising signs acts as a colourful backdrop to the formula 1 car, and has turned what was a potential distraction into a positive subject element.*

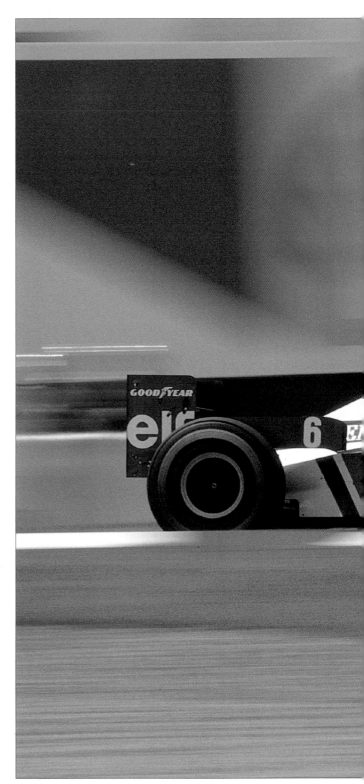

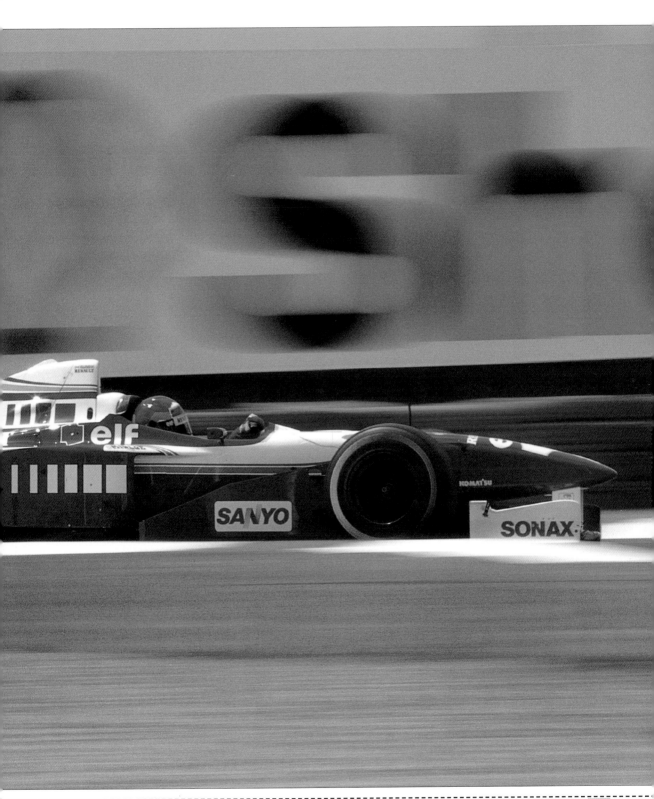

DIFFICULT LIGHTING

The overwhelming majority of modern cameras – SLRs and compacts – feature a range of automatic controls, including, almost universally, autoexposure. In order to achieve the "point-and-shoot" convenience that many people demand, these automatic systems are designed to produce a high percentage of "correctly" exposed images under a variety of "standard" lighting conditions. Multi-mode systems, which give the photographer a good degree of exposure flexibility under many different lighting conditions, or when either the shutter speed (to control subject movement) or the aperture (to control depth of field) needs to be favoured, tend to be anything but point and shoot.

The situation that causes most problems for many autoexposure systems is when they are confronted with adjacent areas of bright highlight and deep shadow. This high-contrast configuration is a problem when it falls either over or nearby the main subject.

If a compromise – or averaging – exposure (one halfway between the two extremes) is selected, then both highlights and shadows may be unsatisfactory. However, if exposure is influenced by the brightest screen areas, then the shadows are likely to be impenetrably dense. Conversely, weight exposure in favour of the shadow areas, and bleached-out, thin, and colourless highlights are likely to result.

In this type of situation, and the many others photographers inevitably encounter, you need the confidence to override the automatics and make decisions about which areas of the frame are most important, and then to set the controls accordingly.

PHOTOGRAPHER:
Bob Martin

CAMERA:
35mm

LENS:
**70–200mm zoom
(set at 135mm)**

FILM SPEED:
ISO 100

EXPOSURE:
¹⁄₁₀₀₀ second at f4

LIGHTING:
Daylight only

▶ In this picture, the fallen speed cyclist is surrounded by a highly reflective track surface and very tall sloping walls. As well, he is wearing a bright, metallic-white top, which acts exactly as a studio reflector. A standard exposure reading for this scene is likely to result in the automatics closing the lens aperture down or selecting a very fast shutter. However, the result would then show an underexposed subject. Without spot metering, all you can do is change to manual mode or use the exposure overrides to ensure that it is the cyclist, and not the race track, that is correctly exposed.

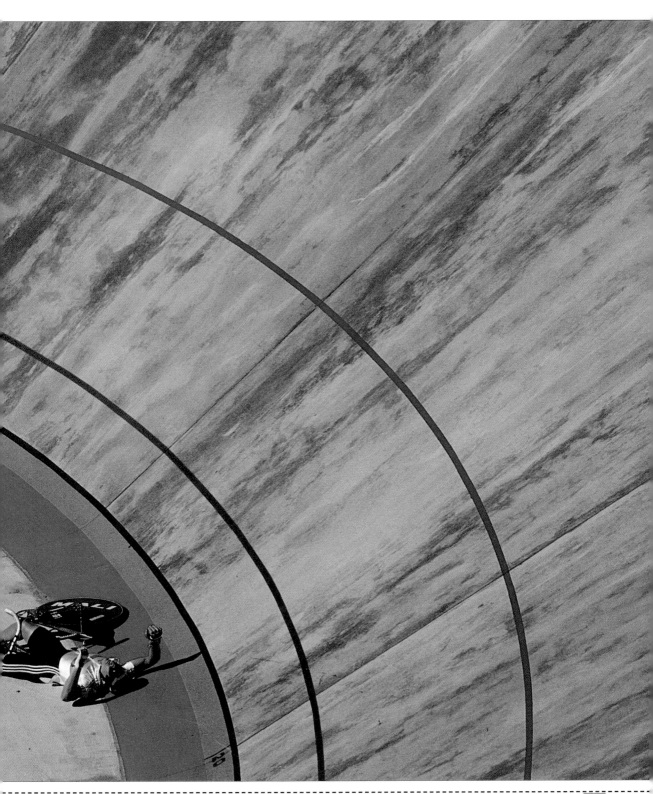

▼ The tennis player in this picture, Lori McNeal, has been photographed in bright and directional afternoon sunlight. This has picked out only her face and white-coloured top, leaving most of the frame in heavy shadow. The normal reaction from many autoexposure systems would be to "see" all that area of heavy shadow and open up exposure to compensate. The result, inevitably, would be an over-exposed tennis player. Faced with this dilemma, the photographer set the exposure manually, taking a reading just from the bright highlights, and allowed the shadows to look after themselves.

PHOTOGRAPHER:
Bob Martin

CAMERA:
35mm

LENS:
400mm

FILM SPEED:
ISO 50

EXPOSURE:
⅟₁₀₀₀ second at f2.8

LIGHTING:
Daylight only

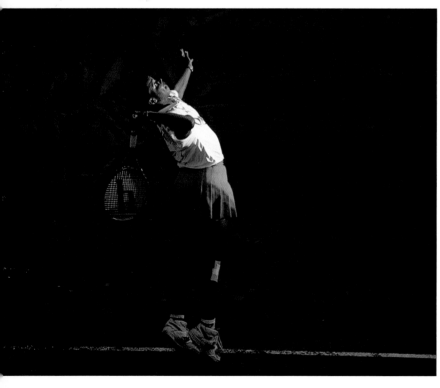

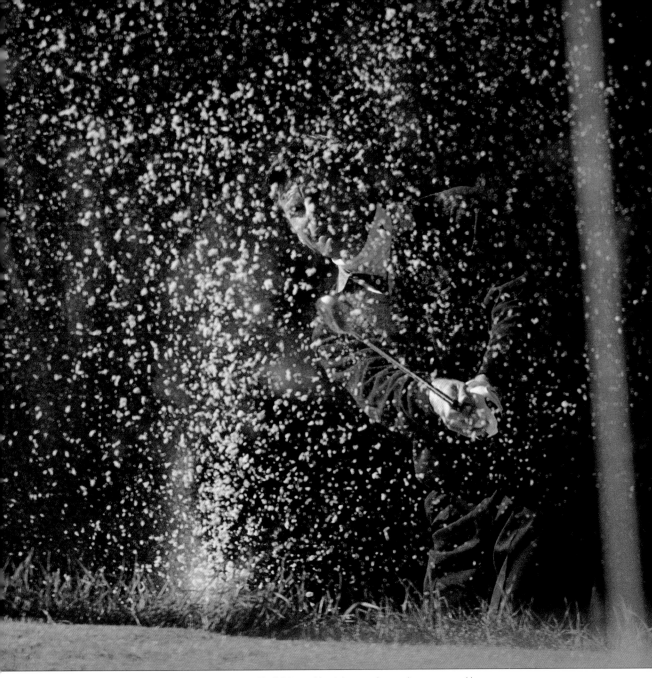

▲ The lighting problem inherent in this scene became obvious only when the photographer saw the shadowy golfer's (Nick Faldo's) practice swing, which kicked a lot of sand up and into the bright sunlight. The read-outs inside the viewfinder immediately dipped by about ⅔ of a stop. Although not a lot, this decrease in exposure would have been sufficient to make instant recognition of the golfer difficult. The solution here was to use the camera's override facility to increase exposure by a little less than a stop. With the technical side sorted out, the photographer could then give all his attention to the timing of the shot.

PHOTOGRAPHER:
Bob Martin

CAMERA:
35mm

LENS:
600mm

FILM SPEED:
ISO 100

EXPOSURE:
¹⁄₁₀₀₀ second at f4

LIGHTING:
Daylight only

Angle for action

No matter how good your anticipation, no matter what camera and lenses you are using or how perfect the light is, if you are not in the right place at the right time to take the shot then all your efforts will end in nothing but disappointment.

To take the photograph featured here, the photographer closely watched the route down the mountain taken by the competing snow board riders. Although not precisely the same on each run, all the competitors were confined within a marked course that took in certain diversions and obstacles designed to test their abilities. Knowing the route in advance, he could plan, with some certainty, the angle he needed to record the shots that communicated most about the sport.

Good practice

If you move outside the roped-off areas set aside for photographers and spectators you need to exercise proper consideration. Snow boarding events are highly competitive, with participants pushing themselves to the absolute limit. Any distraction could result in vital fractions of a second being lost or a less-than-perfect style performance.

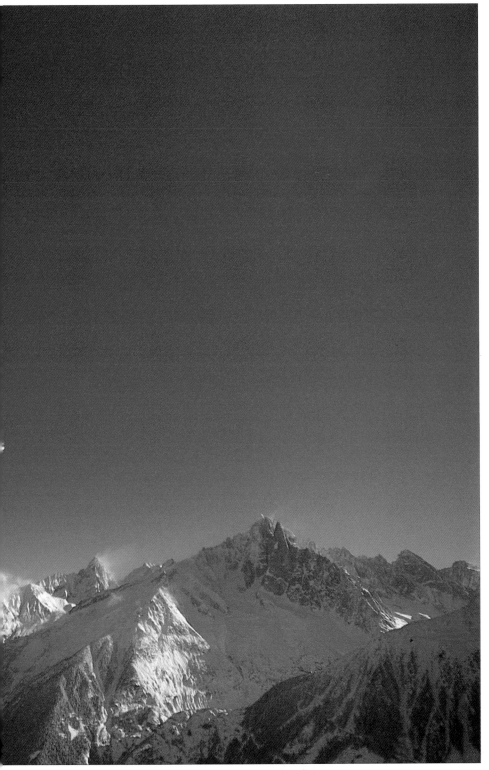

◄ *Taken from any other angle, this airborne snow boarder would have been framed against distant mountains or the snow field itself. This angle, low down at the base of a wall of ice-covered rock, allowed the competitor to be seen far more dramatically – framed against a cloudless, deep-blue sky. A polarizing filter was used to intensify the sky colour and counter the high levels of ultraviolet light commonly found in mountainous countryside.*

PHOTOGRAPHER:
Bob Martin

CAMERA:
35mm

LENS:
**70–200mm zoom
(set at 200mm)**

FILM SPEED:
ISO 50

EXPOSURE:
⅟₁₀₀₀ second at f4

LIGHTING:
Daylight only

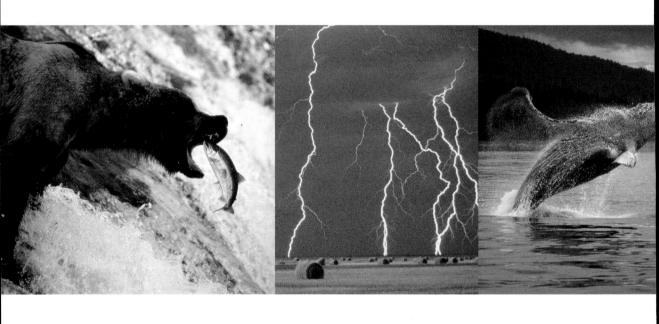

3

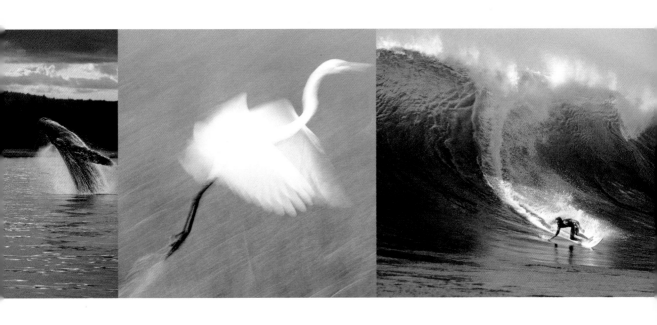

ACTION IN NATURE

ANIMAL ACTION

The natural world, and animals in particular, are recurrent themes in the work of many general photographers. Indeed, many professionals specialize in this field of endeavour, devoting the whole of their working and personal lives to capturing on film the beauty, grace, and – to our eyes – the more raw side of animal behaviour.

As well as having a good knowledge of animal behaviour, consistently successful animal photographers are heavily dependent on having the right equipment. Foremost, are good-quality telephoto and zoom lenses with wide maximum apertures so that frame-filling images of animals can be taken in poor lighting conditions. You need to bear in mind that some animals come out to feed only in the early morning, before the sun is fully up, or toward dusk, when the heat of the day has subsided, at which times light levels may be low. A 250mm telephoto with

a maximum aperture of, say, f2.8 may be as much as ten times the cost of a similar lens with a maximum aperture of only f5.6, but if it allows you to record that single winning shot then the reproduction fees alone could be many times the price of the lens.

Sometimes a winning animal action shot is just a piece of good luck – the photographer was in the right place at the right time and instinctively took the picture. More often, however, the types of shots you see published are the result of skilled and dedicated effort. Photographers may spend weeks in uncomfortable conditions in remote regions, sometimes in physical danger, and still have no guarantee that a good photo opportunity will arise. Once you are familiar with the behaviour of the particular animal you are trying to record, strategically placed offerings of food may encourage it within the range of your lens.

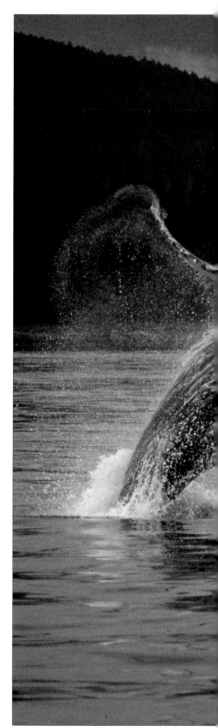

PHOTOGRAPHER:
Sanford/Agliolo/TSM

CAMERA:
6 x 7cm

LENS:
300mm

FILM SPEED:
ISO 200

EXPOSURE:
⅟₁₂₅ second at f8

LIGHTING:
Daylight only

▶ *Although this spectacular image of two humpback whales was shot at sundown, the sky is still full of the warm glow of early evening light, which you can see reflected in the water of the bay. It is not known for certain, but this behaviour of humpbacks is thought to be part of their feeding technique in which numbers of whales co-operate to concentrate a school of fish into one small area of water.*

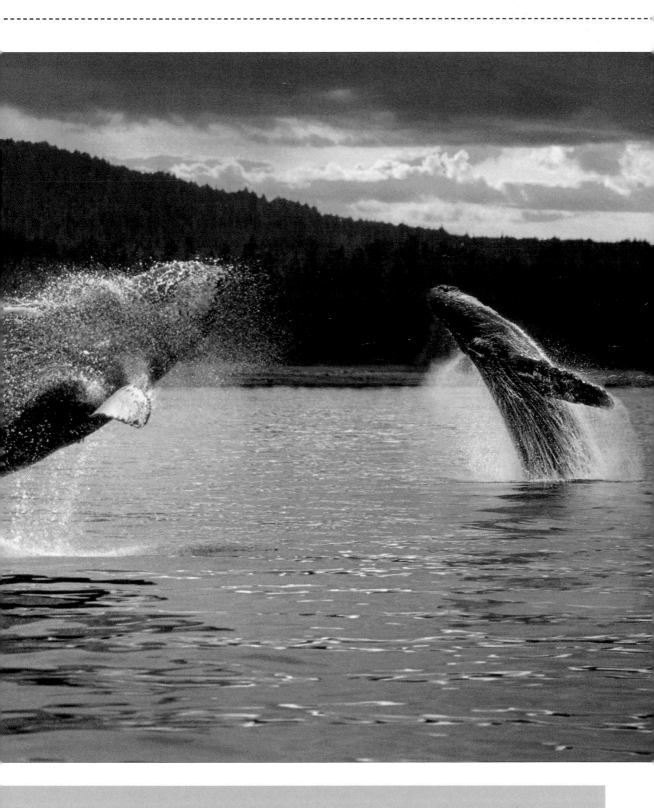

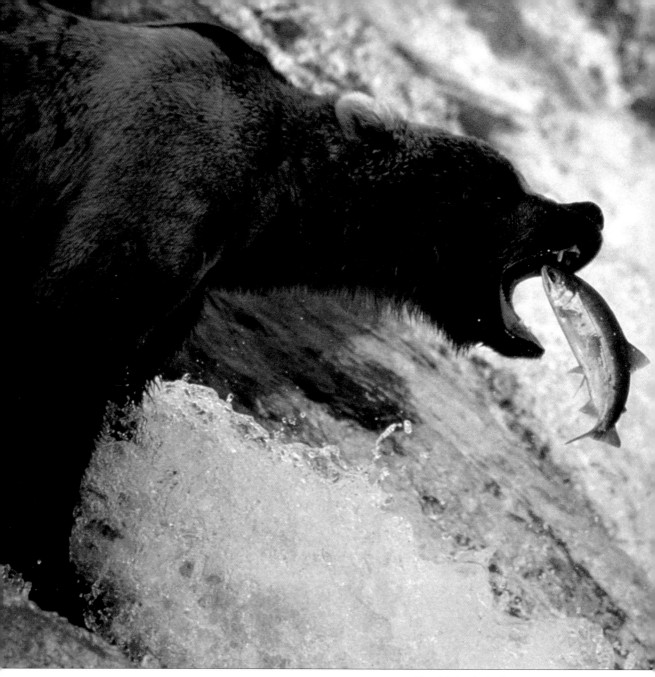

PHOTOGRAPHER:
Ron Sanford/TSM

CAMERA:
35mm

LENS:
400mm

FILM SPEED:
ISO 200

EXPOSURE:
⅟₅₀₀ second at f5.6

LIGHTING:
Daylight only

▲ Although luck undoubtedly plays its part, this winning picture came about principally because the photographer knew the favourite fishing spots of many of the bears in the region and he was able to find a covered shooting position, down wind of the target area, and wait for the bear to arrive and start to feed. As well as the subject matter, showing the salmon nearly leaping into the bear's open mouth, the contrast between the animal's dark brown coat and the frothy whiteness of the waterfall helps to make this image stand out from the crowd. Although keeping your scent away from the bear is important, the deafening roar of the water covers nearly any amount of camera noise.

PHOTOGRAPHER:
Tom Nebbia/TSM

CAMERA:
35mm

LENS:
50mm

FILM SPEED:
ISO 200

EXPOSURE:
¹⁄₅₀₀ second at f11

LIGHTING:
Daylight only

▼ *Although similar in appearance to a panned shot, this image of a racing kangaroo was in fact taken from the open doorway of a low-flying helicopter as it kept pace with the leaping animal. The air currents very close to the ground, especially in hot arid regions,* *are very unpredictable, and it is impossible to guess when the helicopter might suddenly lurch and spoil a shot. The only solution is to shoot lots of film while using the fastest possible shutter speed to counter the constant vibration of the airframe.*

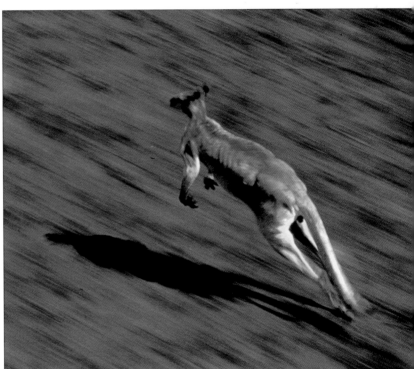

Hints and tips

● Lenses of between 300mm and 500mm offer you the chance to position yourself well back from your subject and still fill the frame.

● Film speeds of about ISO 800 may be necessary when shooting in generally poor lighting conditions. Faster films are available, but any added benefit of using them has to be weighed against the potential loss in image quality due to the appearance of grain.

● Long lenses, especially those with large maximum apertures, are simply too heavy to hand-hold. These types of lenses have tripod-mounting threads built into a collar surrounding the barrel, and the camera body fits, unsupported, on to the back of the lens.

● A motor drive, built-in or an accessory, is useful, but you need to make sure that the noise of the motor does not alert your subject to your presence.

PHOTOGRAPHER:
Steve Elmore/TSM

CAMERA:
35mm

LENS:
300mm

FILM SPEED:
ISO 100

EXPOSURE:
⅕ second at f5.6

LIGHTING:
Daylight only

▼ ▶ *Both of these evocative animal action shots – one of an egret just lifting itself from the water, and the other of a mountain lion in pursuit of its prey – are the result of panning the camera while using a slow shutter speed. Your normal instinct when photographing a moving subject is to select the fastest possible shutter speed in order to reduce subject blurring to an absolute minimum. Here, however, you can see the excitement, power, and dynamism it is possible to create by adopting an entirely different approach.*

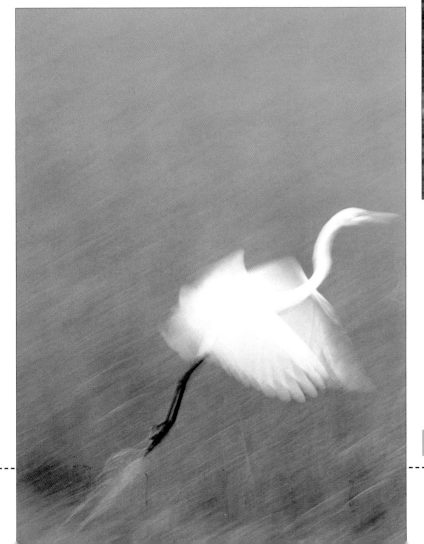

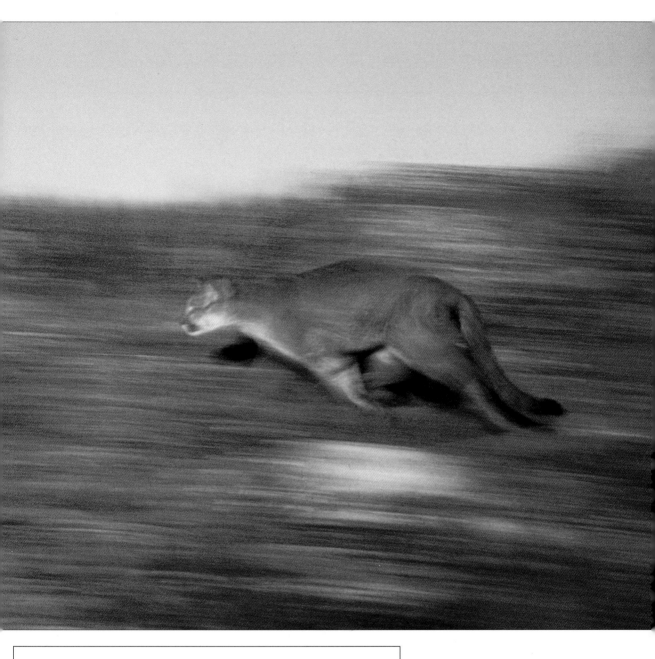

Mirror lenses

As an alternative to traditional optics, which use groups of glass elements to bend and focus the light entering the lens, what are commonly known as "mirror" lenses can be used as lightweight alternatives. With this type of lens, also known as a catadioptric lens, some of the glass elements are replaced by mirrors that bounce the light up and down internally, effectively producing a long focal length lens in a physically short barrel. Image quality can be good with a mirror lens, but the aperture is fixed, usually at about f8, which can be a severe limitation in poor light.

Right **500mm telephoto lens**

Below **500mm mirror lens**

PHOTOGRAPHER:
Ron Sanford/TSM

CAMERA:
35mm

LENS:
**70–210mm zoom
(set at 180mm)**

FILM SPEED:
ISO 100

EXPOSURE:
⅛ second at f16

LIGHTING:
Daylight only

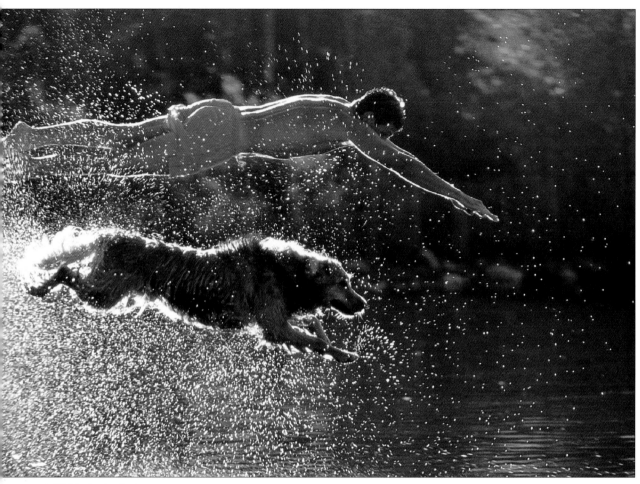

▲ *This labrador dog simply adored the water, and the only problem for the photographer was trying to prevent it from jumping into the river ahead of schedule. Shooting against the light ensured that both subjects and the veil of water droplets suspended in the air were attractively backlit.*

PHOTOGRAPHER:
Grafton Marshall Smith/TSM

CAMERA:
35mm

LENS:
135mm

FILM SPEED:
ISO 100

EXPOSURE:
⅟₅₀₀ second at f2.8

LIGHTING:
Daylight only

PHOTOGRAPHER:
Amos Nachoum/TSM

CAMERA:
35mm

LENS:
105mm

FILM SPEED:
ISO 64

EXPOSURE:
⅟₁₀₀₀ second at f4

LIGHTING:
Daylight only

▶ *For many people, this image of a shark rising out of the inky dark water with its jaws gaping open is the stuff of nightmares. In order to manoeuvre the shark into this area of water, the crew of the fishing boat had baited the surrounding water with blood and well-rotted tuna. Apart from coping with the smell, the trickiest part of taking the picture was to show the subject against a background of pristine clean sea.*

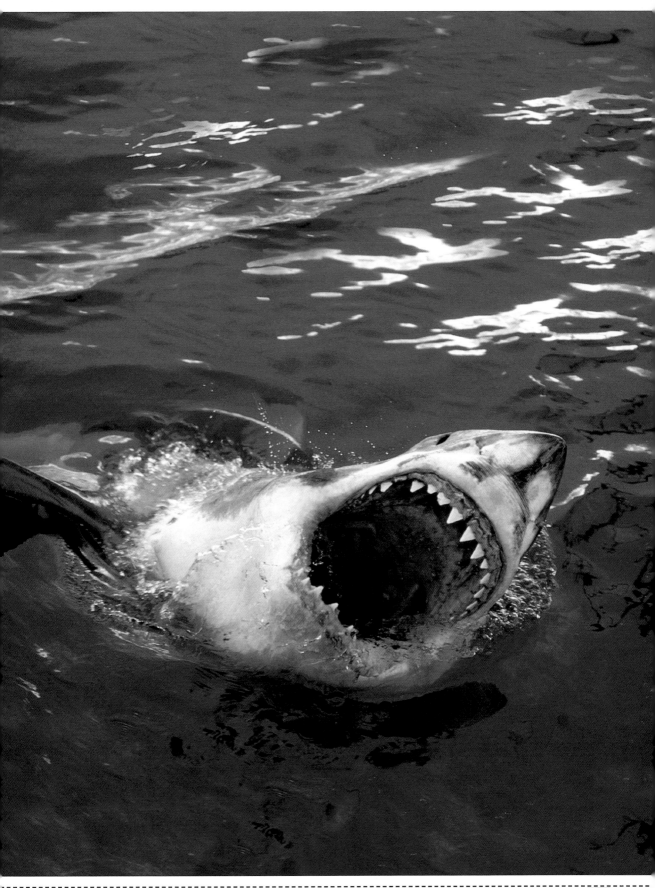

THE FORCES OF NATURE

Capturing dramatic photographs such as the one below, and those on the pages that follow, are not just chance happenings. While it's true that you don't know where or when lightning will strike, for example, or the direction the path of a tornado will take, there are certain parts of the country that are more prone to these types of event at particular times of the year, and this is when your chances of recording a successful image will be that much better. But there are never any guarantees.

If you can't ask for guidance from a photographer who has perhaps developed a specialism in this type of work, then you should be able to get some basic guidance form your local meteorological office. This organization, for example, holds statistical information on lightning strikes by region, the times of year when certain wind conditions are most likely, the times of the lunar cycle when high tides and other weather factors are most likely to produce stormy and dramatic seas, and so on. All too often, when the weather turns inclement, photographers turn their backs on the outdoors and hang their cameras up until the sun appears once again.

PHOTOGRAPHER:
Bill Stormont/TSM

CAMERA:
35mm

LENS:
200mm

FILM SPEED:
ISO 100

EXPOSURE:
1/500 second at f5.6

LIGHTING:
Daylight only

◀ *It is not just the sight of a bush fire burning out of control that is so terrifying, it is also the incessant roar of the air currents it produces and the scream of tortured wood as the flames consume everything in their path. Although it was around midday when this photograph was taken, there was so much smoke in the air that it may as well have been a night-time shot. Exposure was calculated by taking a reading from the brightest part of the flames, which threw the blackened and charred remains of the trees into silhouetted relief.*

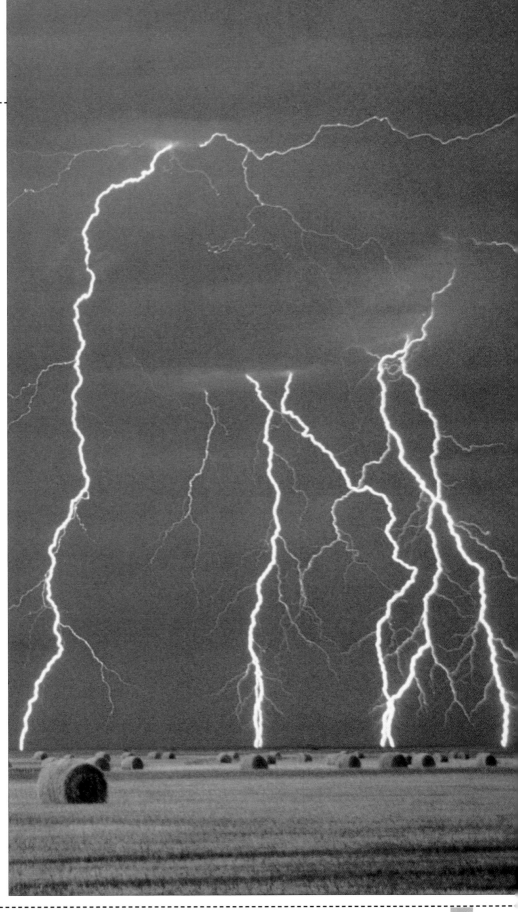

▶ At certain times of the year in some parts of the country lightning strikes are very common. In order to record this series of strikes, the photographers set a camera up on a tripod, focused the lens on infinity, selected the smallest aperture available, and fitted a series of neutral density filters over the lens. These filters reduce the amount of light entering the lens without affecting the colour balance of the resulting photograph, and so they allow you to shoot with long exposure times without overexposing the film. Luck still has to play a part, however – this picture was the sixth attempt to record a lightning strike and it shows a series of strikes hitting the ground virtually simultaneously.

PHOTOGRAPHER:
A & J Verkaik/TSM

CAMERA:
35mm

LENS:
45mm

FILM SPEED:
ISO 25

EXPOSURE:
¼ second at f16

LIGHTING:
Daylight only

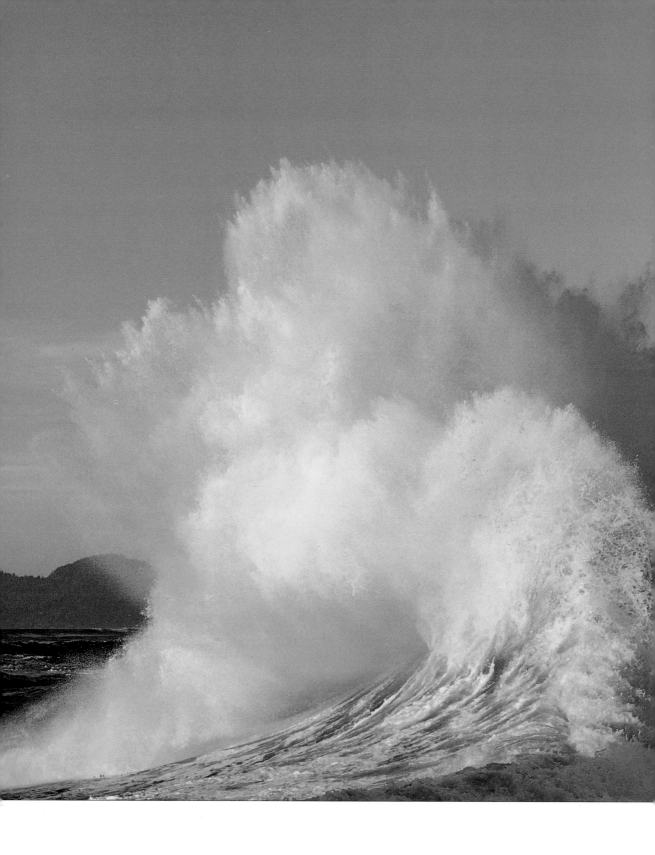

PHOTOGRAPHER:
Graig Tuttle/TSM

CAMERA:
6 x 7cm

LENS:
150mm

FILM SPEED:
ISO 100

EXPOSURE:
⅟₂₅ second at f5.6

LIGHTING:
Daylight only

PHOTOGRAPHER:
Mark A Johnson/TSM

CAMERA:
**35mm
(in waterproof housing)**

LENS:
20mm

FILM SPEED:
ISO 100

EXPOSURE:
⅟₁₀₀₀ second at f11

LIGHTING:
Daylight only

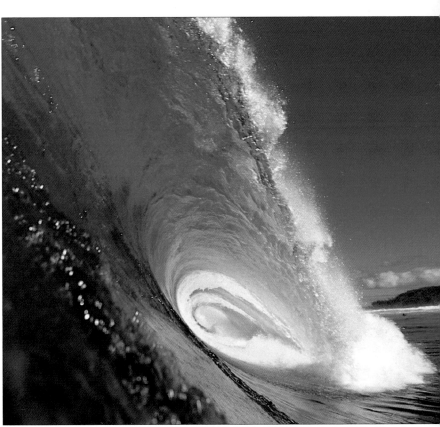

▲ *Two very different seas are represented by these photographs. One, the turbulent Atlantic battering itself against the coastline of Britain, is a perfect example of the unruly might and power of that body of water; the other shows the Pacific off the coast of Hawaii, and here the currents and seabed features have channelled and sculpted the water into a perfectly coherent, glass-like tunnel.*

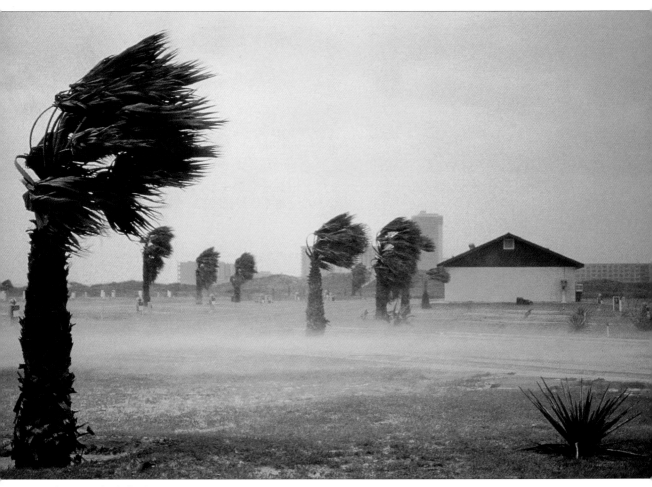

▲ If it were not for the fronds of the palm trees being almost ripped from their trunks by the force of Hurricane Gilbert, this photograph of a battened-down township would look almost calm and placid.

PHOTOGRAPHER:
J B Diederich/TSM

CAMERA:
35mm

LENS:
50mm

FILM SPEED:
ISO 200

EXPOSURE:
¹⁄₁₀₀₀ second at f2.8

LIGHTING:
Daylight only

PHOTOGRAPHER:
A & J Verkaik/TSM

CAMERA:
35mm

LENS:
135mm

FILM SPEED:
ISO 200

EXPOSURE:
¹⁄₂₅₀ second at f4

LIGHTING:
Daylight only

▶ A ferociously spinning funnel of air skips across the landscape, its lower part full of the dust and debris of the destruction it has visited on everything that could not move out of its path. Tornadoes can change direction at any point, and without warning, making this type of photography a high-adrenaline experience.

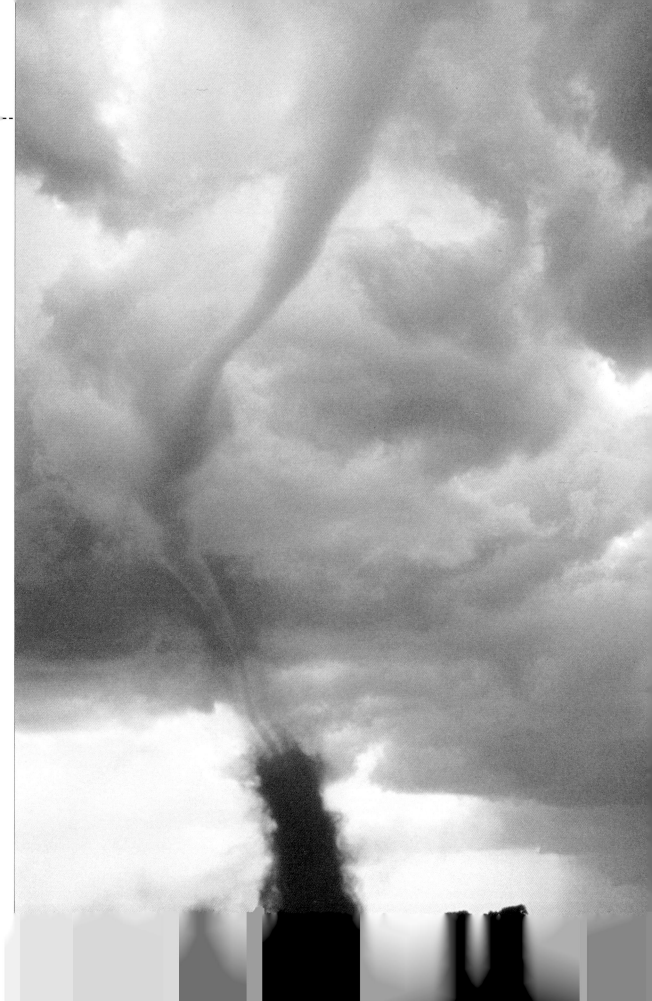

CONFRONTING THE ELEMENTS --

Action subjects abound wherever nature throws up a challenge for people to face. Seas, lakes, rivers, mountains, these are all areas where we choose either to work or play, and so they make fertile territory for the talented action photographer.

Around coastal areas as well as in high mountain regions you often see a veil of mistiness hanging in the air, even on bright and sunny days. Most often, this effect is the result of ultra-violet (UV) radiation from the sun. In photographic terms, however, this mistiness is known as "aerial perspective", since it makes scenes appear increasingly blue (if shooting in colour) or light toned (if shooting in black and white) as they grow more distant from the camera. There will be times when you want to retain, or even enhance, this trick of the light – it is, after all, very evocative and strongly implies both depth and distance. But if your requirements are for something differ-ent, try using a UV or polarizing lens filter to cut through the mist. Both of these filters can be used with colour and black and white film. Another approach is to change your shooting angle so that more distant parts of the scene are excluded.

Underwater cameras

There is a small number of "waterproof" compact cameras to choose from. All of these are resistant to seawater splashes and some can even be used just under the water's surface. But for serious pho-tography, you need a purpose-designed underwater camera housing. These have large, easy to use external controls, which can be worked when your hands are cold or in gloves, linked to the corre-sponding controls on your camera. Dedicated underwater cameras are also available, but these are very expensive to buy. Hiring is a better option if you only have occasional need.

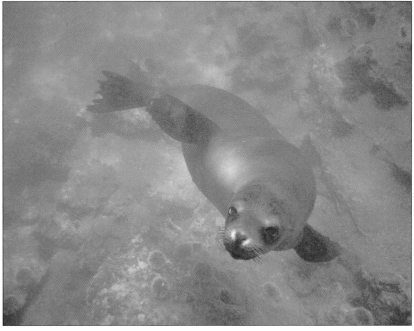

PHOTOGRAPHER:
Catherine Chalmers/Refocus

CAMERA:
**35mm
(dedicated underwater)**

LENS:
80mm

FILM SPEED:
ISO 400

EXPOSURE:
$\frac{1}{125}$ second at f4

LIGHTING:
Daylight only

▲ Except in the clear waters in and around such places as the Galapagos Islands, where this picture of a sea lion was taken, extra illumination in the form of flash is often required. Even when only a few feet down, a dramatic amount of natural sunlight is filtered out. This sea lion was about 3–4.5m (10–15ft) down, intensely curi-ous about the presence of the photographer, and ready for play. The shafts of sunlight penetrating from the surface can be readily seen.

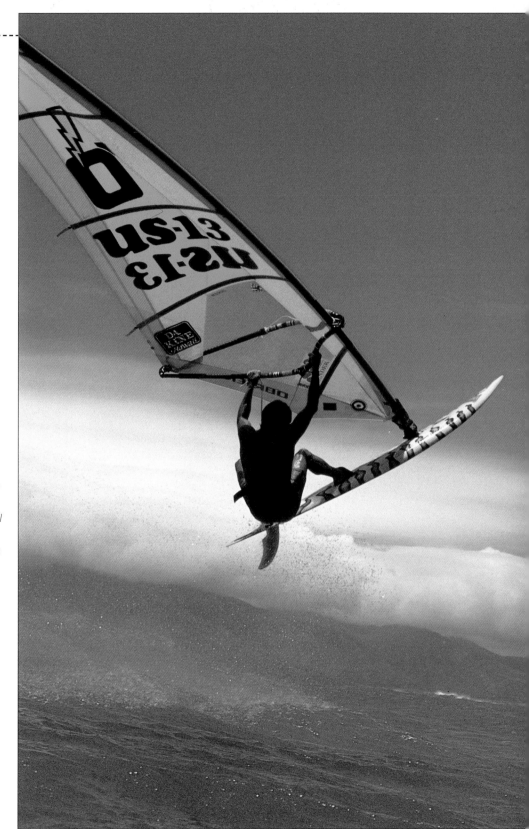

▶ If you haven't a lens long enough to record this type of windsurfing action shot from the beach, you will need to get out on the water in the most stable boat you can find. When judging exposure, make an allowance for the rocking motion caused by the sea swell and use a shutter speed of at least ¹⁄₂₅₀ second, depending on the weight of your lens and the weather conditions.

PHOTOGRAPHER:
Darrell Jones/TSM

CAMERA:
35mm

LENS:
600mm

FILM SPEED:
ISO 100

EXPOSURE:
¹⁄₅₀₀ second at f8

LIGHTING:
Daylight only

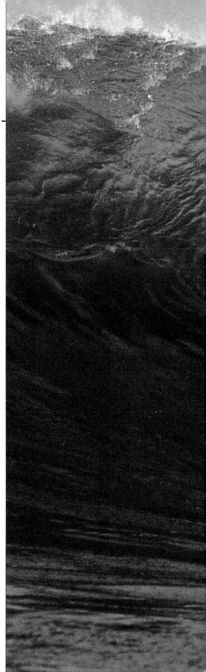

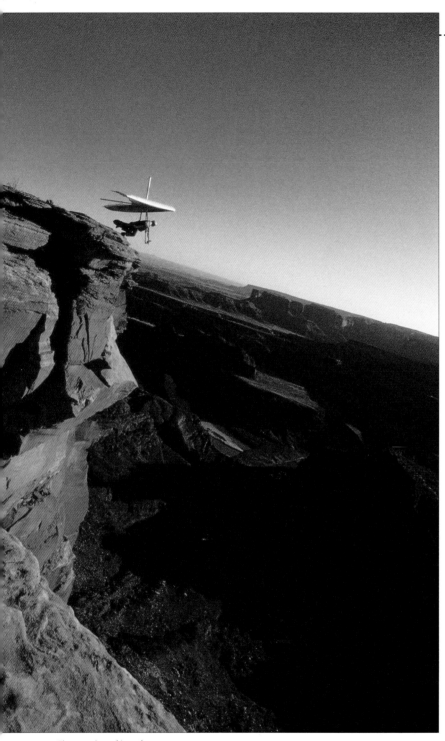

▲ The rosy glow of late afternoon sunlight bathes this weathered river valley as a hang-glider prepares to step off a cliff top to defy the forces of gravity.

PHOTOGRAPHER:
Jim Erickson/TSM

CAMERA:
35mm

LENS:
105mm

FILM SPEED:
ISO 100

EXPOSURE:
1/125 second at f11

LIGHTING:
Daylight only

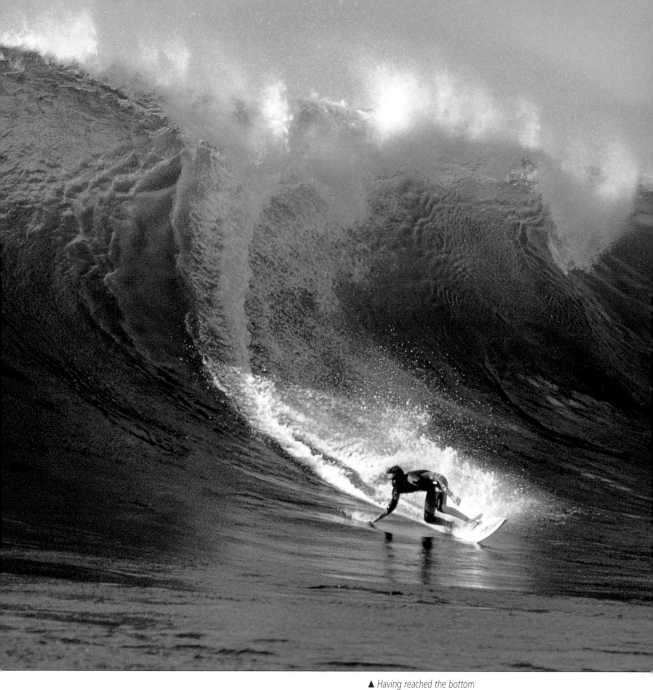

▲ Having reached the bottom of the wave, this surfboard rider now turns in an attempt to race parallel to the wave and out of danger before hundreds of tons of water smash him to the sandy seabed.

PHOTOGRAPHER:
Aaron Chang/TSM

CAMERA:
35mm

LENS:
600mm

FILM SPEED:
ISO 100

EXPOSURE:
1/1000 second at f11

LIGHTING:
Daylight only

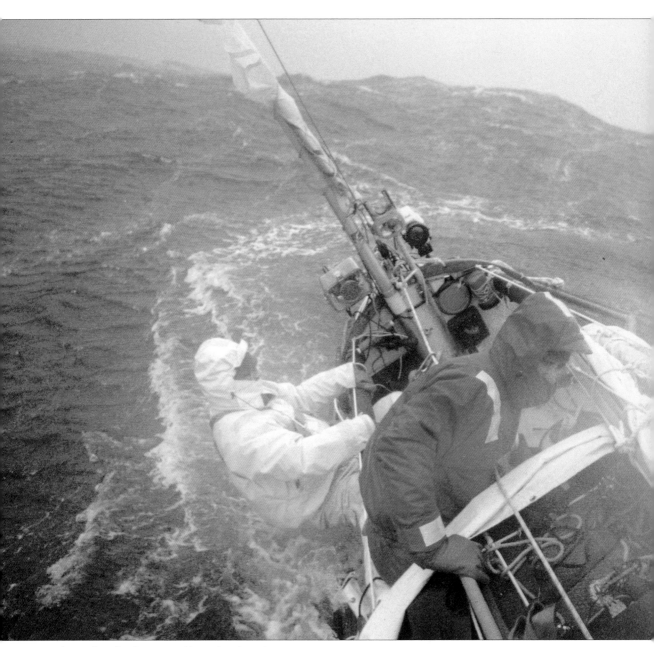

▲ *After two days of battling against heavy seas around Cape Horn, these two sailors were close to exhaustion when this photograph was taken. To take the picture, the photographer had to keep one arm wrapped around the mast at all times. Shooting in conditions such as these, when the platform you are standing on is pitching and heaving, selecting a fast shutter speed is your main priority. Using a wide-angle lens helps, since even at wide apertures you should have ample depth of field to cover focusing errors.*

PHOTOGRAPHER:
Ned Gillette/TSM

CAMERA:
35mm

LENS:
28mm

FILM SPEED:
ISO 200

EXPOSURE:
½₅₀ second at f4

LIGHTING:
Daylight only

PHOTOGRAPHER:
Jose Azel/TSM

CAMERA:
35mm

LENS:
400mm

FILM SPEED:
ISO 100

EXPOSURE:
⅟₆₀ second at f22

LIGHTING:
Daylight only

▼ *The drama and action of this photograph of a mountaineer climbing unaided up a chimney of rock has been made more apparent by pulling back and showing the grandeur of the setting and, thus, the scale of the task confronting the subject.*

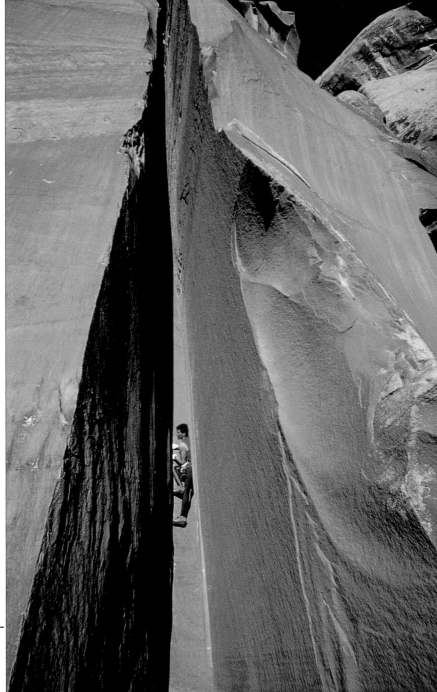

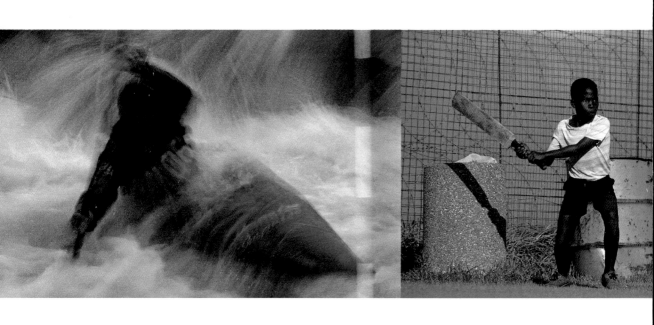

4

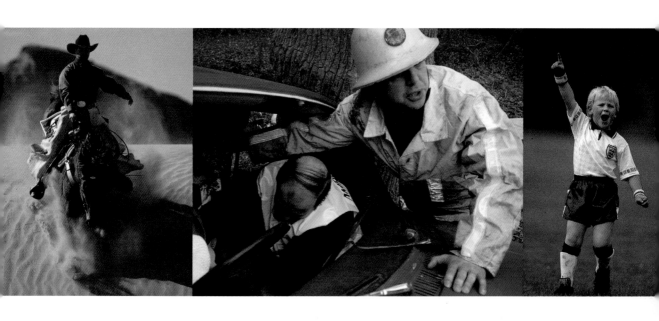

EVENTS

WITH THE FIRE-FIGHTERS

For people working in some occupations, action is a routine part of their daily lives. For fire-fighters – most of the subjects featured on these pages were, in fact, at a training school – every time the station bell rings they could find themselves confronted by a wall of flame laced with toxic fumes threatening life and property, brush fires, flooded homes, or a wasted journey in response to a false alarm.

With real-life action, such as a fire, you simply don't know when it is going to happen and you can't plan for it in advance. However, by widening your photographic range – shooting in as many different types of situation you can contrive, for example – you will start to acquire vital experience about how your camera, lenses, different types of film, effects filters, flash, and so on all work under many different circumstances. Equally important, your ability to see the photographic potential in different situations will also become sharper, and your ability to record it more polished and reflexive.

The turn-over of staff in dangerous and stressful occupations like fire-fighting is such that a steady number of new applicants and trainees need to be attracted to the job. As long as you can reassure the relevant authorities that the pictures you take will be used to show their work in a positive light, and will, therefore, be good publicity for them, you should have no bother obtaining permission to photograph, say, a training session at some mutually agreed time. If you don't ask, you will never get the chance.

At a real fire, however, a fire-fighter's priorities are very different, and your need to get the best shots of the action will rank low on the list.

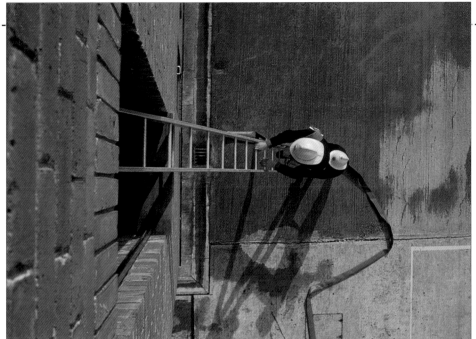

PHOTOGRAPHER:
Simon Hennessey

CAMERA:
35mm

LENS:
28mm

FILM SPEED:
ISO 200

EXPOSURE:
⅟₂₅₀ second at f8

LIGHTING:
Daylight only

◀ ▲ *Shooting down on the trainees and instructors from a high window in one of the fire training towers is a good way to show the dangerous situations the emergency services often have to confront. In the first picture (left), the photographer has used a very strong foreground element – the tops of the fire-fighters' brightly coloured helmets in a window – just beneath the camera position to make the perspective look even steeper and more perilous than it already was. Compare this with the other picture (above) taken in a similar situation, but in which the foreground element is missing, and the action and drama elements are less punchy.*

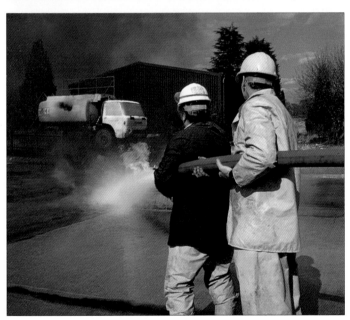

▲ *Using something within the setting, or some part of the subjects themselves, as a way of drawing the attention of the viewer into the frame has been exploited in this photograph. By positioning himself close to, and shooting almost parallel with the fire-fighters, the photographer has made* the hose a perfect lead-in line, directing you toward the action in the middle ground. Looking beyond the fire, the photographer was careful to ensure that the small road tanker could be clearly seen through the smoke, which helps to imply a hint of added danger.

PHOTOGRAPHER:
Simon Hennessey

CAMERA:
35mm

LENS:
35mm

FILM SPEED:
ISO 200

EXPOSURE:
⅟₆₀₀ second at f11

LIGHTING:
Daylight only

▼ ▶ An obvious subject to concentrate on if you are photographing at a fire training school is the drama of fire itself. Although in both of these shots the fires shown had been carefully set to minimize danger to all those present, everybody was only too well aware of the unpredictable nature of a blaze and that any mistake or error of judgement could result in serious injury.

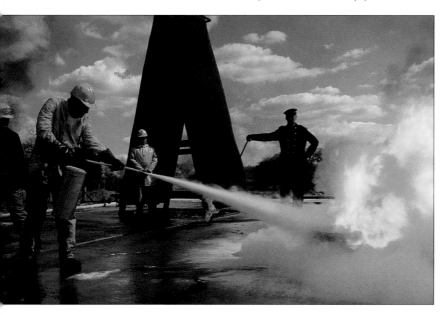

Hints and tips

● When judging the exposure for a scene that contains an area of bright fire, or any other major internal light source, you need to ensure that your meter reading is not being distorted by its presence. If you don't want to underexpose the other subject elements, exclude the light source from the frame when taking the reading, or override the reading by switching to manual mode.

● A bright light source such as a fire is ideal when you want to show your subjects as silhouettes. In this case, don't override the exposure reading.

● Many cameras have an override facility that allows you to select increments of up to 2 or 3 stops of exposure above or below that recommended by the meter.

PHOTOGRAPHER:
Simon Hennessey

CAMERA:
35mm

LENS:
28mm

FILM SPEED:
ISO 200

EXPOSURE:
¹⁄₂₅ second at f11

LIGHTING:
Daylight only

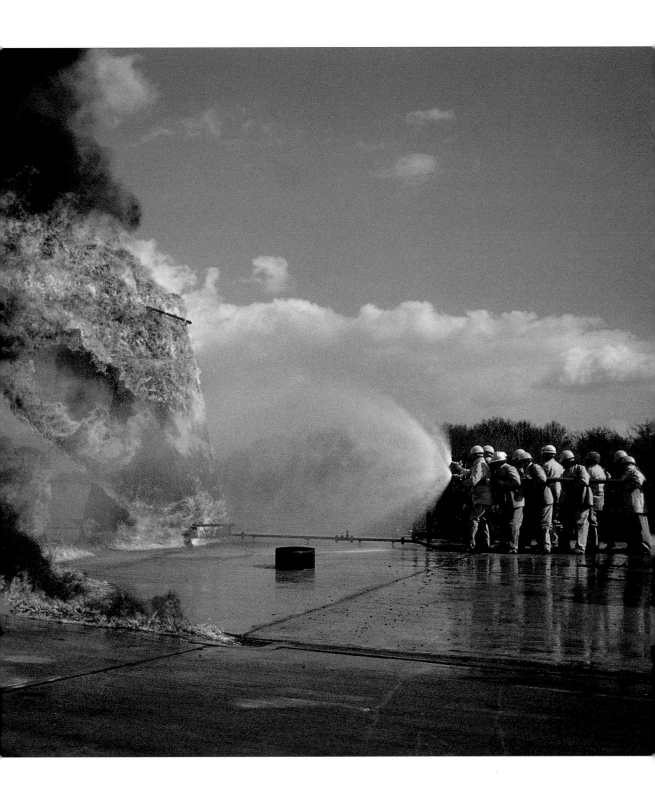

◄ ▶ *The emergency services attend scores of road traffic accidents every day. Some are minor affairs involving only damage to property; in others, however, there will be injured and trapped people to deal with as well as the risk of fires and explosions. Practising how to cope with incidents such as this, and using specialized cutting equipment, are important elements of the training fire-fighters receive. This action sequence starts with the type of shot you might want to lead on for a photostory – a police sign warning of an accident ahead. The other shots are all of the accident, showing the fire-fighters and ambulance crew at work freeing an actor, made up to look like an accident victim, from the wreckage of a car. Because this was a training exercise, the photographer could move in close and use a wide-angle lens. In a real accident, spectators would be kept back and so a telephoto lens would be more appropriate.*

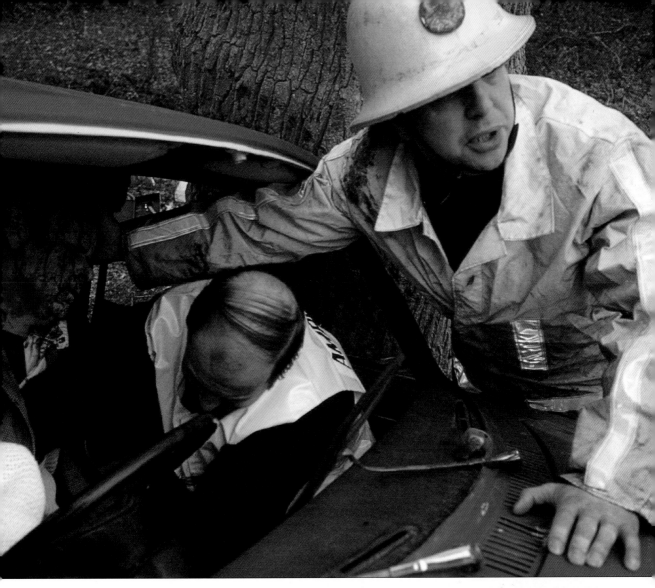

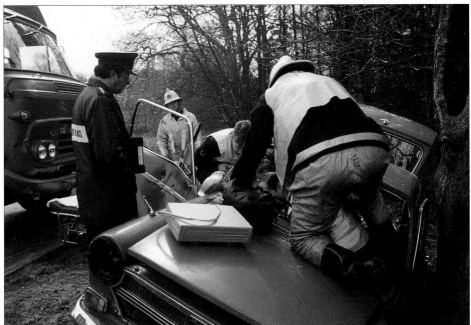

PHOTOGRAPHER:
Simon Hennessey

CAMERA:
35mm

LENSES:
28mm and 35mm

FILM SPEED:
ISO 200

EXPOSURE:
**¹⁄₂₅₀ second at between
f5.6 and f16**

LIGHTING:
Daylight only

CHILDREN'S ACTION

Most photographers interested in recording action-type subjects will not have ready access to some of the major international sporting events and fixtures that feature on many of the pages of this book. But that should not be bar to taking good, action-packed photographs!

Just as exciting and, for many, far more interesting, are pictures of their own children and others known to them participating in their own sporting events or just high-spirited play. A kick-around with a soccer ball in the local park, an informal baseball game in the country during a family picnic, or a more formally organized action event, such as the sports day at your local school, are all potentially excellent camera opportunities.

The principal advantage of photographing events such as these is that there are usually very few, if any, restrictions on the movement of spectators, which means that you can change your camera position whenever you want to. As well, you can often get as close to the action as you like, without actually interfering with the participants of course, so you don't even need a powerful telephoto lens. However, a zoom lens with at least a moderate telephoto option is worthwhile for a range of framing options.

One way of having an enjoyable day's shooting with the possibility of earning some money on top is to contact the organizer of a school sports day and offer your services as the "official" photographer. The best of the pictures you take can then be enlarged to, say, 20 x 25cm (8 x 10in) and be displayed at the school a few days later as an exhibition. Give each one a reference number and allow students, teachers, and parents to order copies of any they would like for themselves. To avoid incurring high costs for a lot of exhibition prints that may not be ordered, enlarge only the very best and show the others as twice-up contact sheets. You can donate the exhibition set to the school as an incentive for them to take up your proposal.

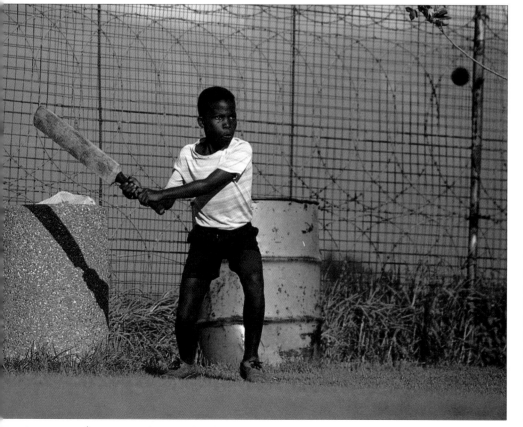

PHOTOGRAPHER:
Bob Martin

CAMERA:
35mm

LENS:
300mm

FILM SPEED:
ISO 100

EXPOSURE:
⅟₁₀₀₀ second at f4

LIGHTING:
Daylight only

◀ *This picture of a make-shift cricket match has been greatly enlivened by bold areas of bright colour – green, blue, and yellow. The photographer has recorded his subject with the bat poised in mid-air and with his eyes firmly fixed on the ball, which has been "frozen" in front of him by using a fast shutter speed.*

▶ This is a typical example of the strictly fun, novelty-type races often included along with the more serious competitions at a school sports day. Although based on the traditional egg-and-spoon race, here the eggs have been replaced by potatoes, which don't break quite as easily. Although only a fun race, this boy's rapt concentration is evident as he sees the finishing line looming up in front of him. This is the perfect type of image to enlarge as part of a school exhibition for parents to order from.

PHOTOGRAPHER:
Bob Martin

CAMERA:
35mm

LENS:
**28–70mm zoom
(set at 65mm)**

FILM SPEED:
ISO 100

EXPOSURE:
$\frac{1}{250}$ second at f4

LIGHTING:
Daylight only

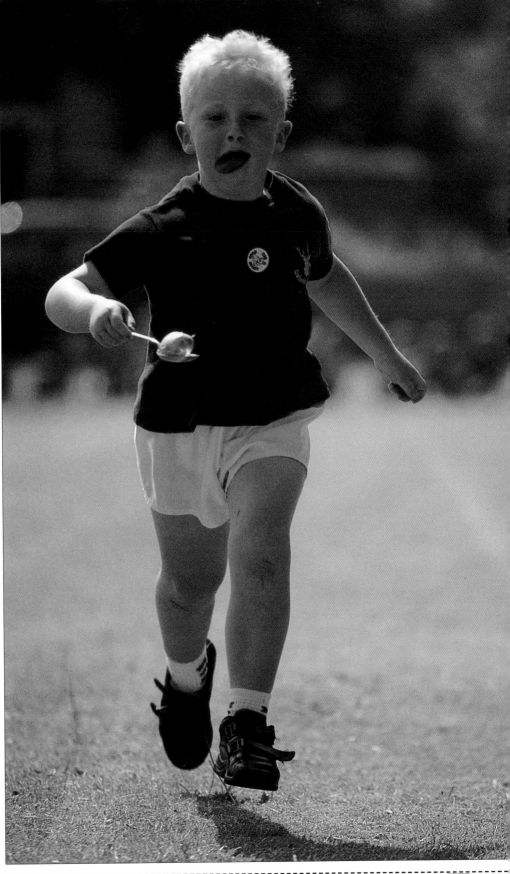

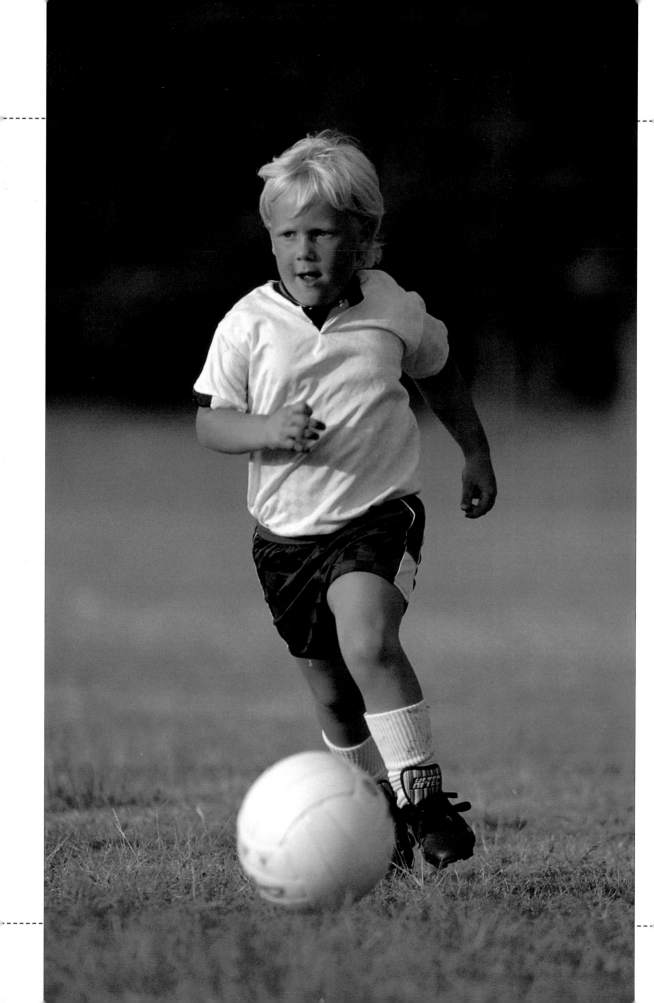

PHOTOGRAPHER:
Bob Martin

CAMERA:
35mm

LENS:
**28–70mm zoom
(set at 70mm)**

FILM SPEED:
ISO 100

EXPOSURE:
⅟₅₀₀ second at f4

LIGHTING:
Daylight only

◀ *This young striker fills nearly all of the frame, yet he was photographed using only a moderate telephoto lens. Shot during an inter-schools soccer match, the photographer was able to walk the length of the pitch right along the sidelines, which made a more powerful lens unnecessary.*

Zoom lenses

Many makers of point-and-shoot compact cameras include models with zoom lenses, often in the range of 35–70mm, although some of the more expensive types have zoom lenses up to 120mm or even 130mm. Even a modest zoom-lens compact gives you a great degree of flexibility when it comes to both camera position and framing. However, for SLR camera owners, the choice of zoom lenses is far more extensive. The two most popular focal lengths are 28–70mm and 70–210mm. The wide-angle 28mm setting is ideal for both close-up shots (although you may see some distortion near the frame edges with some cheaper types), while the 210mm telephoto setting will allow you to fill the frame with just one or two competitors, if you can get reasonably close to the action. More powerful focal length options are also available, such as 300–500mm zooms, although these can be heavy and cumbersome to use, especially when you need to be working quickly, picking off action shots.

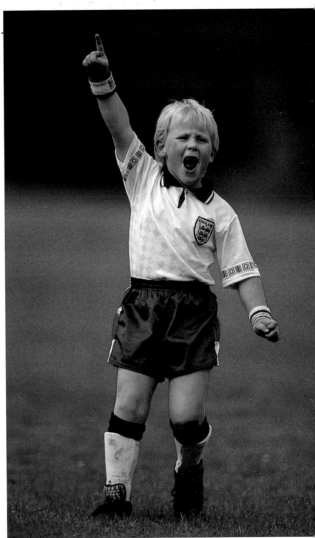

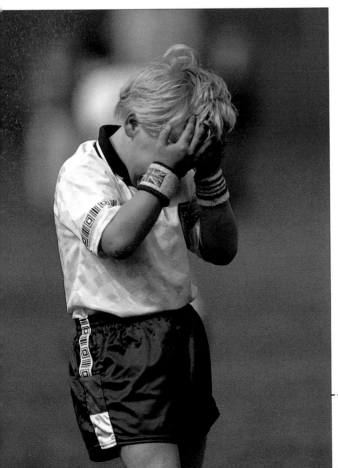

◀▲ *The agony and the ecstasy can be plainly seen in these two photographs taken of another of the rising soccer stars playing in an inter-schools competition. In one shot, he triumphantly punches the air as his pass is hammered into the back of the net by one of his team-mates. In the other, however, his whole posture tells of the bitter disappointment he is feeling as a golden chance to score goes awry.*

PHOTOGRAPHER:
Bob Martin

CAMERA:
35mm

LENS:
300mm

FILM SPEED:
ISO 100

EXPOSURE:
⅟₅₀₀ second at f5.6

LIGHTING:
Daylight only

AT THE CIRCUS

The colour, costumes, and spectacle all come together to make the circus an exciting event for photographic coverage. As well as making a useful addition to a personal portfolio of pictures, there is also the possibility of earning some money – there is a slow but steady requirement for good circus images and a picture library may be interested in keeping your work on file. Alternatively, the circus itself may want to use some of your shots for publicity purposes.

Check beforehand that photography is allowed during the performance.

Most circus owners don't object, although there may be a prohibition on using flash – especially during the more dangerous routines, such as the trapeze or high wire, when the performers cannot afford to be distracted by flashguns firing at random from down below.

Even if you attend a daytime performance, once under the canvas of the big top, natural light levels will be low. If flash photography is allowed, then low light will not be a problem for any action that occurs close to the spectators' stands, but an average

accessory flashgun or built-in flash unit will not be adequate for anything at any distance from the camera. This leaves you dependent on the theatrical/stage type of lighting employed by the circus. In many instances, this type of lighting will be brightly coloured – not at all natural in its colour content. Rather than trying to correct colour content by using film balanced for tungsten or colour-correcting filters with daylight-balanced film, allow the colours to distort as they will, since it will, more often than not, simply add to the excitement and action depicted.

 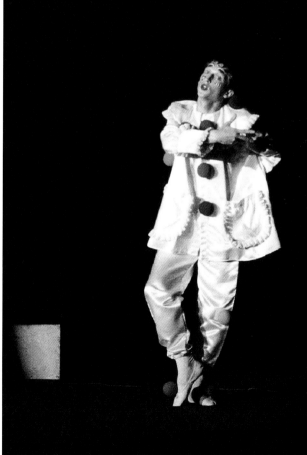

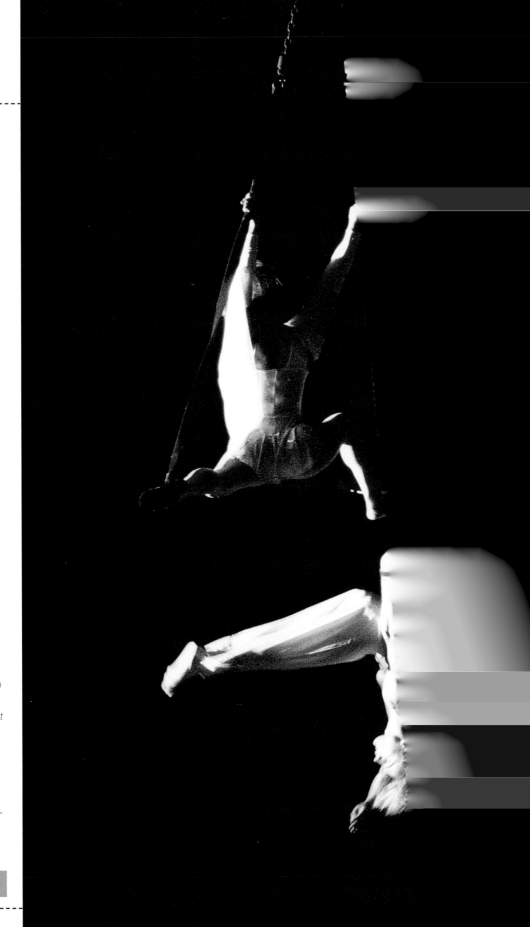

◀ ▶ *Circus lighting can be used to create the maximum dramatic impact – spotlights producing intensely bright highlights, for example, to show the performers isolated in an otherwise totally dark space. The darkness is often a cover for the stage hands to prepare the arena for the next act without distracting the audience. Pictures by Simon Hennessey, using a 35mm camera, 90mm lens, and ISO 1600 film. Exposure settings varied between ⅟₆₀ and ½₅₀ second and apertures between about f4 and f8.*

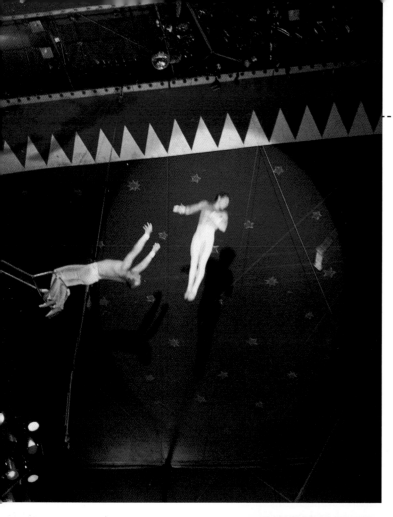

◀ ▼ ▶ *High up in the roof of the big top, the trapeze is probably the most exciting and dangerous of all the circus events. In order to record a decent-sized subject you should be using a lens of at least 250mm (on a 35mm camera). A lens of this focal length is heavy, however, and should be mounted on some sort of camera support when shutter speeds slower than $\frac{1}{125}$ or $\frac{1}{250}$ second are set in order to prevent camera shake. The high-powered spotlight used to light these performers not only cast a dramatic shadow up on to the roof of the tent, it also allowed reasonably fast shutter speeds. All pictures by Simon Hennessey, using a 35mm camera and 300mm lens. The camera was loaded with ISO 1600 film and shutter speeds varied between $\frac{1}{60}$ and $\frac{1}{125}$ second with the lens set at its maximum aperture of f5.6.*

Hints and tips

● Even with a fast lens and the camera loaded with fast film, you may still need to use shutter speeds that are too slow for movement-free, hand-held exposures. In these situations, you can use a mono-pod. Although not as stable as a tripod, a monopod will still help to stabilize the camera and help to reduce the worst effects of camera shake.

● Whenever possible, try to compose your shots so that any bright light sources cannot be seen in the frame. Including the light source often distracts attention from the main subject and may also distort exposure readings, leading to underexposure. Sometimes this will not be possible, however, especially if you cannot move around and you are con-fined to a single shooting position.

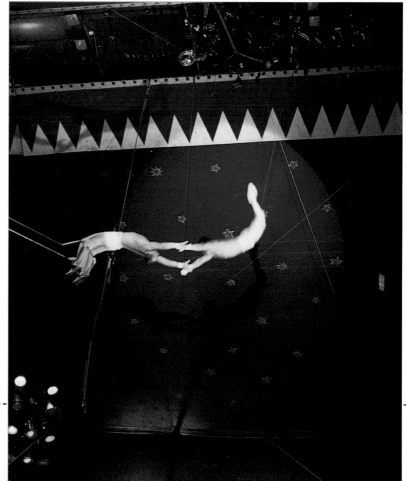

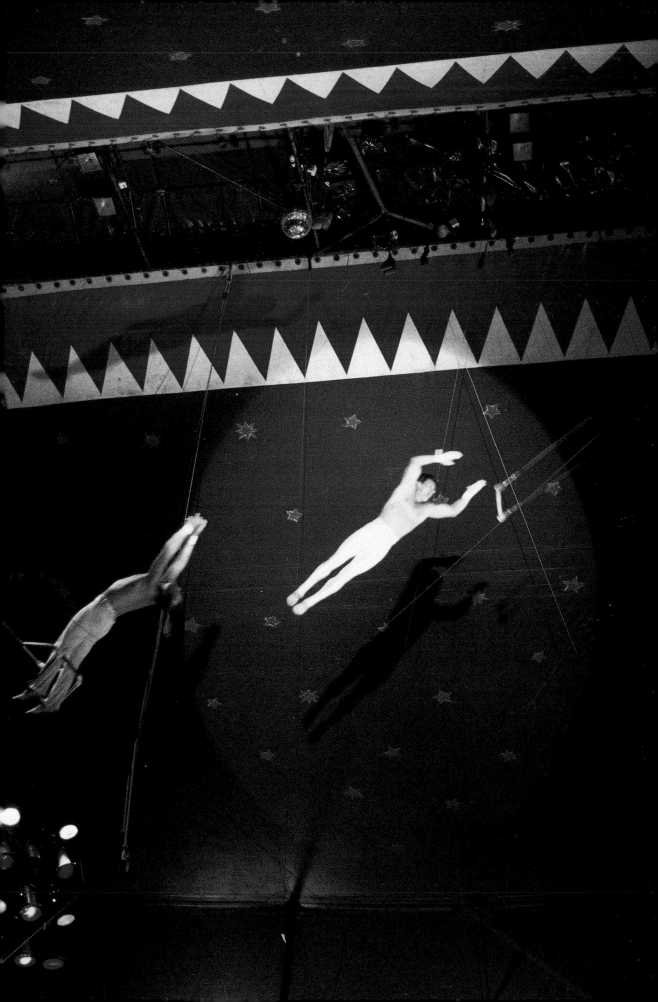

Lenses and film

As in all low-light situations, your choice of lens and film is critical. Lenses with wide maximum apertures – "fast" lenses – will not only give you a brighter viewfinder image (when using a reflex camera), which makes focusing easier and more accurate, they will also allow you to record correctly exposed images while using faster shutter speeds than would be possible with a slower lens.

When it comes to selecting film, you have a huge choice of types and speeds available. If you tell the film processor in advance, then negative film can be pushed during processing to compensate for a stop or two of underexposure – more so than is possible with slide film – but it is usually better to use a faster film. Ideally, you should have two camera bodies. One can be loaded with a relatively slow film, such as ISO 200, for use with flash for close-up action; the other can be loaded with, say, ISO 1600 film for when you have to rely solely on the stage lighting provided.

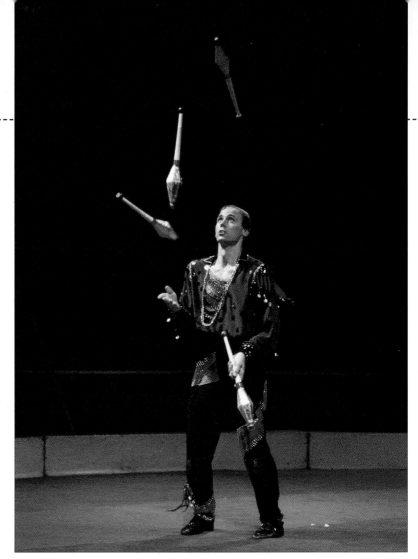

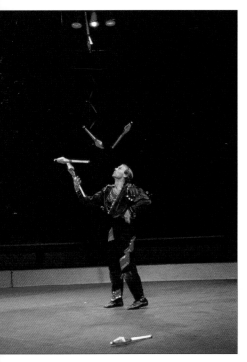

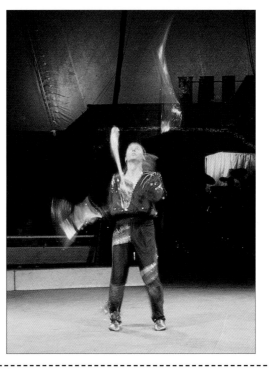

◀ ▲ ▶ *It is not always necessary to use shutter speeds that will "freeze" the action. Sometimes a blurred image helps to convey mood and atmosphere. This set of pictures of a circus juggler makes the point very well. Although the skill of the performer can best be seen when a fast shutter speed has been used, and everything in the frame is sharp, it is the shots where a slow shutter speed has been used that have most aesthetic appeal. All pictures by Simon Hennessey, using a 35mm camera, 50mm lens, and ISO 200 film. The shutter speeds used varied between $\frac{1}{15}$ and $\frac{1}{125}$ second and apertures between f1.4 and f4.*

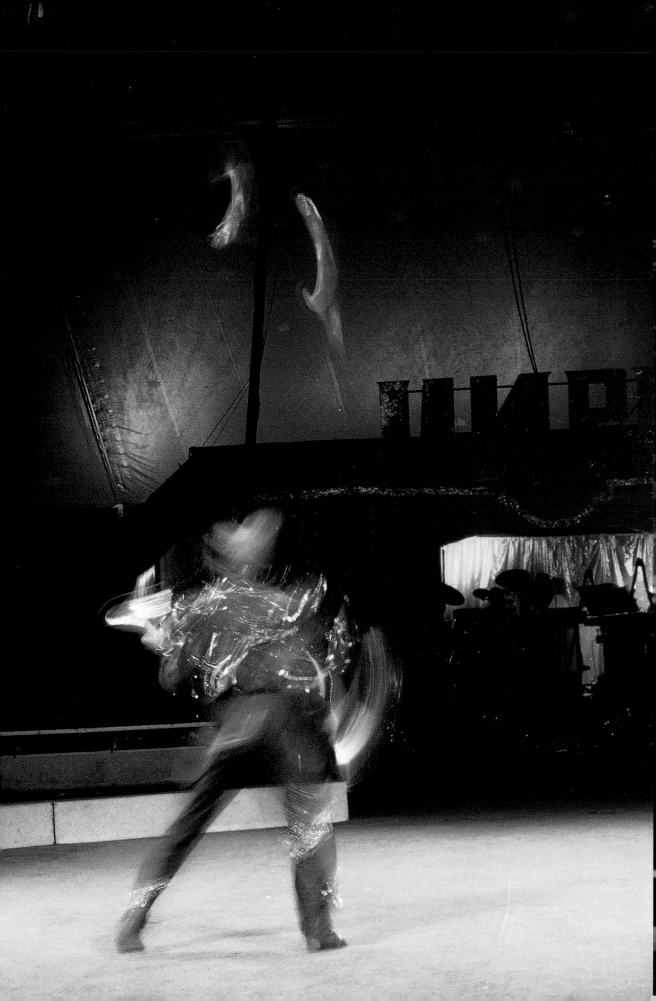

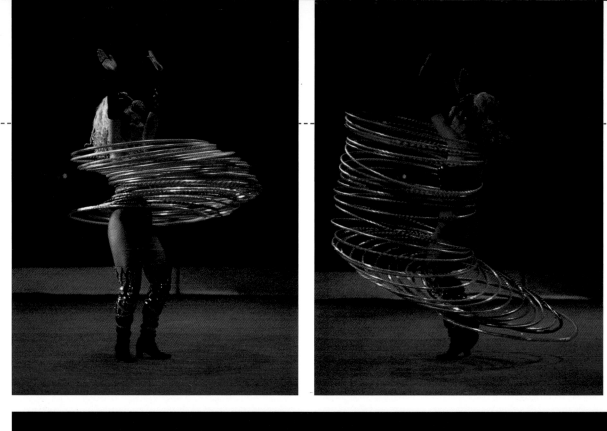
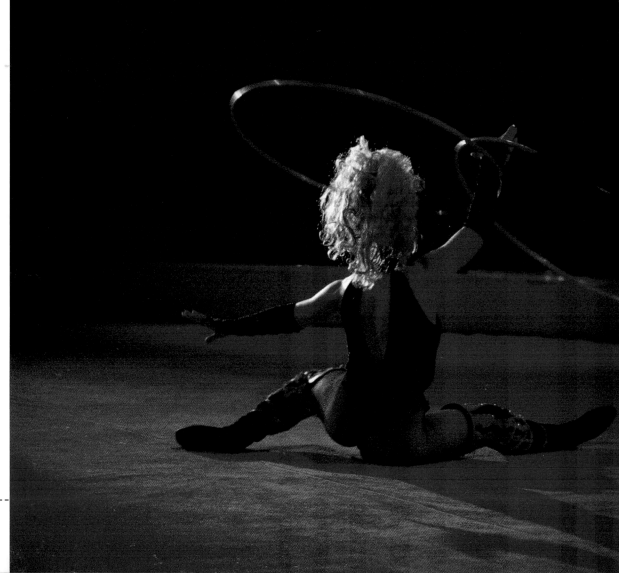

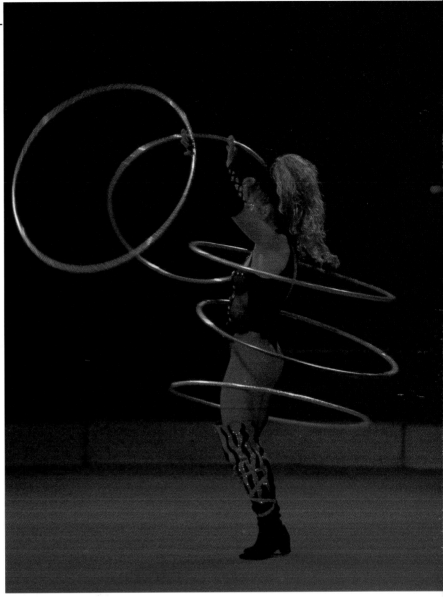

◀ ▲ When the action is at ground level, a powerful telephoto may not be necessary, but you will still probably need to use a moderately long lens – something in the 90 to 135mm range – or the subject may be too small in the frame. The subject of this set of photographs was close enough for flash to have made a difference to exposure, but the photographer decided to forego the extra illumination in favour of retaining the atmosphere created by the coloured stage lighting. All pictures by Simon Hennessey, using a 35mm camera, 90mm lens, and ISO 200 film. The shutter speed used was ¹⁄₂₅ second with an aperture of f2.8.

WESTERN REVIVAL

A love of the wide open spaces coupled with the romantic image of the Western pioneers and the role of the horse in the development of the great prairie lands of the United States have all come together in the collective consciousness to ensure the continuation of the cowboy tradition. And this tradition is not confined just to its native US – Germany, Britain, Scandinavia, Australia, and many other countries all have their dedicated contingents of weekend "ranch hands" and "cowpokes" – even if all they have seen of the "real thing" comes courtesy of Hollywood.

As photographic subjects, the costume, the characters, the countryside, and all the paraphernalia that is part of working with horses are very rewarding. And the Western tradition has insinuated itself into so many different aspects of our lives – leisure activities, hunting, tourism, clothing, footwear, food, and toiletries – that there is a ready market for good photographic material.

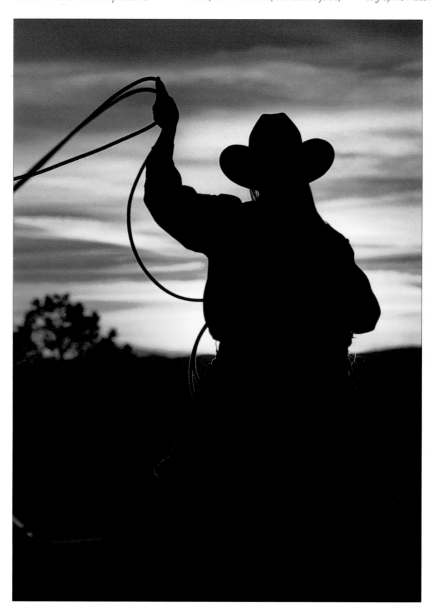

PHOTOGRAPHER:
Chris Marona/Refocus

CAMERA:
35mm

LENS:
135mm

FILM SPEED:
ISO 200

EXPOSURE:
$\frac{1}{125}$ second at f11

LIGHTING:
Daylight only

◀ *In this picture, the photographer has effectively exploited that old cliché about cowboys and sunsets by creating a graphically stark, silhouetted image. The lasso frozen above the subject's head, and the loops of rope outlining the figure's shape, are vital to the success of the composition, helping to lift the picture out of the page.*

Taking a silhouette

A successful silhouette depends on the figure being positioned between the light source and the camera so that the lens is flooded with direct illumination. Effectively, this means that the side of the subject facing the lens will be in shadow. If you want the subject to appear completely dark – lacking all surface detail – then you need to fully exploit the difference in exposure between the light source and the figure. To do this, take your light reading directly from the brightest area of sky. If you are using an automatic camera, you will have to lock this reading in before recomposing your shot with the subject more centrally framed. In the silhouetted picture on the left, a light reading taken from the brightest part of the sky gave $\frac{1}{125}$ second at f11, which was the exposure used; however, a light reading taken exclusively from the shadowy figure gave $\frac{1}{30}$ second at f4 – a massive exposure difference of 5 stops in total.

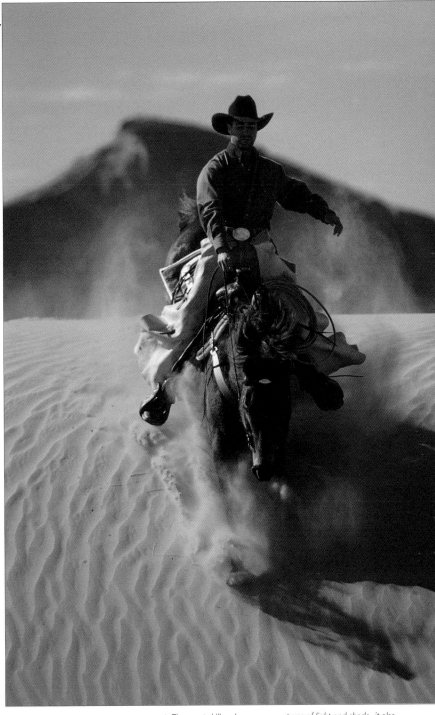

PHOTOGRAPHER:
Chris Marona/Refocus

CAMERA:
35mm

LENS:
70mm

FILM SPEED:
ISO 200

EXPOSURE:
$\frac{1}{500}$ second at f4

LIGHTING:
Daylight only

▲ The great skill and concentration required by both horse and rider are evident in this photograph as they slide down the shifting surface of a sand dune. Gentle backlighting not only creates interesting patterns of light and shade, it also helps to highlight the wind-drawn ridges on the surface of the sand itself. It is the care taken in recording detail such as this that adds depth and character to your work.

PHOTOGRAPHER:

Chris Marona/Refocus

CAMERA:

35mm

LENS:

180mm

FILM SPEED:

ISO 200

EXPOSURE:

¹⁄₁₂₅ second at f8

LIGHTING:

Daylight only

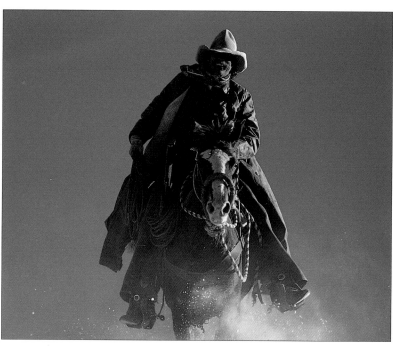

PHOTOGRAPHER:

Chris Marona/Refocus

CAMERA:

35mm

LENS:

250mm

FILM SPEED:

ISO 200

EXPOSURE:

¹⁄₂₅₀ second at f8

LIGHTING:

Daylight only

▲ *Taken with a long lens, the action in this photograph is implied by the sand, which can be seen at the bottom of the frame as it is kicked up by the horse's hooves at full gallop. The excitement and exhilaration of the ride are evident on the cowboy's face, which is thrown into sharp relief by the harsh and intense afternoon sunlight, while the backdrop of sky, deep blue and cloudless, makes an attractive frame without distracting attention away from the subject.*

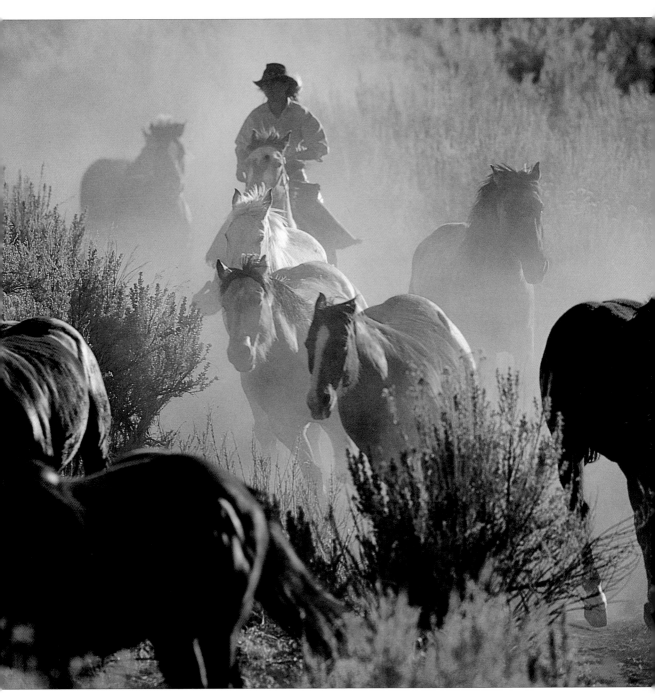

▲ The real West is alive and well. In a scene that would have been familiar a hundred years ago or more, wild horses are seen here being herded toward holding pens before being broken in as saddle mounts. Dust is a serious problem in these types of conditions. Using a long lens will keep you well back from the worst of the dust without the subjects then appearing too small in the frame, but it is still a good idea to keep your camera locked safely out of harm's way in its ever-ready case whenever it is not in use.

▼ *An altogether softer, more romantic mood is evident in this photograph. Featuring a female subject and introducing a new element – waves gently frothing against the sand – both emphasize the leisure aspects of horse riding, rather than concentrating on its working role.*

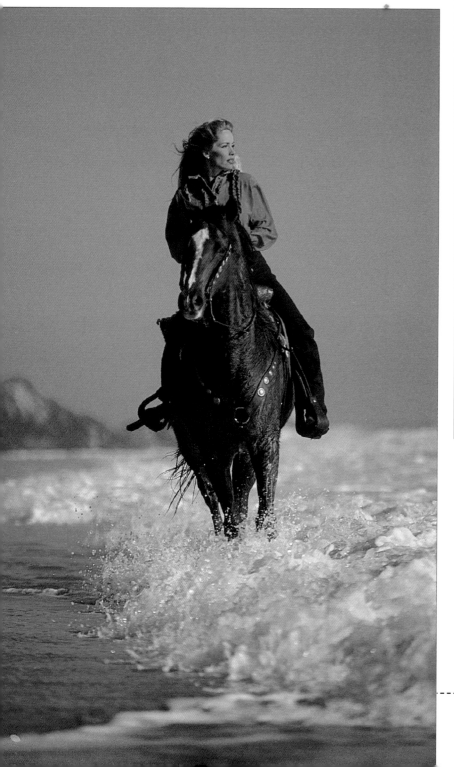

PHOTOGRAPHER:
Chris Marona/Refocus

CAMERA:
35mm

LENS:
135mm

FILM SPEED:
ISO 200

EXPOSURE:
¹⁄₁₂₅ second at f5.6

LIGHTING:
Daylight only

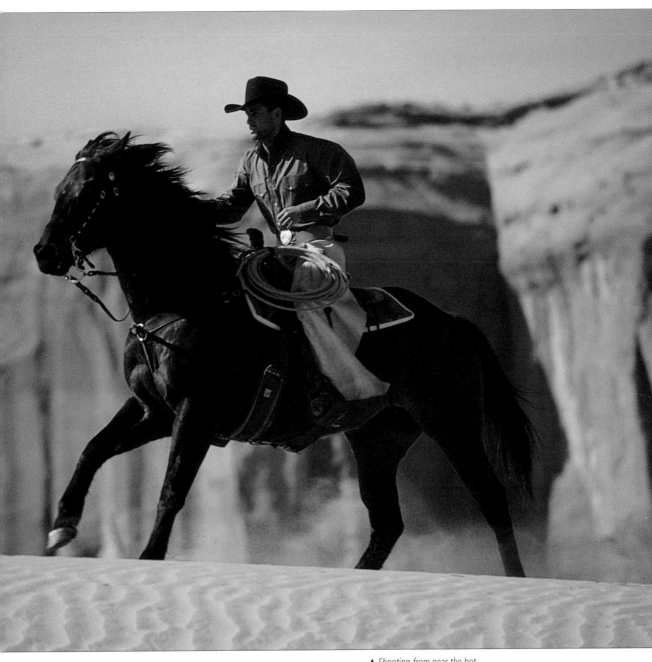

▲ *Shooting from near the bottom of a sand dune shows the horse and rider against a backdrop of cliffs and blue sky. A large aperture on a moderate telephoto lens has reduced depth of field to the point where only the subjects are in critically sharp focus.*

PHOTOGRAPHER:
Chris Marona/Refocus

CAMERA:
35mm

LENS:
105mm

FILM SPEED:
ISO 200

EXPOSURE:
1/500 second at f4

LIGHTING:
Daylight only

WHITE WATER ACTION

It cannot be said too many times: successful action photography relies on the photographer knowing at least something about the event being covered, anticipating where the action will develop so as to be in the right place at the right time, and, finally, being fully familiar with the camera, lens, and any accessories so that not a second is lost.

Even a simple thing – such as knowing whether to turn the lens focus ring clockwise or anticlockwise to keep an erratically moving subject sharply framed while you wait for the right moment to snap the picture – may mean that you have dozens of

good shots to select from at the end of the day, rather than just a few lucky well-focused examples.

When photographing an action-filled event such as white water canoeing, as on these pages and the ones that follow, the movement of the subjects is so fast and their precise position in the frame so variable, it helps to have a few camera automatics at your disposal. Through-the-lens (TTL) metering, for example, frees you from worrying about getting the exposure right (at least, a lot of the time), while autowinders (now commonly built into SLRs and many compacts) and motor drives (only available as add-ons for

SLRs and larger formats) ensure that there is always a fresh frame of film wound on and waiting – and you don't have to take your eyes away from the viewfinder to manually operate the film-advance lever.

In the context of an action activity such as white water canoeing, however, autofocus is of less certain benefit. Although becoming faster, more responsive, and more accurate, autofocus systems still generally have some shortcomings – especially when the subject you want to focus on is not necessarily positioned in centre frame, or some other designated target zone in the viewfinder.

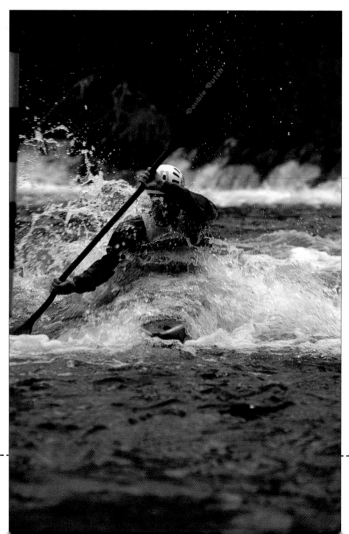

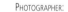

PHOTOGRAPHER:
Gary Foxton/Refocus

CAMERA:
35mm

LENS:
80–210mm (set at 210mm)

FILM SPEED:
ISO 200

EXPOSURE:
⅟₁₀₀₀ second at f8

LIGHTING:
Daylight only

◀ *Movement directly toward the camera is easier to halt than when the subject is moving more at an angle to the camera position. Here, the photographer selected ⅟₁₀₀₀ second to stop most subject movement. However, this same shutter speed would not always create the same effect, since there are many other factors involved.*

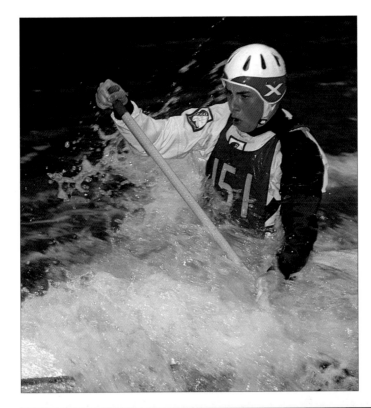

PHOTOGRAPHER:
Gary Foxton/Refocus

CAMERA:
35mm

LENS:
85mm

FILM SPEED:
ISO 200

EXPOSURE:
⅟₆₀ second at f4

LIGHTING:
Daylight and flash

◀ ▼ *When light levels are low, or lighting contrast is flat, and the subject is close to your camera position, you have the option of boosting the available light with flash. Accessory flashguns are designed to be used principally indoors, where you usually have many surfaces to reflect and contain the light. Outdoors, however, the effective range of the flash is much reduced. As well, the flash synchronization speed on some cameras is quite slow (⅟₆₀ or ⅟₁₂₅ second), which may not be fast enough for the effect you want to achieve. But for both of these pictures, the photographer timed his shots so that the canoes were relatively stationary and so he was able to shoot at quite slow shutter-synchronization speeds.*

PHOTOGRAPHER:
Gary Foxton/Refocus

CAMERA:
35mm

LENS:
200mm

FILM SPEED:
ISO 200

EXPOSURE:
⅟₃₀ second at f22

LIGHTING:
Daylight and flash

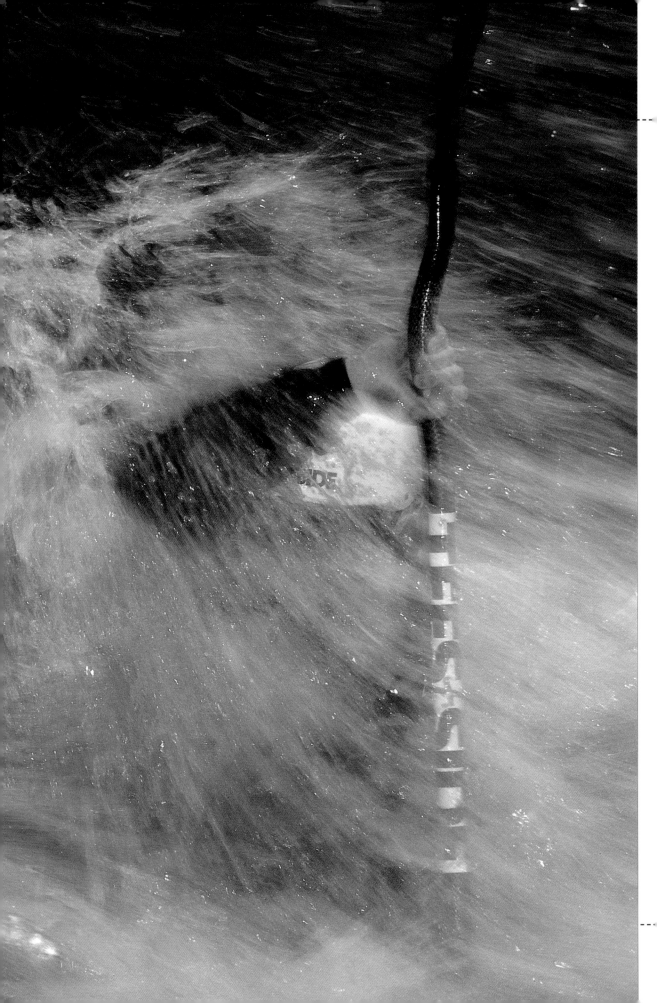

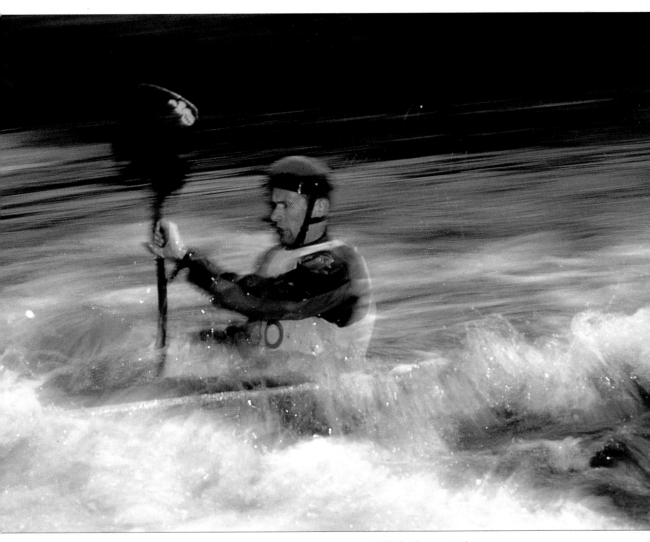

◄ The power, and the danger, of this sporting activity has been graphically recorded in this shot. The canoeist is seen battling against the waves and cross-currents and is all but submerged by the sheer ferocity of the river. Flash combined with a very slow shutter speed have created an image with an intriguing mixture of sharp and unsharp detail.

PHOTOGRAPHER:
Gary Foxton/Refocus

CAMERA:
35mm

LENS:
85mm

FILM SPEED:
ISO 200

EXPOSURE:
⅛s second at f16

LIGHTING:
Daylight and flash

▲ Moving the camera to keep the subject in the frame is a natural reflex for action photographers. If you then shoot while the camera is following through like this you will keep the subject sharp (or relatively so, depending on shutter speed, the direction and speed of the subject, and the lens focal length) while reducing everything else to more of a blur. Moving the camera while exposing the film like this is known as "panning".

PHOTOGRAPHER:
Gary Foxton/Refocus

CAMERA:
35mm

LENS:
105mm

FILM SPEED:
ISO 200

EXPOSURE:
⅛0 second at f8

LIGHTING:
Daylight and flash

▶ *Had the photographer selected the fastest shutter speed he had available on his camera – ¹⁄₄₀₀₀ second – he probably could have stopped the movement of the canoeist and the thundering river practically dead in their tracks. It is arguable, however, whether that interpretation would have communicated the atmosphere of the event any better than this superb image, which was taken with a shutter speed many stops slower.*

PHOTOGRAPHER:
Gary Foxton/Refocus

CAMERA:
35mm

LENS:
85mm

FILM SPEED:
ISO 200

EXPOSURE:
⅕ second at f5.6

LIGHTING:
Daylight only

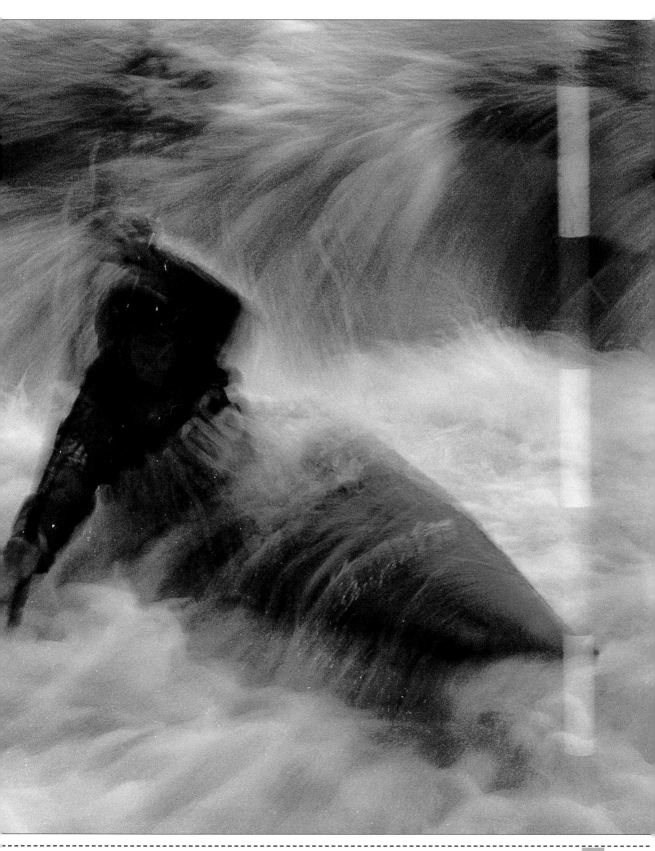

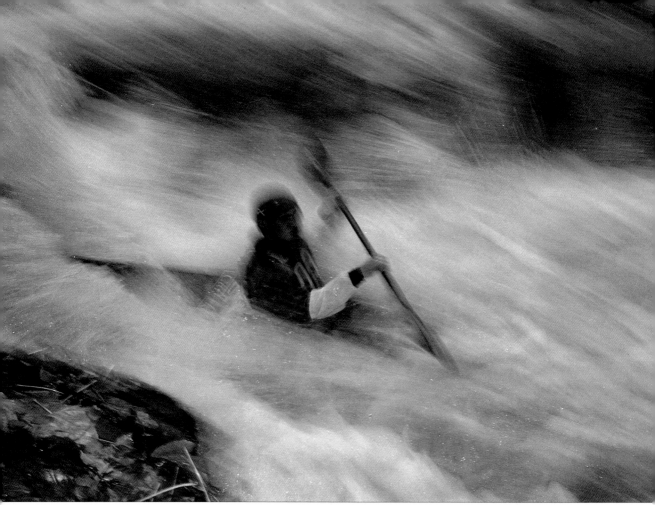

Exposure programs

For very fast-moving events, your main technical consideration (apart from the overall exposure) is often to ensure that the subject is recorded with the right degree of sharpness. In other words, you need to select the best shutter speed to show the subject frozen and sharply detailed or more blurred and streaky. Better-quality automatic cameras will give you the option of switching between different exposure programs, such as aperture priority or shutter priority. With these, you manually set either the aperture (and the system compensates by selecting the best shutter speed for correct exposure), or the shutter (again, the system then compensates, this time selecting the best aperture for correct exposure). Shutter-priority programs are not as commonly available as aperture-priority ones, however, so check carefully before choosing a camera that it has the right features for the type of work you will want to do.

PHOTOGRAPHER:
Gary Foxton/Refocus

CAMERA:
35mm

LENS:
135mm

FILM SPEED:
ISO 200

EXPOSURE:
⅟₆₀ second at f11

LIGHTING:
Daylight and flash

▲ ▶ *These images demonstrate just how important it is to find the best possible shooting positions to record the action. Although the movements of the different canoeists are extremely erratic, being pushed and pulled wherever the water takes them, they all must follow a predetermined route through the series of rapids that make up the course. You should be able to select, with a good degree of certainty, a few different camera positions that will bring the competitors well within the range of whatever lens you are using.*

PHOTOGRAPHER:
Gary Foxton/Refocus

CAMERA:
35mm

LENS:
85mm

FILM SPEED:
ISO 200

EXPOSURE:
⅟₁₅ second at f4

LIGHTING:
Daylight and flash

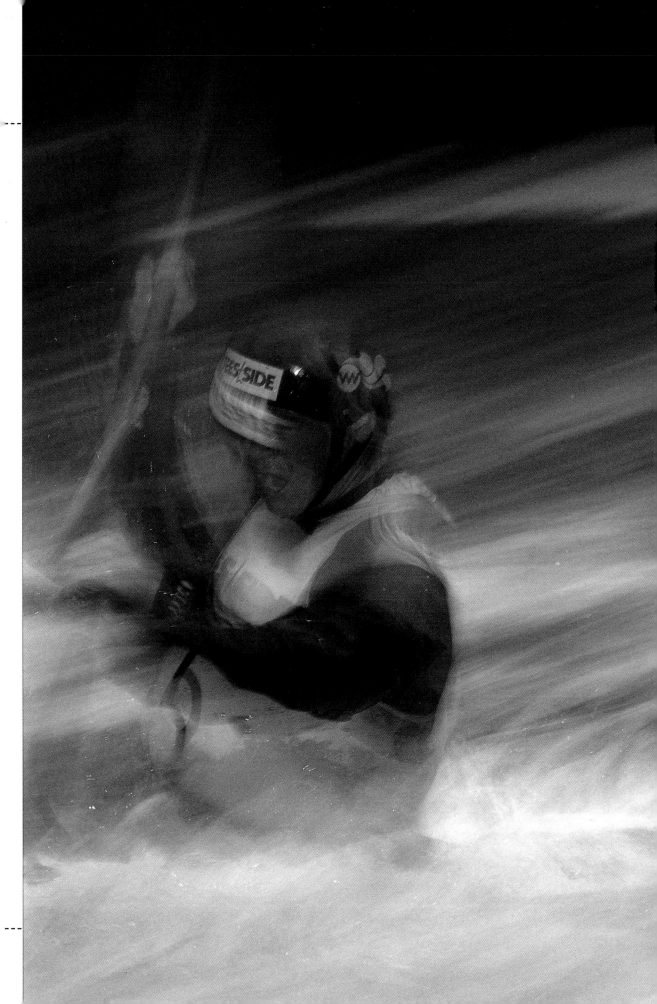

5

SPECIAL TECHNIQUES

A DAY AT THE RACES

F or action shots taken at the race-
track to work effectively, you have
to get as close to the action as you
possibly can in order to see and record
the subjects in full detail. In this type of
situation, it helps to know how the
event is likely to develop so that you
can be in position with your camera
ready before the horses arrive.

At the flat races, for example, a
camera position adjacent to one of the
bends may be best, since this is where
you see the horses and their jockeys
leaning over dramatically as they round
the circuit at speed. A bend near the
start of the race is worth investigating
because it is here that the horses are
likely to be bunched up – later on in
the race, the few fastest horses may be
lengths ahead of the field.

For safety reasons, all racetracks
have restrictions on how close
spectators, including accredited pho-
tographers, can get to the horses
during a race. As a result, particularly
dramatic shots taken from almost
under the horses' hooves are not
normally possible because of the dan-
ger this would pose not only to the
photographer, but also to the horses
and their riders. One way around this
restriction is, with the racetrack orga-
nizers' permission, to set up a
remote-controlled camera, set to
automatic exposure and prefocused
on a spot where you know the subjects
will be. Then, from a safe distance
away, all you need do is transmit the
signal that will trip the shutter at the
appropriate moment.

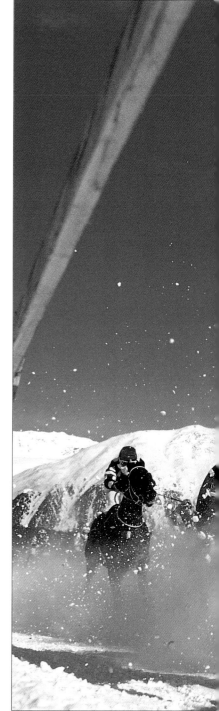

PHOTOGRAPHER:
Bob Martin

CAMERA:
35mm (remote-controlled)

LENS:
35mm

FILM SPEED:
ISO 50

EXPOSURE:
½₀₀₀ second at f2.8

LIGHTING:
Daylight only

▶ *In order to achieve this shot,
the photographer set up a
remote-controlled 35mm cam-
era adjacent to one of the
early turns. The track, in fact,
is on a frozen lake at St
Moritz, Switzerland. With the
camera in position, he was
able to back away to a safe
distance from the track side
and wait for the horses to
reach just the right spot before
sending the signal that trig-
gered the shutter.*

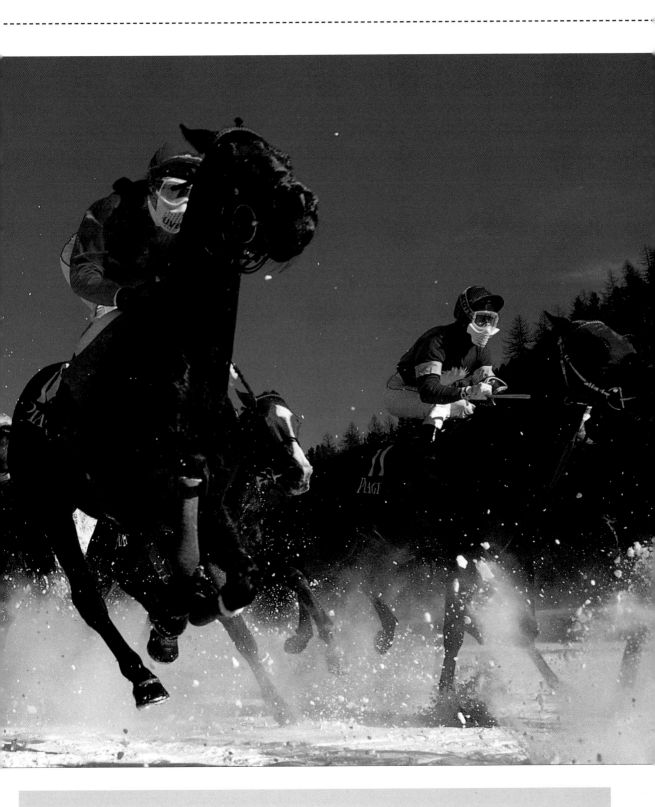

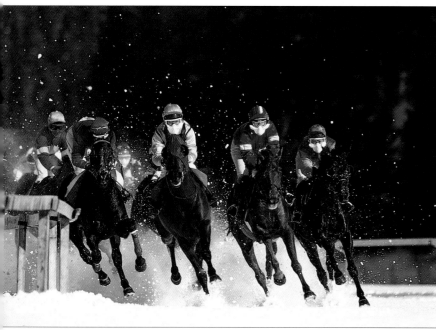

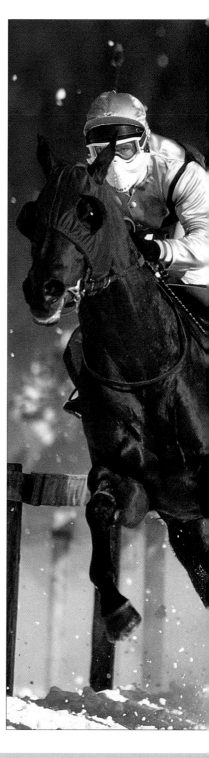

▲ ▶ *Using two cameras to cover the action is one way of doubling your chances of coming away with a winning shot. One of these shots (above) was taken with a hand-held camera; the other (right) with a remote-controlled camera not far from the photographer's original position.*

Hints and tips

● When using a remote-controlled camera, a model with a motor drive or film advance feature will wind the film on automatically after each frame is taken without you having to approach the camera position.

● Autofocus cameras can sometimes lock on to a background or foreground feature, instead of the subject you intended. When using a remote-controlled camera, manually setting the focus control is often a better option.

● A sheet of clean, high-quality optical glass in front of a remote-controlled camera will help to protect it from dirt splatters or accidental damage .

PHOTOGRAPHER:
Bob Martin

CAMERA:
35mm (manual) and 35mm (remote-controlled)

LENS:
600mm and 400mm

FILM SPEED:
ISO 50

EXPOSURE:
1/1000 second at f4.5

LIGHTING:
Daylight only

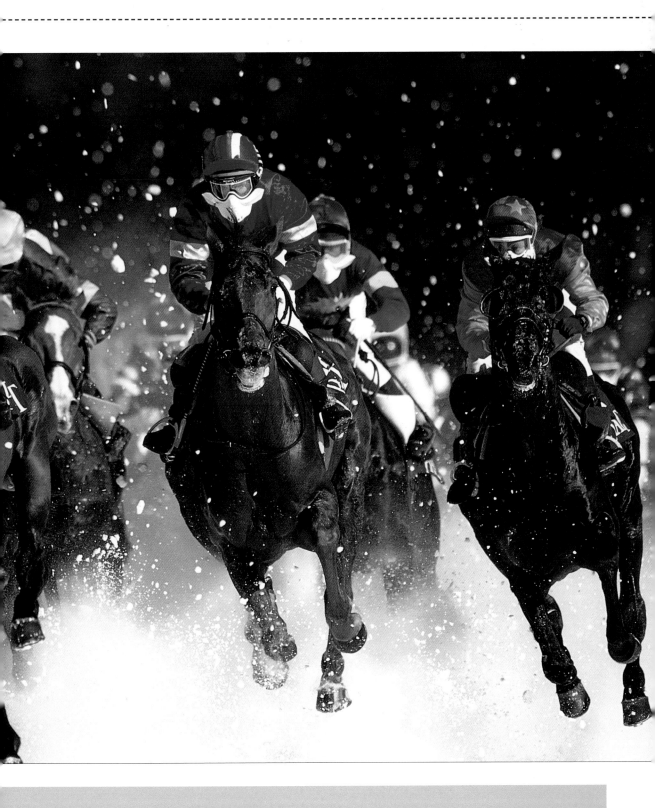

FREE-FALL ACTION

Before attempting to take photographs while in free fall you have to be an expert skydiver yourself. As you plummet toward the ground from an aircraft you are falling at nearly 200km (120 miles) per hour – that is until your parachute opens, when your rate of descent instantly slows to a mere 17km (10 miles) per hour. This near instantaneous decrease in speed is equivalent to a force of about three times normal gravity. While in free fall, however, you, and all of your equipment, are effectively weightless – a camera tethered to your body by its strap, for example, would simply float about leaving you with the awkward task of trying to grab it back again. The only effective way to take photographs such as the ones on these pages is to use a lightweight camera clamped securely to your helmet that you can trigger via a hand-operated shutter release cable.

PHOTOGRAPHER:
Tom Sanders/TSM

CAMERA:
35mm (and motor drive)

LENS:
17mm

FILM SPEED:
ISO 100

EXPOSURE:
¹⁄₅₀₀ second at f8

LIGHTING:
Daylight only

Hints and tips

● Skydiving normally only happens in good weather when there is plenty of light for photography. High-speed film is, therefore, unnecessary.

● A motor drive model camera is essential, since you will not be able to wind the film on manually.

● Use an autofocus camera or pre-set the focus on a manual model at about 5m (16ft). Use a wide-angle lens and a small aperture to ensure that you have sufficient depth of field to cover most subject distances.

● Use an optical sighting device attached to the helmet so that you can see approximately the same view as that encompassed by the camera's lens. In order to work properly, the device needs to be calibrated for your camera and specific lens.

▲ To take this picture, shot at thousands of feet above the beautiful coral reefs and atolls of the Pacific Ocean, the photographer used an extreme wide-angle fish-eye lens. The depth of field associated with every aperture on such a lens is so great that focusing is almost irrelevant – everything from a few inches in front of the camera to infinity will be sharp, even when using just a moderately small aperture.

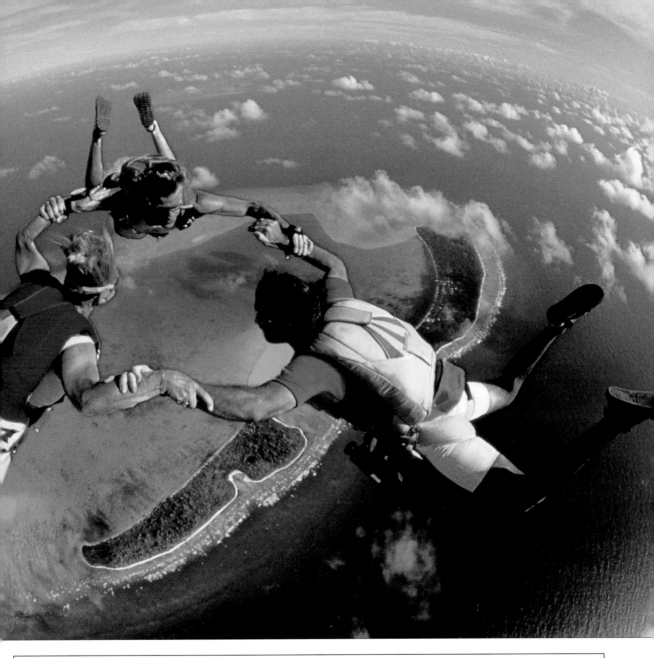

Essential equipment

Apart from the normal sky-diving clothing and safety equipment, you will need the following photographic equipment:

1 Camera with built-in motor drive

2 Camera-mounting bracket

3 Long-cabled shutter release (runs from the camera and up the inside of the sleeve of the jump suit)

4 Optical sighting device

5 Battery pack (for electronic release)

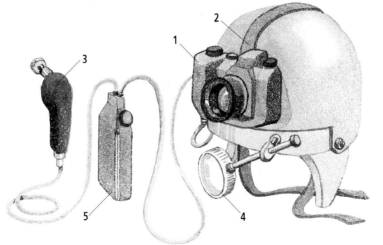

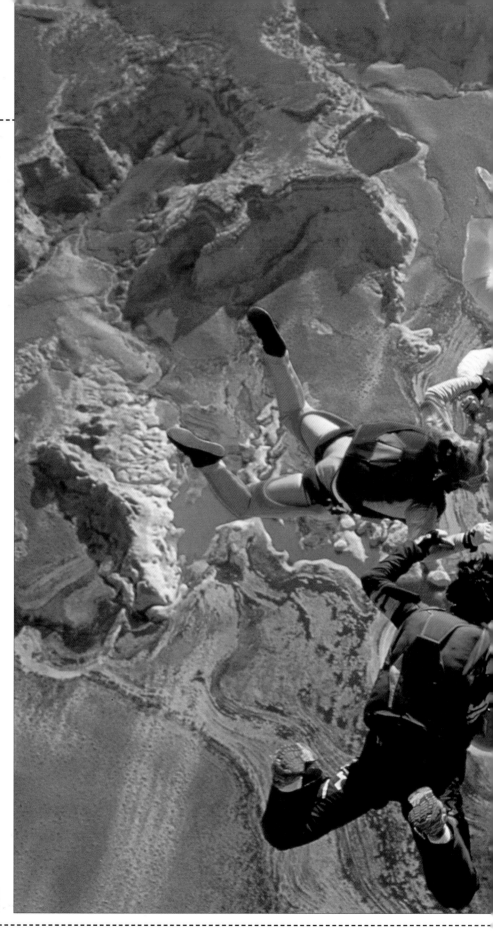

▶ *Using a less-extreme focal length than in the previous skydiving photograph meant that the photographer had to prefocus the lens before jumping because depth of field might not have been sufficient to cover all focusing eventualities. The required shutter speed was also pre-set, with a view to freezing subject movement and stopping any camera shake, and the aperture was set by the camera's built-in exposure system.*

PHOTOGRAPHER:
Tom Sanders/TSM

CAMERA:
35mm (and motor drive)

LENS:
28mm

FILM SPEED:
ISO 100

EXPOSURE:
⅟₅₀₀ second at f5.6

LIGHTING:
Daylight only

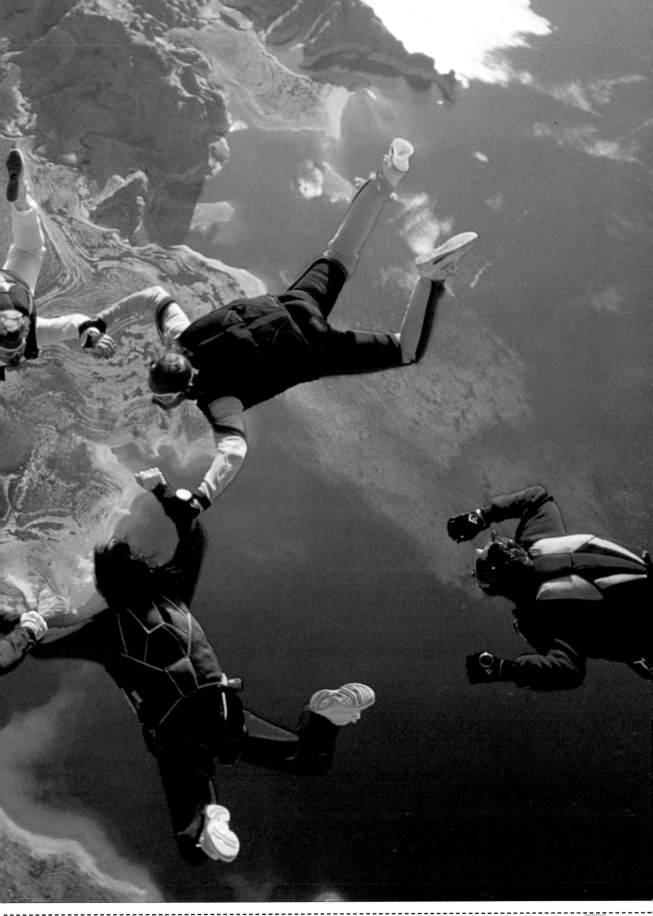

COMBINING IMAGES...

One way of using slide images that, by themselves, could not be described as action shots is by combining two together in the same slide mount. You can then project this slide "sandwich" and, if you are completely happy with the effect you see, take a photograph directly from the screen. This technique can also be used with negative originals – colour and/or black and white – but you will first have to print both of the originals together in order to see if your choice of originals has really worked to good effect.

PHOTOGRAPHER:
Joe Baker/Refocus

CAMERA:
35mm

LENS:
**(airplane)
400mm
(sunset sky)
50mm**

FILM SPEED:
ISO 100

EXPOSURE:
**(airplane)
⅟₅₀₀ second at f4
(sunset sky)
½₅₀ second at f11**

LIGHTING:
Daylight only

▲ *The inspiration for this sandwiched image started with the photograph of the aircraft (taken on a slide original) climbing steeply with its wheels still down just after take-off. The photograph was, however, not only too thin, being about 2½ stops over-exposed, the sky above it was* *also flat and uninteresting. To rescue the situation, a slightly thin sunset slide image was found and combined with the first on a light-box. After carefully aligning the two, both were placed in the same slide mount and projected on to a screen and rephoto-graphed as a single image.*

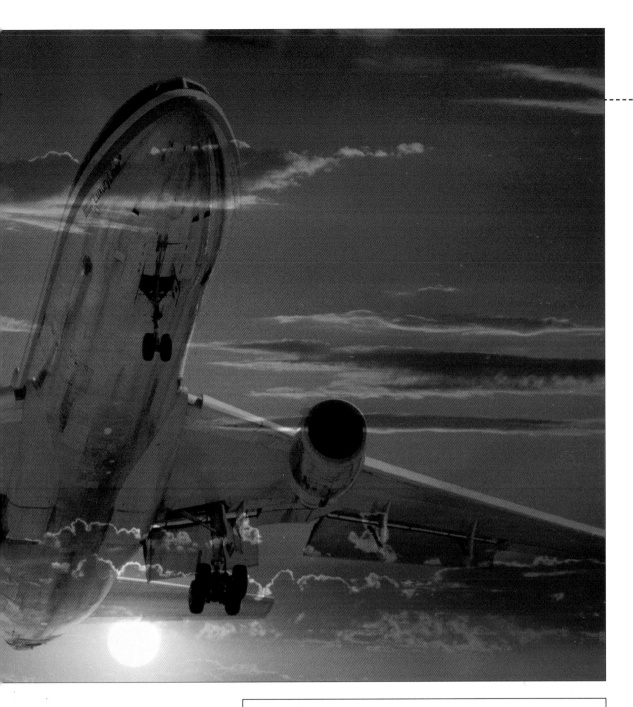

Hints and tips

● To allow sufficient light from the projector to penetrate the combined densities of two slide images, both of the originals should be overexposed in the camera. This produces "thin" positives after processing, which represent less of a barrier to the projector light. Some models have high and low settings for the projector's light output.

● When taking a photograph from a screen, exclude all light other than that from the projector. Extraneous room light will weaken image contrast and may also cause colour casts.

● Slide sandwiches can also be printed in a darkroom directly on to positive/positive paper, using the appropriate processing chemistry.

ANATOMY OF ACTION

There are a number of specialist photographic techniques, such as the stroboscopic image below, that as well as producing spectacular action shots in their own right, also give us an insight into the anatomy of movement.

Trainers, coaches, sports scientists, and physiotherapists are just some of the people vitally concerned with the minutiae of human movement and the effects this has on performance. But a detailed knowledge of human movement is needed by others with very different concerns and in diverse fields of activity – everything from the shape of the kettle you boil your water in first thing in the morning to the layout of the car you drive home in the evening, is the result of detailed study by designers and scientists of how people move and carry out specific tasks.

With the correct lighting and camera equipment, producing a stop-frame image of any action sequence is not difficult. The principle is surprisingly simple: a rapidly flashing, high-intensity stroboscopic light, or a series of synchronized lights, is used to illuminate the subject while the camera's shutter is held open for as long as that part of the movement under study takes place. Each burst of light, which may be a millionth of a second or less in duration, is enough to produce a frozen image of the subject. Even during a "normal" exposure time of, say, $\frac{1}{60}$ second, a strobe light will produce many of these action segments on the same frame of film.

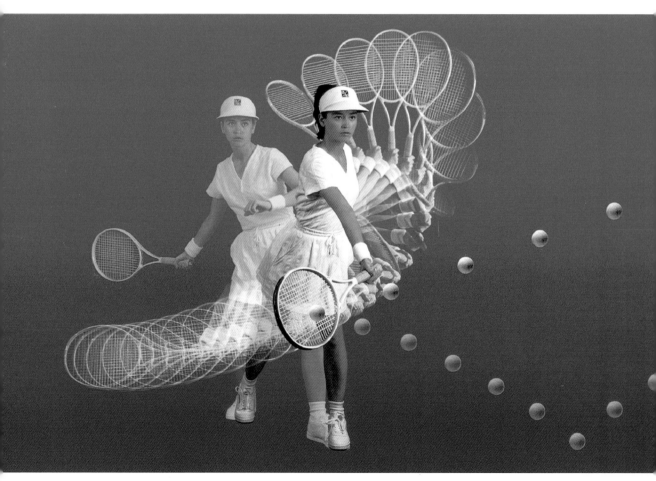

PHOTOGRAPHER:
Globus, Holway & Lobel/TSM
CAMERA:
**Panoramic rollfilm camera
with swivelling lens**
FILM SPEED:
ISO 100
EXPOSURE:
¹⁄₃₀ second at f8
LIGHTING:
High-speed stroboscopic

▼ *Two different tennis strokes can be seen here – one a defensive block, the other a forehand swing – and the trajectory of the ball resulting from each is clearly visible. As well as having a potential market as an advertising image, photographs identical in principle to this are used for analysis of technique by equipment manufacturers and coaches.*

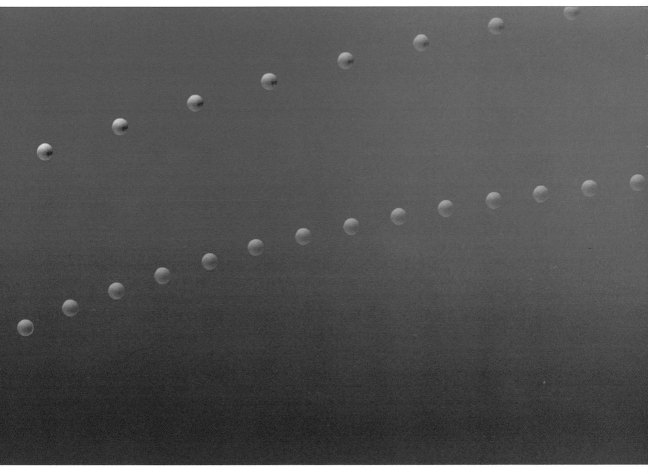

ACTION-STOPPING FLASH

When covering indoor action events, or outdoors when light levels are particularly low, you can opt to load the camera with high-speed film (ISO 800 or faster) and accept the inevitable slight fall-off in image quality that will be discernible if enlargements are blown up too big. As an alternative, and where the organizers allow it, you could supplement existing light levels using flash. Camera-mounted flashguns are fine if you are working close in to the action, but if you need to light a large area then you will have to use larger studio-type flash heads. If you are using electronic flash lighting (camera-mounted or studio heads), make sure that its output completely swamps illumination coming from any other source, such as tungsten light bulbs or fluorescent tubes. Each type of light has it own "colour temperature" and reproduces colours in the scene with a different bias.

Apart from increasing light levels over the image area, flash has the additional advantage of producing an extremely brief pulse of light – as brief as ¹⁄₁₀,₀₀₀ second or less. Action that is too fast to be stopped, even with a camera's briefest shutter speed, could thus be frozen completely.

PHOTOGRAPHER:
Bob Martin

CAMERA:
35mm

LENS:
**70–200mm
(set at 135mm)**

FILM SPEED:
ISO 50

EXPOSURE:
¹⁄₂₅₀ second at f5.6

LIGHTING:
**Studio lighting heads x 4,
plus softboxes**

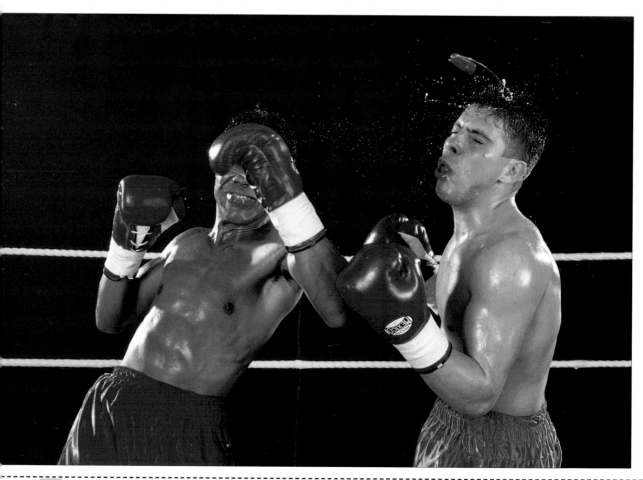

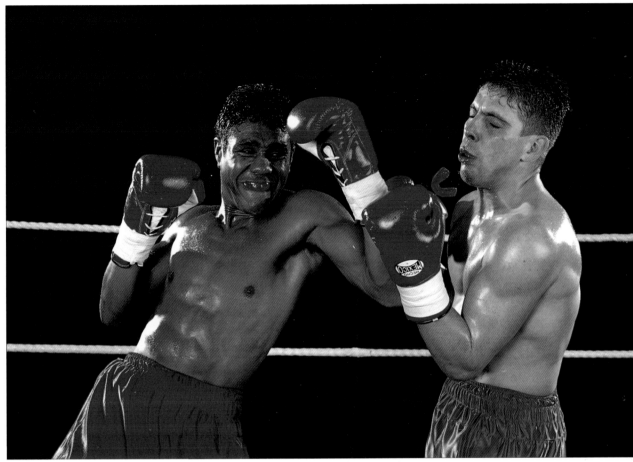

◀▲ The type of lighting set-up used to take these shots could not be employed during a real contest. The punches shown here are real enough, as is the pain evident in the face of the fighter on the receiving end, but they were in fact taken in a gym during a training session. During a real fight, you would need to get as close to the action as possible and use camera-mounted flash.

◀ To light the whole of the boxing arena evenly, two studio flash units were set up at the front and two at the rear of the ring. All four heads were fitted with softboxes to spread and soften the light and prevent the often over-harsh effect produced by undiffused flash. One flash unit was synchronized to the camera and the other three were fitted with slave units to ensure that all fired at precisely the same instant.

▶ *Although the light from a flash unit is only of very brief duration, if you select a slow shutter speed and there is plenty of ambient light falling on the scene, the film may record a secondary, blurred after image along with the flash-illuminated one. If, for example, a light reading indicated that a shutter speed of ⅕ second would be sufficient for a normal exposure, as was the case for this photograph of a boxer training in a gym, the subject will continue to be recorded on the film after the flash has fired and until the shutter closes. The result is a combination of sharp and blurred detail that seems to add to the speed, action, and vitality of the boxer's workout session. The light used here was a single studio flash fitted with a softbox.*

PHOTOGRAPHER:
Bob Martin

CAMERA:
35mm

LENS:
**28–70mm
(set at 65mm)**

FILM SPEED:
ISO 50

EXPOSURE:
⅕ second at f8

LIGHTING:
**Daylight and studio
lighting head, plus softbox**

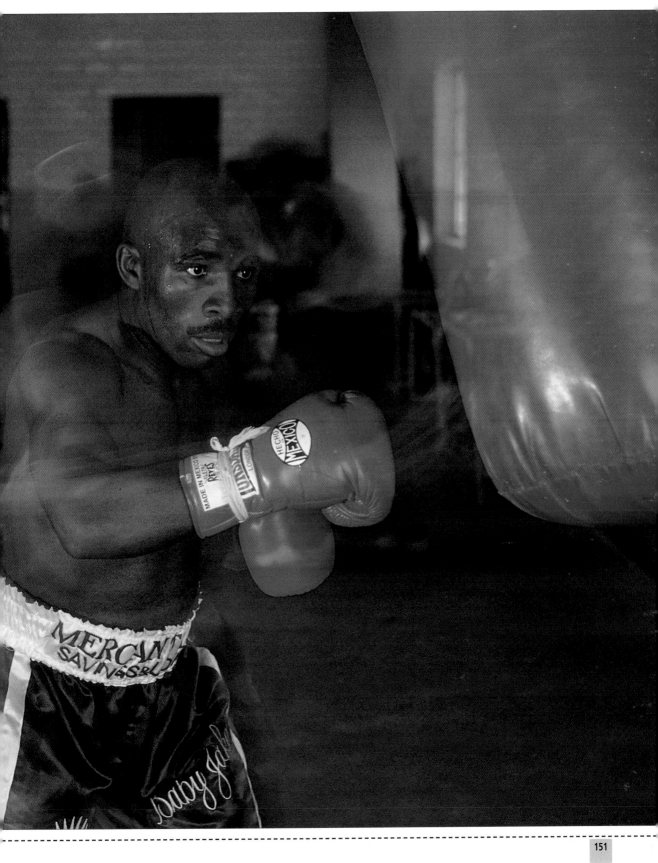

DIRECTORY OF PHOTOGRAPHERS

Autosport Photographic
60 Waldegrave Road
Teddington
Middlesex
TW11 8LG
UK
Telephone: + 44 (181) 9435918
Fax: + 44 (181) 9435922

Photographs on pages 68, 69, 70–1

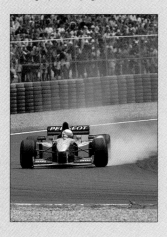

Jose Azel
c/o TSM
PO Box 210
20 Conduit Place
London W2 1HZ
UK
Telephone: + 44 (171) 2620101
Fax: + 44 (171) 7242274

Photograph on page 99

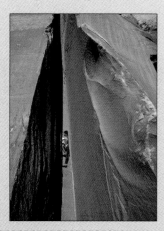

Joe Baker
c/o Refocus
The Photographic Agency
11 Poplar Mews
London W12 7JS
UK
Telephone: + 44 (181) 7430588
Fax: + 44 (181) 7460242

At the age of eight Joe Baker was given his first camera and photography remained his hobby throughout childhood. During his high school years, he worked in a portrait studio and camera shop, but on entering college he majored in mechanical engineering. It soon became apparent that he was not cut out for a career in this field, and so he switched to the Rochester Institute of Technology to study photography.

Three years later, Joe undertook his first assignment as a freelance photographer, working for the *Washington Post Photomac Magazine*. In Washington, DC he worked as a freelancer for both the *Washington Post* and the *Washington Star*.

After two years in Washington, Joe moved to New York City, starting in the darkroom of an advertising photography studio. Seven studios and 30 years later, Joe has photographed everything from super stars to presidents.

Joe Baker is now working in illustration, combining photography and paint to produce his finished artworks.

Photographs on pages 24, 25, 26, 27, 144–5

Catherine Chalmers
c/o Refocus
The Photographic Agency
11 Poplar Mews
London W12 7JS
UK
Telephone: + 44 (181) 7430588
Fax: + 44 (181) 7460242

Catherine Chalmers graduated from Stanford University in 1979 with a BS Engineering degree and from the Royal College of Art, London, in 1984 with an MFA in Painting. Catherine has held major exhibitions in London and New York.

Photograph on page 94

Aaron Chang
c/o TSM
PO Box 210
20 Conduit Place
London W2 1HZ
UK
Telephone: + 44 (171) 2620101
Fax: + 44 (171) 7242274

Photograph on page 96–7

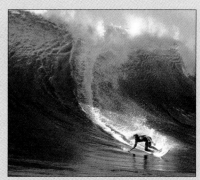

J B Diederich
c/o TSM
PO Box 210
20 Conduit Place
London W2 1HZ
UK
Telephone: + 44 (171) 2620101
Fax: + 44 (171) 7242274

Photograph on page 92

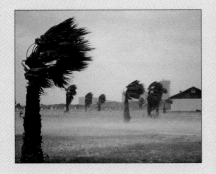

Steve Elmore
c/o TSM
PO Box 210
20 Conduit Place
London W2 1HZ
UK
Telephone: + 44 (171) 2620101
Fax: + 44 (171) 7242274

Photograph on page 84

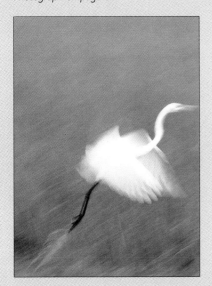

Jim Erickson
c/o TSM
PO Box 210
20 Conduit Place
London W2 1HZ
UK
Telephone: + 44 (171) 2620101
Fax: + 44 (171) 7242274

Photograph on page 96

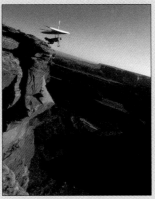

Gary Foxton
c/o Refocus
The Photographic Agency
11 Poplar Mews
London W12 7JS
UK
Telephone: + 44 (181) 7430588
Fax: + 44 (181) 7460242

Gary Foxton's favourite photographic subjects tend to be sports in which people pit themselves against the elements – surfing, canoeing, mountain biking, and so on.

When Gary photographs a sporting activity, he strives through his work to convey the action and motion of the event to the viewer, always trying to capture the spirit of what it is like to be there actually seeing it happen in front of you. To achieve this end, Gary uses a combination of techniques, such as slow synchronized flash and slow shutter speeds with wide-angle lenses.

Photographs on pages 28, 29, 126, 127, 128, 129, 130–1, 132, 133

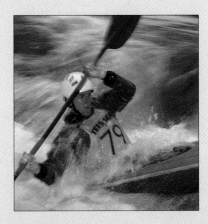

Mark Gamba
c/o TSM
PO Box 210
20 Conduit Place
London W2 1HZ
UK
Telephone: + 44 (171) 2620101
Fax: + 44 (171) 7242274

Mark Gamba enjoys taking photographs of adventure sports, such as climbing, because he enjoys participating in them himself. In fact, many of his images simply would not be possible to take without some experience of the sports involved. His favourite photographic subjects at present include whitewater kayaking and scuba-diving, although he also has a love of other activities, including skiing, ice climbing, mountain biking, canoeing, and trekking.

Photograph on page 160

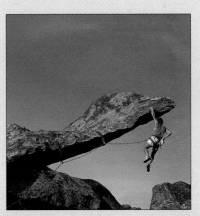

Ned Gillette

c/o TSM
PO Box 210
20 Conduit Place
London W2 1HZ
UK
Telephone: + 44 (171) 2620101
Fax: + 44 (171) 7242274

Ned Gillette claims that he is primarily an explorer who picked up photography in order to be able to tell a story. Bringing home "you-are-there" pictures is the key to his being able to make a living out of what he most loves to do – being part of expeditions to the remotest corners of the world.

Photograph on page 98–9

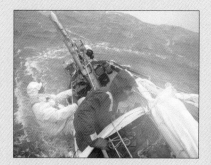

Globus, Holway & Lobel

c/o TSM
PO Box 210
20 Conduit Place
London W2 1HZ
UK
Telephone: + 44 (171) 2620101
Fax: + 44 (171) 7242274

Photograph on page 146–7

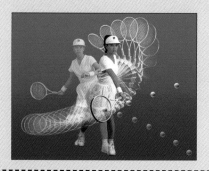

Hans Halberstadt

c/o TSM
PO Box 210
20 Conduit Place
London W2 1HZ
UK
Telephone: + 44 (171) 2620101
Fax: + 44 (171) 7242274

Hans Halberstadt is the author of many books on modern military communities and systems, with an emphasis on special operations, combat aviation, and modern land combat. Hans trained as a documentary film-maker and applies documentary techniques to his photography. His 37 book titles are nearly all heavily illustrated, and as well as his 25 military books he also has titles on such subjects as the American farm heritage, fire engines, and railroads and locomotives.

Photograph on page 52

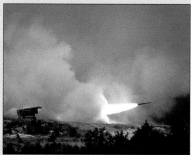

Simon Hennessey

18 Southdown Road
Portslade on Sea
East Sussex BN41 2HN
UK
Telephone: + 44 (1273) 415763

Simon Hennessey studied photography at Epsom school of art and design for two years, leaving with a Datec diploma with distinction in audiovisual photography. His time immediately after leaving college was taken up with freelance photography for a local newspaper, taking on portrait and wedding commissions whenever the chance

arose to make ends meet. Simon returned to college in 1984 to take an SIAD diploma in photography, working during the two-year course with the fire service as a press and forensic photographer. On finishing the diploma course, Simon worked as a freelance press photographer on several papers while retaining his links with the fire service. His big career change came in 1988 when he moved into, first, the print trade and, then, into book publishing.

Photographs on pages 64, 65, 66–7, 102, 103, 104, 104–5, 106, 107, 112, 113, 114, 115, 116, 117, 118, 119

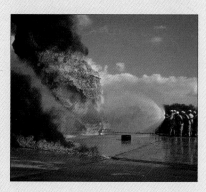

Mark A Johnson

c/o TSM
PO Box 210
20 Conduit Place
London W2 1HZ
UK
Telephone: + 44 (171) 2620101
Fax: + 44 (171) 7242274

Although Mark Johnson has many photographic specialities, they all have to do with the outdoors. He concentrates on shooting surfing and wave studies, windsurfing, mountain biking, nature and scenics, lifestyle, and travel. Mark started taking surfing photographs when he was about 15 years old, an activity that grew quite naturally out of his love for the sport. He has been a full-time professional photographer for the past six years.

Photograph on page 91

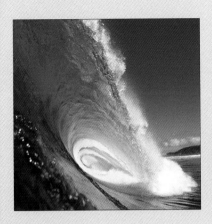
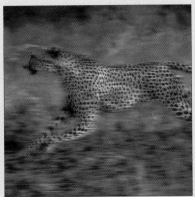
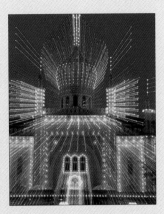

Darrell Jones
c/o TSM
PO Box 210
20 Conduit Place
London W2 1HZ
UK
Telephone: + 44 (171) 2620101
Fax: + 44 (171) 7242274

Photograph on page 95

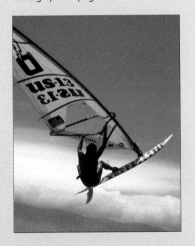

Nick Kleinberg
c/o TSM
PO Box 210
20 Conduit Place
London W2 1HZ
UK
Telephone: + 44 (171) 2620101
Fax: + 44 (171) 7242274

Photograph on page 7

Bob Krist
c/o TSM
PO Box 210
20 Conduit Place
London W2 1HZ
UK
Telephone: + 44 (171) 2620101
Fax: + 44 (171) 7242274

Bob Krist is a freelance photographer working regularly on assignment for such magazines as *Travel/Holiday*, *Travel & Leisure*, *Islands*, *Gourmet*, and *National Geographic*. His photographs from these worldwide assignments have won awards in the Pictures of the Year, Communication Arts, and World Press competitions. He was named Travel Photographer of the Year '94 by the Society of American Travel Writers and his work has featured on the cover, and in a 10-page portfolio, in an issue of the prestigious *Communication Arts* publication.

A writer as well as a photographer, Bob has been the contributing editor and photography columnist at *Travel & Leisure* magazine for seven years. Currently, he is a contributing editor at *National Geographic Traveler*, where he writes a photography column. Bob appears periodically as a photography correspondent on television and teaches a travel photography class at the Maine Photo Workshops.

Photograph on page 17

Mark M Lawrence
c/o TSM
PO Box 210
20 Conduit Place
London W2 1HZ
UK
Telephone: + 44 (171) 2620101
Fax: + 44 (171) 7242274

Mark Lawrence lives in Fort Lauderdale, Florida, and has been photographing the underwater world since 1977. As a freelance photographer, stretching back to 1983 Mark has recorded many facets of NASA operations, while his environmental portrait assignments appear in numerous US business publications. His underwater and NASA images of the space shuttle have been published as posters, in books, annual reports, and magazines, and have been used in advertisements around the world.

Photograph on page 53

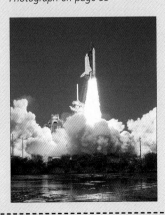

Chris Marona
c/o Refocus
The Photographic Agency
11 Poplar Mews
London W12 7JS
UK
Telephone: + 44 (181) 7430588
Fax: + 44 (181) 7460242

Cowboy photographer Chris Marona has a unique vision of the American West. His photographs possess a unique blend of colour, light, and drama that show the very essence of the cowboy legacy. He portrays real working cowboys, following them as they carry out their chores with his 35mm and rollfilm format cameras.

Chris has been working as a photographer since 1983 and has earned national acclaim in the US for his fine-art photographs, which are showcased in galleries across the country. His photographs have appeared in numerous magazines and newspapers, including *Time*, *USA Today*, and *Cowboys and Indians*. Although raised in Arizona, Chris now lives in Durango, Colorado.

Photographs on pages 120, 121, 122, 122–3, 124, 124–5

Bob Martin
14 West End Gardens
Esher
Surrey KT10 8LD
UK
Telephone: + 44 (1372) 464400
Fax: + 44 (1372) 468335

During Bob Martin's 15-year career as a sports photographer he has established an enviable reputation. As well as winning such awards as the prestigious Sports Photographer of the Year, for the last three years he has been working on a contracted basis to *Sports Illustrated* in New York. Bob's photographs have appeared in magazines and newspapers such as *Time*, *Life*, *Sports Illustrated*, *Newsweek*, *New York Times Magazine*, *Paris Match*, *Stern*, *Bunte*, and *The Sunday Times* (London).

Photographs on pages 20, 21, 22, 23, 30–1, 31, 32–3, 34–5, 35, 36, 37, 38, 39, 42–3, 43, 44–5, 46, 46–7, 48, 49, 50–1, 54, 55, 56, 56–7, 59, 60, 61, 62, 63, 72–3, 74, 74–5, 76–7, 108, 109, 110, 111, 136–7, 138, 138–9, 148, 149, 150–1

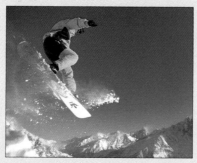

Don Mason
c/o TSM
PO Box 210
20 Conduit Place
London W2 1HZ
UK
Telephone: + 44 (171) 2620101
Fax: + 44 (171) 7242274

After graduating from the Rochester Institute of Technology, Don Mason moved to Chicago where he learned his photography by working as an assistant. His next move was to Kansas City, where he worked as the in-house photographer for a design agency. In 1986, Don moved to Seattle, where he has since opened his own studio.

Photograph on page 1

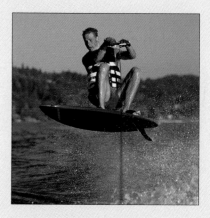

Douglas Mesney
c/o TSM
PO Box 210
20 Conduit Place
London W2 1HZ
UK
Telephone: + 44 (171) 2620101
Fax: + 44 (171) 7242274

Douglas Mesney has specialized in corporate/industrial photography for nearly three decades. Much of Douglas's work has been used as components in large-scale audio-visual shows, involving the use of up to a hundred projectors. His preferred film stock most recently is colour negative material – with much of his work being transferred to Photo CD, he finds that negative film is "more forgiving" of the colour casts commonly experienced when shooting in the types of mixed-light situations found in factories and similar locations.

Photograph on page 9

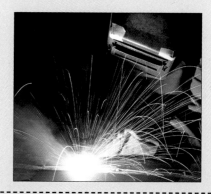

Amos Nachoum
c/o TSM
PO Box 210
20 Conduit Place
London W2 1HZ
UK
Telephone: + 44 (171) 2620101
Fax: + 44 (171) 7242274

Amos is a wildlife photographer who appreciates and is inspired by the outdoor life. His main subject for the camera are the life and behaviour of sharks, whales, and dolphins, photographing them all around the world. For the shark picture featured in this book, Amos suspended fresh tuna from a pole just above the water. Anticipating the shark's behaviour by focusing his camera on the bait. Amos didn't have to wait long for a 17-feet-long shark to lunge out of the water. Pressing his knees into the boat for stability, and holding his breath to help calm his body movements on the heaving deck, he managed to squeeze off three shots of this particular subject.

Photograph on page 87

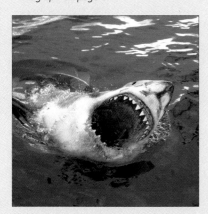

Tom Nebbia
c/o TSM
PO Box 210
20 Conduit Place
London W2 1HZ
UK
Telephone: + 44 (171) 2620101
Fax: + 44 (171) 7242274

Tom Nebbia's introduction to photography was born on the battlefields of the Korean conflict as an army combat cameraman. On returning to civilian life, Tom was employed as a press photographer in Columbia, South Carolina, winning numerous photographic awards over the next three years. In 1958 he became a permanent member of the staff of *National Geographic*, where, again, his work was rewarded many times with prizes and awards.

Photograph on page 83

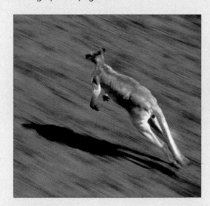

Dale O'Dell
c/o TSM
PO Box 210
20 Conduit Place
London W2 1HZ
UK
Telephone: + 44 (171) 2620101
Fax: + 44 (171) 7242274

Photograph on pages 2–3

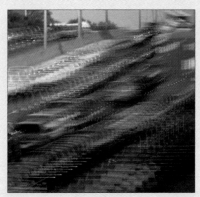

David Pollack
c/o TSM
PO Box 210
20 Conduit Place
London W2 1HZ
UK
Telephone: + 44 (171) 2620101
Fax: + 44 (171) 7242274

Photograph on page 8

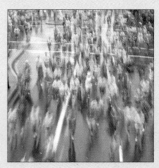

Benjamin Rondel
c/o TSM
PO Box 210
20 Conduit Place
London W2 1HZ
UK
Telephone: + 44 (171) 2620101
Fax: + 44 (171) 7242274

Whenever Benjamin Rondel travels he attempts to record on film the unique qualities that every city has to offer.

Photograph on page 19

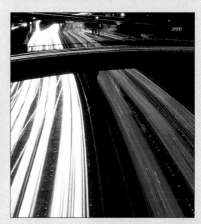

Pete Saloutos
c/o TSM
PO Box 210
20 Conduit Place
London W2 1HZ
UK
Telephone: + 44 (171) 2620101
Fax: + 44 (171) 7242274

Photograph on page 18

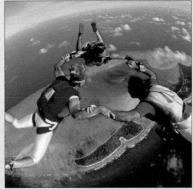

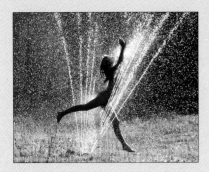

Tom Sanders
c/o TSM
PO Box 210
20 Conduit Place
London W2 1HZ
UK
Telephone: + 44 (171) 2620101
Fax: + 44 (171) 7242274

The key to Tom Sanders' success as a sky-diving photographer is his adapted motorcross helmet on which his camera is mounted. Easy and simple operation is important in getting the shots during free fall. Tom uses a military-style siting device to aim the camera, an electronic shutter release in one hand, and a series of push-button controls to operate the motor drive. Because of the extra weight of the camera equipment, Tom wears a special winged jump suit, and to compensate for this weight being carried largely on his head he uses only well-used parachutes. The more a parachute is used the more the material stretches, which lessens the jolt on his neck when it opens.

Photographs on pages 140–1, 142–3

Ron Sanford
c/o TSM
PO Box 210
20 Conduit Place
London W2 1HZ
UK
Telephone: + 44 (171) 2620101
Fax: + 44 (171) 7242274

For well over 20 years Ron Sanford has been a successful wildlife and travel photographer, and his work has taken him all over the world. For the sheer drama and the quality of the subject matter available, however, Ron still finds the area of southeast Alaska, where his picture of whales was taken, to be one of the most visually exciting areas remaining on earth. As with all his wildlife photography, his goal is to capture a unique moment in our natural world, but never to interfere with it.

Photographs on pages 80–1, 82–3, 84–5

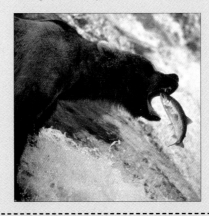

Grafton Marshall Smith
c/o TSM
PO Box 210
20 Conduit Place
London W2 1HZ
UK
Telephone: + 44 (171) 2620101
Fax: + 44 (171) 7242274

Photograph on page 86

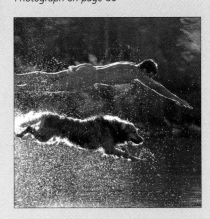

The Stock Market (TSM)
PO Box 210
20 Conduit Place
London W2 1HZ
UK
Telephone: + 44 (171) 2620101
Fax: + 44 (171) 7242274

TSM is one of the leading independent international stock photography agencies, a position it has achieved since it was founded in 1981. 15 years on, and still expanding, TSM boasts an extensive and tightly edited contemporary library of more than 3 million images sorted into more than 7,500 categories, and representing the work of over 250 of the world's top photographers. TSM's products include ten print catalogues and three fully keyworded, Mac/PC-compatible CD-ROMs. TSM has also constructed its own website (http://www.trmphoto.com).

Bill Stormont

c/o TSM
PO Box 210
20 Conduit Place
London W2 1HZ
UK
Telephone: + 44 (171) 2620101
Fax: + 44 (171) 7242274

Bill Stormont has photographed fires for the last ten years. His interest was sparked when he moved from the city to a rural part of the US and became a member of a volunteer fire department. Bill says that photographing fires is like shooting sports – peaks of intense drama surrounded by the unexpected. Eschewing the business end of the hose in favour of his camera, he says that getting really close and preserving a fire on film is intensely satisfying.

Photograph on page 88

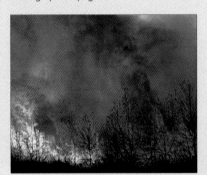

Lena Trindade

c/o TSM
PO Box 210
20 Conduit Place
London W2 1HZ
UK
Telephone: + 44 (171) 2620101
Fax: + 44 (171) 7242274

Whenever Lena Trindade thinks of what best evokes the essence of life, the word "motion" comes to mind, and among mankind's higher expressions, motion is best depicted by the dance.

Photograph on page 19

Graig Tuttle

c/o TSM
PO Box 210
20 Conduit Place
London W2 1HZ
UK
Telephone: + 44 (171) 2620101
Fax: + 44 (171) 7242274

Graig Tuttle has built up a particular expertise in photographing waves. He regularly risks death by being slammed against the rocks if he get too close to the action in order to capture one of his magical images.

Photograph on pages 90-1

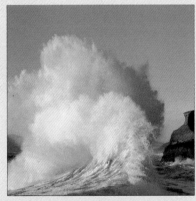

Arjen & Jerrine Verkaik

c/o TSM
PO Box 210
20 Conduit Place
London W2 1HZ
UK
Telephone: + 44 (171) 2620101
Fax: + 44 (171) 7242274

Arjen & Jerrine Verkaik (Skyart) are the members of an internationally recognized photography team who "chase the sky", capturing its many faces on film. Their vast photographic resource contains more than 40,000 images as well as time-lapse film.

Their enthusiasm for the subject of the sky is infectious, and they have been featured on radio, television, and in print, encouraging others to take more notice of the beauty and mystery that is constantly available to the alert skywatcher.

Photographs on pages 89, 93

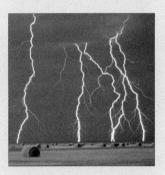

Anne-Marie Weber

c/o TSM
PO Box 210
20 Conduit Place
London W2 1HZ
UK
Telephone: + 44 (171) 2620101
Fax: + 44 (171) 7242274

Photograph on page 16

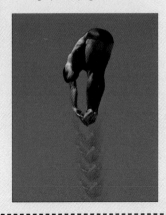

ACKNOWLEDGEMENTS

In large part, the production of this book was made possible only by the generosity of many of the photographers who permitted their work to be published free of charge, and the publishers would like to acknowledge their most valuable contribution. Similarly, the publishers would also like to thank all of the subjects who appear in the photographs included in this book.

The publishers would also like to thank the following individuals and organizations for their support and professional and technical assistance and services, in particular Brian Morris and Angie Patchell at RotoVision SA, Bob Martin for so generously allowing us access to his photographic collection, E.T. Archive, and the equipment manufacturers whose cameras, lenses, flash units and other lighting equipment appear at the beginning of the book, and especially to the importers of Hasselblad and of Multiblitz.

All of the illustrations in this book were drawn by Kate Simunek.